Birds and Beasts of Ancient Latin America

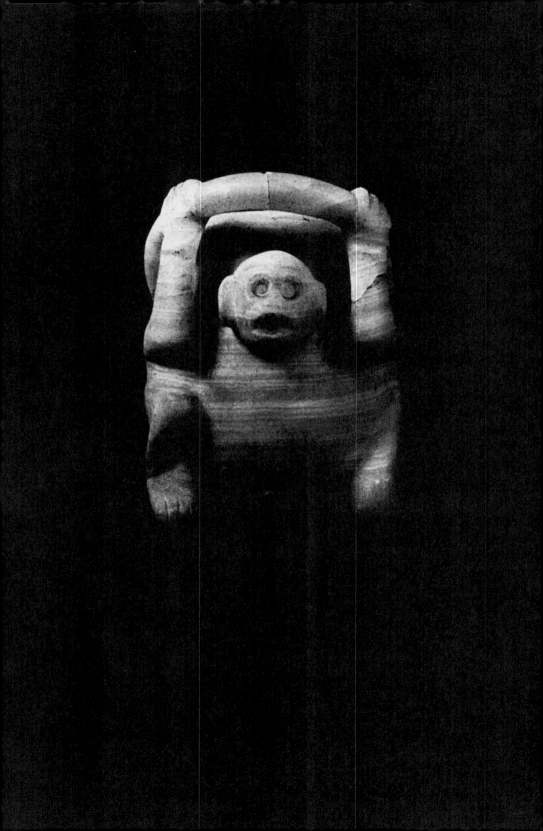

# Birds and Beasts of Ancient Latin America

Elizabeth P. Benson

Foreword by Susan Milbrath

University Press of Florida

Gainesville · Tallahassee · Tampa · Boca Raton
Pensacola · Orlando · Miami · Jacksonville

02   01   00   99   98   97   6   5   4   3   2   1

*Library of Congress Cataloging-in-Publication Data*
Benson, Elizabeth P.
Birds and beasts of ancient Latin America / Elizabeth P. Benson;
foreword by Susan Milbrath.
    p.  cm.
Includes bibliographical references and index.
ISBN 0-8130-1518-9 (alk. paper).
1. Indian art—Latin America. 2. Indians—Ethnozoology.
3. Indian mythology—Latin America. 4. Ethnozoology—Latin America.
5. Animals—Latin America—Mythology. I. Title.
E59.A7B46   1997
398.24'52'098—dc21   97-2976

The University Press of Florida is the scholarly publishing agency for
the State University System of Florida, comprised of Florida A & M
University, Florida Atlantic University, Florida International University,
Florida State University, University of Central Florida, University of
Florida, University of North Florida, University of South Florida, and
University of West Florida.

University Press of Florida
15 Northwest 15th Street
Gainesville, FL 32611

# Contents

# Mesoamerica

| 1500 B.C. | 1000 B.C. | 500 B.C. | 0 | A.D. 500 | A.D. 1000-1500 | 1521 |
|---|---|---|---|---|---|---|

| PRECLASSIC OR FORMATIVE | | | CLASSIC | | POSTCLASSIC | |
|---|---|---|---|---|---|---|
| Early 1500-900 B.C. | Middle 900-250 B.C. | Late 250 B.C.-A.D. 250 | Early 250-600 | Late 600-900 | Early 900-1200 | Late 1200-1521 |

**OLMEC** 1200-400 B.C.
Tlapacoya 1200-900 B.C.
San Lorenzo 1500-400 B.C.
La Venta 1200-400 B.C.

**WEST MEXICAN CULTURES** 250 B.C.-A.D. 250

**TEOTIHUACAN** 150 B.C.-A.D. 750

**ZAPOTEC** 250 B.C.-A.D. 800
Monte Alban 250 B.C.-A.D. 800

**VERACRUZ** A.D. 500-1521
El Tajin A.D. 500-900

**TOLTEC** 900-1200
Tula A.D. 800-1200

**MIXTEC** 1200-1521
Mitla A.D. 1100-1521

**HUASTEC** 1200-1521

**AZTEC** 1325-1521
Tenochtitlan A.D. 1325-1521

**CLASSIC MAYA** A.D. 250 - A.D. 900
Uxmal A.D. 700-1000
Palenque A.D. 400-800
Piedras Negras A.D. 600-800
Tikal 200 B.C.-A.D. 870
Copan A.D. 400-850
Quirigua A.D. 600-800

**POSTCLASSIC MAYA** A.D. 900 -1546
Chichen Itza A.D. 600-1200
Tulum A.D. 800-1527

# Central Andes

| 1500 B.C. | 1000 B.C. | 500 B.C. | 0 | A.D. 500 | A.D. 1000 | 1500-1534 |
|---|---|---|---|---|---|---|

| INITIAL PERIOD | EARLY HORIZON | EARLY INTERMEDIATE | MIDDLE HORIZON | LATE INTERMEDIATE | LATE HORIZON |
|---|---|---|---|---|---|
| 1500-900 B.C. | 900-200 B.C. | 200 B.C.-A.D. 600 | A.D. 600-1000 | 1000-1470 | 1470-1534 |

**NORTH COAST**

CUPISNIQUE 1200-200 B.C.

MOCHE A.D. 1-700

LAMBAYEQUE A.D. 900-1250

CHIMU A.D. 900-1470
Chan Chan A.D. 900-1470

**CENTRAL COAST**

Pachacamac A.D. 100-1534
Chancay A.D. 900-1534

**SOUTH COAST**

PARACAS 700 B.C.-A.D. 200

NASCA 200 B.C.- A.D. 600
Cahuachi A.D. 200-500

**HIGHLANDS**

CHAVIN 900-200 B.C.

TIWANAKU 300 B.C.-A.D. 1000

HUARI A. D. 500-800

INKA A.D. 1400-1534
Cuzco A.D. 1400-1534
Machu Picchu A.D. 1450-1550

# Figures and Plates

PLATES *(following page 74)*

# Foreword

Pre-Columbian people did not separate themselves from animals in quite the way we do today. They believed that animals have spirits and power, much the same as human beings. They feared nocturnal animals that shared a connection with the darkness of the underworld. Jaguars were especially powerful, for they were nocturnal hunters known to attack humans. More often, however, man was predator and the animals prey.

Animal remains from archaeological sites indicate that wild and domesticated animals were a significant source of protein in the diet. Hunting was a ritual event as well as a way to provide food. Deer and foxes were the most important large game animals. Other food animals included wild birds and domesticated animals, most notably dogs and partially domesticated animals such as guinea pigs—a favorite food in Pre-Columbian Peru. Turkeys were domesticated in Central Mexico and llamas in the Andes of South America. Llamas served as pack animals carrying light burdens, but they were never used as draft animals. Indeed, there was no need to develop wheeled vehicles because there were no animals to pull such conveyances. Llamas and wild birds sometimes substituted for humans as blood sacrifices, the blood of the animals apparently being an apt counterpart for human blood.

Animal gods shared the stage with gods of human form in Pre-Columbian cosmology. Most often the deified creatures represented animals from the local environment, but some exotic animals also appear as Pre-Columbian gods. Animal gods did not always inhabit their natural environment; hence we see feathered serpents in the sky and birds in the

cave-like interior of the earth associated with the underworld. Some animal deities combine a number of different animal forms, a mythological mixture that defies precise definition. Their changing attributes express the infinite variety of the natural world as well as the relationship between people and animals. For example, Peruvian artists painted otherworldly creatures decked with plants and human trophy heads to suggest a connection between the cults of agricultural fertility and human sacrifice.

In this book Elizabeth Benson explores Pre-Columbian zoology and the important role of animals as companions to man in this world and in the afterlife. She is widely acknowledged as the leading expert on animal imagery in Pre-Columbian America. Although she was trained as an art historian, her extensive study of Latin American zoology, past and present, lends a new dimension to the interpretation of the artistic images. As director of the Center for Pre-Columbian Studies at Dumbarton Oaks in Washington, D.C., she organized many conferences on Pre-Columbian art and archaeology and edited numerous volumes published by Dumbarton Oaks. As curator of the Pre-Columbian Collection there, she worked with some of the finest ancient art works from Latin America. In addition to many exhibit catalogues, she has authored books on the Maya of Mesoamerica and the Moche of Peru as well as numerous articles on animal imagery in Pre-Columbian America. Most recently she is coeditor and coauthor of the catalogue of the exhibit "Olmec Art of Ancient Mexico" at the National Gallery in Washington, D.C. Indeed, she remains one of the best-known and best-loved scholars in the field of Pre-Columbian art.

This book forms a text parallel to the traveling exhibit "Birds and Beasts of Ancient Latin America." The art works published here, many for the first time, represent a substantial sample of the artifacts in the exhibit. They are drawn from four collections: the University of Pennsylvania Museum of Archaeology and Anthropology; the Carnegie Museum of Natural History; and the Samuel P. Harn Museum of Art and Florida Museum of Natural History, both part of the University of Florida. The exhibit was funded by a consortium formed by the Florida Museum of Natural History, the Carnegie Museum of Archaeology and

Anthropology, the University of Pennsylvania Museum, and the California Academy of Sciences.

Elizabeth Benson and I developed this exhibit as an expression of our shared interest in the connection between Pre-Columbian art and natural history. Most Pre-Columbian cultures lacked writing, so many of their ideas about the world of nature had to be conveyed over generations through the oral tradition and through visual arts. Myths involving animals recorded at the time of first European contact reveal the Pre-Columbian view of the natural world. Myths collected recently among people speaking the languages of their Pre-Columbian ancestors also help us to understand the natural history of Pre-Columbian Latin America. The art forms of the Pre-Columbian past speak eloquently of the world of nature. Weaving the myths and art images together with our knowledge of animal behavior helps to form a more complete picture of the natural world in Pre-Columbian times—a world in which people were kin to the birds and beasts of ancient Latin America.

Susan Milbrath
Florida Museum of Natural History

# Preface

*Birds and Beasts of Ancient Latin America* evolved from a traveling exhibition of the same name. This is not a catalogue of that exhibit but a record of it and an expansion of its themes. The exhibit and the book explore animals that are depicted in Pre-Columbian art and their possible meanings for ancient peoples as well their significance for the descendants of those peoples, which is reflected in recent myths and rituals.

In the past, animals shared human environments and were associated with what was most important to mankind. The understanding of animals and human relationships to them gives insight into myth, religion, ritual, and social structure, into human dealings with each other, with nature, and with the concept of the cosmos, for animals had great symbolic value for the forefathers of all of us. The beliefs of "simple Indians" today are anything but simple; thought structures would perhaps have been even more complex in the Pre-Columbian past. Ancient peoples could not have known all that modern science tells us about zoology, but they were observant, they lived close to animals, and they had a feeling for what was special about them.

The subject has broad implications in terms of indigenous peoples in rain forests and mountains everywhere, in terms of preserving animal species and their environments, and in terms of understanding peoples of the past and how they lived—perhaps even understanding more about ourselves.

This introduction to the subject merges past and present in a sense of relationship if not continuity. It focuses on animals and the patterns of their significance to people through time and space rather than on the

development of cultures in the Americas. The view is cross-cultural and sometimes, perhaps, rather whimsical, for it grew out of the dictates— the objects—of the exhibit and focused on finding good examples from archaeology, ethnohistory, ethnography, and natural history while keeping as tight as possible a bibliography that crosses at least four fields. The same subject might have been treated with a different bibliography. This is a tapestry of observations to be thought about: what common themes lie in the relationship of human beings and animals, and what do these tell us about society and its perceptions?

The book will, I hope, be of some interest to those knowledgeable about the fields touched upon here; but even more, I hope that it will whet appetites of those less knowledgeable to explore further in thicker books.

The exhibit was originated by Susan Milbrath of the University of Florida, Gainesville, who also contributed useful ideas to the book. I am grateful to her for involving me in her project. She organized the consortium of museums that cooperated in the organization of the exhibit: the California Academy of Sciences, San Francisco; the Carnegie Museum of Natural History, Pittsburgh; the Florida Museum of Natural History, University of Florida, Gainesville; and the University of Pennsylvania Museum of Archaeology and Anthropology, Philadelphia. These institutions were the lenders, the basic exhibitors, and the backers of the exhibition.

Many people helped to develop the exhibit—hence the book—and I am very grateful to all of them that I worked with. I especially appreciate the cooperation of Pamela Hearne Jardine of the University of Pennsylvania Museum, not to mention that of the director, Jerry Sabloff, and Lucy Williams, Leslie Hammond, Jack Murray, and others of the University Museum staff. A number of people at the Carnegie Museum of Natural History aided the project with great efficiency, particularly James E. King, David R. Watters, James B. Richardson III, Joan Gardner, Deborah Harding, and Mindy McNaugher. And I would like to thank Linda Kulik of the California Academy of Sciences and Elizabeth S. Wing of the Florida Museum of Natural History for their help. Justin Kerr too receives my appreciation.

I am also grateful to a number of very knowledgeable, mostly anonymous biologists, who took me to task for some of my natural-history attributions and with whom I argued about the liberties that indigenous peoples were apt to take with otherworldly animal depictions in adding, subtracting, and abstracting animal traits. It was very important to me to have their contributions.

Many of the objects illustrated here have not previously been published, and many come from some of the earliest museum excavations in the Americas. Max Uhle, a pioneer German archaeologist, was in Peru in 1896 for The University Museum, University of Pennsylvania. His work in that year at the great central-coast site of Pachacamac was basic to modern excavation techniques. At the same time, the entomologist Herbert Huntingdon Smith was excavating and collecting at Gairaca, a Tairona site in Colombia, for the Carnegie Museum of Natural History. The work of the Swedish archaeologist Carl V. Hartman in Costa Rica in 1896 for the Royal Ethnographical Museum, Stockholm, was, like Uhle's, some of the earliest serious archaeology in the Americas; many objects illustrated here come from his 1903 excavations at Las Huacas for the Carnegie Museum of Natural History.

This book celebrates the hundredth anniversary of the pioneering work of Max Uhle, C. V. Hartman, and Herbert Huntingdon Smith.

Birds and Beasts of Ancient Latin America

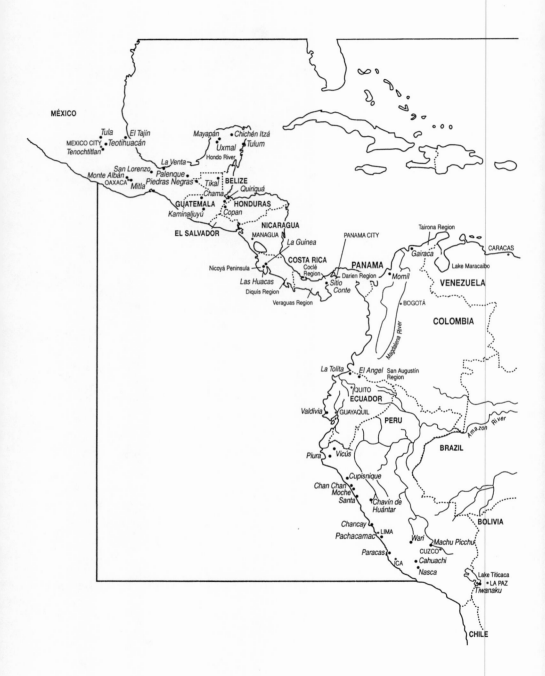

# 1    Introduction

Between ca. 2000 B.C. and the time of the Spanish conquest, ca. A.D. 1500, distinctive cultures developed in succession in various parts of what is now Latin America.[1] The geography of tropical America is extremely varied: it contains lush lowland forest, arid desert, highland plains above the tree line, and snow-capped volcanic mountains that are some of the tallest in the world. The principal subsistence base was usually farming, often with maize (corn) as the basic crop, accompanied by other cultivated plants and very limited animal domestication. Slash-and-burn farming and various forms of raised-field, terrace, and irrigation agriculture were prevalent in different environments. Hunting, fishing, and long-distance trade or tributes of special goods were parts of the pattern.

The region archaeologists call Mesoamerica (the southern half of Mexico, Guatemala, Belize, and adjacent parts of Honduras and El Salvador) achieved high stages of development throughout its history, from the early Olmec culture (beginning ca. 1500 B.C.) to the last culture, the Aztec, or Mexica.[2] There was always some form of communication and exchange within the region. The art style called Olmec is found over much of Mesoamerica. The great Classic cultures of the Maya, Teotihuacan, Oaxaca (Monte Albán), and Veracruz communicated with and influenced each other. The Aztec had a loose form of power over a good deal of the area, at least in terms of controlling trade and demanding tribute payments. Mesoamerica produced impressive, carefully oriented ceremonial centers, usually with stone architecture, sculpture, and mural painting. Among other traits that define Mesoamerica were a ritual ball game, fine pottery, jade working, and folding-screen, bark-paper books

(codices) that had glyphs or symbols for names and numbers (the Maya developed a much more complex writing system).

Another region of high cultural development was the Central Andes, comprising most of Peru and the adjacent part of what is now Bolivia.[3] Ceremonial architecture began here by the third millennium B.C. Structures on the coast were generally of adobe, those in the highlands of stone. Stone sculpture was also a highland trait. Traditions of fine textiles were beginning to develop around the same time, and metallurgy somewhat later. Andean textiles can be appreciated better than those of other regions in the Americas because many have been preserved in the Peruvian coastal desert. The widespread art style known as Chavín (and its north coast relative Cupisnique) marked the earliest great culture. The last was the remarkably organized Inca empire that stretched from Cuzco, in the southern highlands of Peru, to the Ecuador-Colombia border in the north and to central Chile in the south. The geography—coastal desert, mountains, eastern slopes, and Amazon basin—encouraged trade of goods produced by these very different areas, control of water and of certain crops, and a tendency toward empire building.

The Intermediate Area—lower Central America, Colombia, and Ecuador—has yielded most of the earliest pottery in the Americas. This region had a long history of producing remarkable artifacts: the ceramics are varied and informative, small cast-gold objects are plentiful and exceptional, and the jadeite pendants from Costa Rica are finely carved and polished.[4] With a few exceptions, however, the region lacked stone architecture, monumental sculpture, and other evidence of strong political development seen in the areas to the north and south.

The criteria of civilization in the Americas are different from those in the Old World. By Old World standards, the great early civilizations here were essentially Stone Age cultures. But their achievements were extraordinary.

There were no draft animals in the Americas, surely a major reason no society here used wheeled vehicles, although the Maya made ceremonial roads in their forests, and the Incas and their predecessors in the Andes constructed impressive road systems through the mountains and along the coast, principally for the use of llama trains, armies, ritual processions, and the Inca runner-messengers known as *chasquis*.

The potter's wheel also was not employed. Quantities of ceramics were made by coil method, modeling, or molds in a variety of shapes of vessels, figurines, and musical instruments. A typical ancient form in the north of Peru is the stirrup-spout vessel; it must have been a sacred form. Other forms were traditional in other places—a double-spout-and-bridge form on the Peruvian south coast, for example. On ceramic vases with painted, modeled, or relief designs and scenes, the Classic Maya, of Mesoamerica, and their contemporaries, the Moche, of Peru, probably told more about themselves than any other people in the ancient world, even more than the Greeks.[5] Gods, kings, myths, rituals, battles, offerings, flora, fauna, architecture, and other facets of their lives and beliefs are depicted on ceramics.

American gold working presumably began in Peru, ca. 1000 B.C. The metal was mostly placer gold, panned from rivers. Metallurgical techniques did not enter Mesoamerica (certainly not to any significant extent) for about two thousand years. The emphasis in metallurgy was not on function; metal was rarely used for tools, a major use in the Old World. In the Americas, smiths worked mostly copper, gold, and silver to make objects that expressed prestige and religious symbolism for use in rituals, including burial. The principal types of objects in the Intermediate Area were jewelry—pendants, pectorals, beads, ear and nose ornaments—and ritual objects. In the Central Andes there were also mace heads, cups, disks, plaques, banners, spatula-like scepters, and sacrificial knives.[6] Fine gold objects were manufactured with lost-wax casting, as in the Old World, or made of hammered gold, often with intricate cutting. Inlay of stone and shell was also used. *Tumbaga,* or *guanín,* an alloy of gold and copper, was popular in the Intermediate Area. With depletion gilding—removing the surface copper with acid—the object could be made to gleam as brightly as gold. Copper-arsenic and copper-tin bronzes were developed later and flourished in South America during Inca times.

The textile craftsmen of Latin America, usually employing backstrap looms—with one end tied to a tree or post, the other around the weaver's waist—were among the finest preindustrial weavers anywhere; they used cotton and, in the Andes, the wool of camelids in a variety of techniques that were often complex. Cloth was of great value and symbolic meaning to the ancient peoples.[7] In Inca times, fine cloth, woven as gar-

ments, was wealth: it was an official royal gift; it was an offering to the gods; it was sacred. Royal rites involved frequent changes of dress; it was said that the Inca never wore the same garment twice. Though few textiles have survived in the moister climates of Mesoamerica, it is obvious from depictions on sculpture, ceramic, and murals that cloth and clothing were of great significance. Weaving and garment traditions are still strong in the Andes and in Mesoamerica.

Great city-states and the capitals of empires proclaimed their power and glory with architecture and sculpture. Their architecture was splendid, whether it was Maya stone pyramids and palaces with corbel vaults; massive Moche and Chimú complexes of adobe; closely fitted, gigantic masonry walls of Inca structures; or the volcanic stones of the great Aztec capital buildings that lie beneath modern Mexico City. Sculpture, although worked with stone tools, could be as fine as any in the Old World. Aztec sculptors carved monumental depictions of deities; the Maya erected stelas dedicated to kings and presenting their portraits and histories. Sculpture in Chavín-period Peru was mainly part of the architecture, as was that in Classic-period Teotihuacan and Veracruz, in Mexico.

Like many cultures at a certain stage of development, early peoples in the Americas—the Maya especially—were excellent astronomers who could predict eclipses and who knew the cycles of sun, moon, Venus, Orion, the Pleiades, and other astral bodies. Sky watching was vital to everyday life; it helped people know when to plant and when to gather; when fish would run, birds would migrate, and game would start seasonal activities. It was important also for other reasons in the peoples' awareness of their environment and the rituals that celebrated it. Time, like the seasons, was cyclical. Calendars and almanacs were essential to the cosmologies that evolved. Astronomy was used also for astrology, for prognostication.

The Maya bar-and-dot arithmetical system was remarkably inventive and efficient. A dot was one; a bar was five. Using these, one counted to nineteen and then moved to another place to count units of twenty. Like our decimal system, this vigesimal counting was a place-value system. There was a cipher for zero, which European contemporaries, coping with Roman numerals, lacked. Through the use of this system, with units of twenty years, great lengths of time could be recorded in the

Maya Long Count.[8] It was time that the Maya were counting. The Maya, the only Pre-Columbian people with a true form of writing, inscribed hieroglyphic texts on monuments and painted them on vases. There are four existing Maya codices, known as the Dresden, Madrid, Paris, and Grolier.[9] These, like a number of other codices from other parts of Mesoamerica, are essentially almanacs. The Mixtec codices, from Oaxaca, give genealogical and historical information much like that on the Maya stelas. In the Central Andes, the *quipu*, a sort of abacus of knotted string, was a decimal-system recording device widely used by the Incas. Its use was probably more complex than we yet realize.

The most advanced cultures in the Americas had stratified societies and cosmologies of considerable complexity. Burials of varying richness and content give evidence of this, as do architectural remains and various other sources. Rulers held great political power and responsibility for administration and the strategies of warfare. They were also required to have effective relationships with the gods of nature in order to achieve successful agriculture and hunting to feed their people. Indeed, rulers were related to the gods through their ancestors, who were sacred. Rulers were "divine kings" who reinforced their bonds with the supernatural otherworld through rituals that often involved their own self-mutilation by bloodletting or centered on the human sacrifice of others, usually by decapitation. The head was the most important part of the body to be offered, although heart and limbs were also presented. Animals were sacrificed as well. The more important the animal, the more important the sacrifice. The shedding of blood had regeneration as its purpose, the nourishing of the earth and the sacred beings, frequently ancestors, that controlled the world. Human sacrificial victims were often prisoners of war. Warfare is a major theme in virtually all Pre-Columbian art. War and sacrifice appear to be closely related to agriculture. War was fought for the control of land and water for planting and probably for the capture of prisoners to be sacrificed for the appeasement and nourishment of the gods of nature whose benevolence was required. There were undoubtedly rituals that were mock battles. War itself was to a large degree a ritual activity, but blood was shed in it, and power was gained.

## 2    The Animals

The Pre-Columbian Neotropics (the Americas between the Tropics of Cancer and Capricorn) before the arrival of the Europeans at the beginning of the sixteenth century had a wealth of plants. Maize, potatoes, tomatoes, peanuts, cacao (chocolate), guavas, certain beans and squashes, and many other vegetables and fruits—not to mention the leaves of tobacco and coca—are indigenous to the Americas. Wild fauna was also rife, especially in the lush forests. The richest variety of animal species can be found around the Equator: this includes, among others, jaguars and several smaller felines, armadillos, bats, deer, foxes, monkeys, peccaries, tapirs, eagles, owls, parrots, toucans, vultures, water birds, frogs and toads, crocodilians, iguanids, turtles, and snakes and fish of various kinds.

On the other hand, there were few domesticated animals. Dogs and ducks were tamed in many places; in the Andes, there were also llamas, alpacas, and guinea pigs. Turkeys were domesticated late in Mesoamerica; wild turkeys are still fairly widespread there. In certain regions bees were kept. In addition, some wild animals could be a part of daily life. In forest villages today there may be a pet tapir, peccary, or monkey as well as parrots and macaws.

Thousands of animal depictions appear in Pre-Columbian art, naturalistic, schematic, and—to us—fantastic. In pottery, stone, cloth, metal, wood, bone, and mural painting, animals are shown alone or as actors in scenes with other animals or with human beings or supernaturals. Animals, animal parts, or imitations of them are depicted as accessories for gods, kings, or other mortals of high status. Headdressses with animal heads were common. In some instances, they may represent a clan or

lineage. The Classic Maya sometimes wore their names in their head-dresses: a macaw, a quetzal, and so on. Moche headdresses often symbol-ized the rite in which the wearer was engaged: owl and jaguar head-dresses usually indicated warfare, for example. The social rank of the human and the importance and attributes of the animals were always factors in what was worn.

The sources of information about Pre-Columbian animals and their symbolism are many. In addition to the archaeological objects them-selves, excavation reports from all over the Americas describe both fau-nal remains and the contexts of animal effigies found in burials, caches, and middens.[1] Native codices contain pictures of animals and often give natural and cultural contexts for them. The Classic Maya wrote texts on virtually everything they made; today the rapidly increasing ability of linguists, archaeologists, and others to read Maya inscriptions has added greatly to the store of knowledge. A sixteenth-century manuscript from the Guatemalan highlands, the Popol Vuh,[2] the council book of the Quiche Maya, reveals symbolic meanings for many creatures, as do some other colonial Maya manuscripts. Bernal Díaz del Castillo, one of Cortés's men in the conquest of Mexico, tells that Moctezuma, the last Aztec ruler, maintained a "zoo" in the highlands of Mexico, where he kept many exotic birds and beasts.[3] In Peru, Garcilaso de la Vega and Bernabé Cobo described the Inca ruler's receipt of live animals and birds as gift offerings.[4]

Many early Spanish writers were impressed by the biota of the New World, much of which was very different from what they had known. Hummingbird and armadillo, for example, belong to distinctive families that exist only in the Americas. The sixteenth-century friar Bernardino de Sahagún collected a great deal of factual and visual information from Indian informants about animal life and many other aspects of the Aztec world of what is now Mexico.[5] Friar Diego Durán, a sixteenth-century Dominican, is another source of Central Mexican information. Diego de Landa, the first Bishop of Yucatán, left similar information—but not illustrated—for the northern Maya area.[6] Some aspects of animal life in the Inca domain were reported by Cobo and Garcilaso and also by Felipe Guaman Poma ("Hawk Puma") de Ayala in his richly illustrated chronicle. Their purpose was usually, in part, to inform the Spanish

Crown about the New World and often to understand what the Church had to combat in the extirpation of idolatry, in which animals were intimately involved. These writers not only described animals but also recounted myths about them and ritual use of them. There are other early sources, including some European depictions of animal life in the Americas, that are truly fanciful, with human heads added to animal bodies. (In ancient America it was usually the other way around: the body was human, the head animal.)

Animals continue to appear in folk narrative and ritual, in folk art and dances.[7] A wide range of narratives compiled by many ethnographers over the last century has been published—for example, the comprehensive series of South American folk literature edited by Johannes Wilbert and Karin Simoneau and published by the Latin American Center at the University of California at Los Angeles, a few volumes of which are cited here. A body of other mythic material, in individual sources, is available.[8] Myths and narratives offer a kind of history of symbolism, perhaps a history of myth itself. They can also be interpreted in terms of social controls or models; and they tell a great deal about the environment and ways of dealing with it. Many themes seem to have great longevity. Modern folklore and the art of the past are connected.

There are dangers, of course, in using present-day, acculturated, corrupted, and watered-down material to interpret the past, but one can find in it general ideas about meaning and direction for study. In some regions the original people are living in their old homeland—or were within the last hundred years—and there are traditions and folklore that connect (although not always very directly) to old patterns. In other regions the ancient population is largely dispersed or eradicated, and there are few long-lived traditions. Many groups that exist today in relatively isolated places are not descended from the great civilizations of the past, yet they retain elements of lore and ideas of artisanship that belonged to that ancient world.

Natural history books are also sources of information, for the behavior of an animal often explains its symbolism.

Clearly identifiable species are sometimes shown in Pre-Columbian art, or the family or order is recognizable. At other times the depiction seems

to be a generic bird, fish, or mammal. Sometimes it is difficult to tell even whether the animal is a mammal, reptile, or bird. Perhaps the scene or the myth or the context was so well known that it was not necessary to show the creature with care; perhaps only the most general sort of depiction was needed to convey an idea. Often conventions for portraying an animal make it recognizable to someone familiar with the art style, its range of faunal depictions, and the cultural context but perhaps unidentifiable to a zoologist who is much more familiar with the animal but unfamiliar with the artistic and mythic conventions. Often a recognizable animal has attributes that do not properly belong to its species— teeth on a bird, for example, or feathers on a snake.

Animal and human traits are often combined. A human-bodied figure with a crocodilian head and a snake foot, from the Tairona culture in Colombia, surely represents a mythical being (fig. 1). It is seated on a bench or throne, as important personages were. Creatures with an animal head and appendages and a human body, who take human poses and wear human dress (figs. 23 and 24), may be ritually masked and/or shamanically transformed human beings or, probably more often, the mythic beings who were imitated in ritual, for ritual is by and large a reenactment of myth.

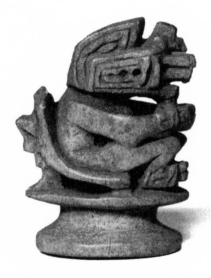

**Figure 1**

Carved bone figure with crocodilian (?) head and snake foot, on a seat or throne. Colombia, Santa Marta region, Gairaca. Tairona, A.D. 700–1500. H. 6.5, D. 3.1 cm. Carnegie Museum of Natural History 2005-1195 (Herbert Huntingdon Smith expedition, 1896-98).

A small *tumbaga* animal with an erect tail and legs like wheels or coiled snakes is unusual; its sources are not obvious to the modern viewer, although its body may be based on an anteater (fig. 2). Found in a Tairona urn burial in Colombia, it surely had relevance for those people. Some Pre-Columbian images combine telling traits of several significant creatures—jaguar dentition, eagle wings and talons, and serpent appendages. The Chavín art style, in Peru, produced some striking examples of these.[9] Whether the images were deliberate abstractions of concentrated power, shamanic visions, mythic beings, or creatures like European gargoyles or chimeras is not clear. These ancient Latin American hybrids surely carried potent messages, but they remain mysterious because they are rarely described in existing myths or lore. Sometimes we can guess at myths and meanings.

A Moche supernatural beast—part feline, part reptile—holds a severed human head; the creature may be either the sacrificer or the recipient of the offering.[10] In other Moche scenes, anthropomorphic jaguars or bats or owls are sacrificers. The Moche do not show ordinary mortals performing decapitation. The Maya also show strange supernatural sacrificers.[11]

The so-called Anthropomorphic Mythical Being of Nasca art, from the south coast of Peru, usually wears a whiskered mouth mask and a fox headdress; its ears may be feline, and its tail normally terminates in a

**Figure 2**

*Tumbaga* animal. Colombia, Santa Marta region, Gairaca. Tairona, A.D. 700–1500. H. 2.5, W. 1.2, D. 3.6 cm. The Carnegie Museum of Natural History 2005-153c (Herbert Huntingdon Smith expedition, 1896–98).

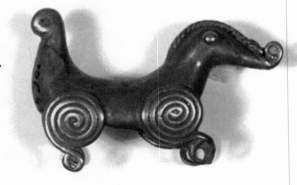

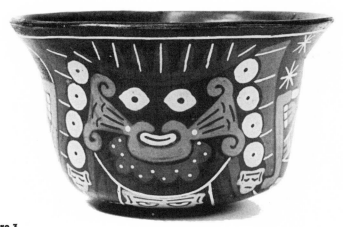

**Figure 3**

Polychrome ceramic bowl with the Anthropomorphic Mythical Being. Peru, south coast. Nasca, A.D. 100–400. H. 6.5, D. 10.5 cm. Florida Museum of Natural History, University of Florida, 102239.

feline head (fig. 3).[12] It often holds a knife and a "trophy" head, a human head severed in ritual sacrifice. The body of the Mythical Being may be decorated with schematized trophy heads. Vegetables or fruits can be added, in a likely indication that human sacrifice is a proper offering to the gods of nature in exchange for successful agriculture.

"There is no strict dividing line between men and animals," say the Kogi people in northeastern Colombia.[13] The Kogi are descendants of the Pre-Columbian Tairona, who were some of the finest goldsmiths in the Americas and among the few groups in the Intermediate Area to produce stone architecture.[14] For many peoples in remote parts of the Americas today, animals are like a different group of people, neighbors of a sort with whom people share their environment. This was probably more widely true in the past, when there were more animals and fewer people and urban areas. Recent narratives still describe a person wandering through forest or countryside and coming to an animal village, a proper community inhabited by a certain kind of animal.

Animals were intimately involved with human activities in Pre-Columbian times. They were hunted for food and hides and also for teeth and claws that adorned objects used in shamanic or priestly rites. Ritual ornaments were carved from animal bone, and feathers were used on headdresses and symbolic ornaments. Elite trade items included pelts, feathers, and marine shells. Animals and animal parts were used in medicine. Sometimes animals were removed from their native habitats and transported for considerable distances. Sometimes they were pets.

In art and narrative, animals not only signified themselves, their habits, and their usefulness; they were also part of man's ambiance on more symbolic levels. Animals, or their imitators, took roles in hunting ritual, royal rites, and seasonal ceremonies. Supernatural animals are still thought of in many places as the "owners" or "masters" of animals. Animals are believed to own trees, plants, and springs. Animals were associated with agriculture and food, sun and water, sky and the often-watery underworld that was the home of both the dead, sacred ancestors and the roots of live, nourishing vegetation. Animals were also related to secular power and supernatural connections, warfare and statehood, life and death.[15] They often stood for and interpreted the dualism of oppositions found in New World thought, the practical and mystical aspects of the same entity, the up-and-down levels of the universe, and the importance of the four world directions or world corners in a cosmological plan.

Like human beings, animals were frequent sacrificial offerings. They were sacrificed in temples and in caves, which were sacred; animals were also offered in human burials. The Aztec made elaborate offerings in their Great Temple, in what is now Mexico City, in which a puma might be buried in the same way that people were buried.[16] Animals were also venerated. Sacrifices had to be worthwhile offerings. To sacrifice is to make sacred. Certain species of archaeological fauna have been found more commonly in caches and burials than in midden (trash) deposits.[17] Their remains had been placed with care in special places, not simply thrown out with the trash. They were a part of ritual and mythic life.

In narratives and myths, especially origin myths, animals were involved in the creation of the human world—how the world was made or discovered, how people came into it, how the race or tribe originated,

how elements in nature were created, how maize and other basic foods were acquired. Animals represent mythic beings, personifications or forces or spirits of nature, and projections of human character and aspirations.

Although animals or animal images could personify or signify places in the cosmos—sky, earth's surface, underworld, and sea—they do not necessarily stay in one place. The jaguar can be a sun being; it can also be the sun in the underworld. There are sky serpents and underworld serpents, sky caimans and earth caimans.[18] In some narratives an animal goes to the sky to become a constellation. Much animal symbolism mirrors the cyclical movements of the sky and the seasons.

Similar symbolic patterns for certain animals may prevail over a wide geographical range, in the Old World as well as in the Neotropics: large cats and raptorial birds are significant virtually everywhere; the deer and the mollusk are other examples of creatures with widespread similar symbolism. Sometimes an animal may be very meaningful in one place and much less so in another: the fox is much more significant in the Andes than it is to the north, the rabbit more important in Mesoamerica than to the south. Some animals are found only in one region: the llama and the guinea pig in the Andes, for example. But the importance of an animal in iconography does not necessarily depend on its presence in the environment. Jaguars are important metaphors far from their natural habitats—in the mountains of central Mexico, for example.

Certain animals are paired repeatedly in art. Some pairs may define an environment—fish and aquatic birds, for example (figs. 4 and 5), or a shell and aquatic birds (fig. 6). The projections at the sides of figure 5 may represent islands rising from the sea. The steps at the spout suggest a temple or sacred place. It is known that rites were held on islands covered with bird guano, which was used for fertilizer. Many animal combinations express a duality in Pre-Columbian symbolism that is also a duality in nature: predator and prey, captor and captive, above and below. Jaguar and deer are hunter and hunted: they interact in origin myths; they are shown together in art.[19] Figures in a presentation-of-prisoners scene at the Maya site of Bonampak wear jaguar and deer headdresses, and the wearers of antlered deer headdresses have jaguar skins as capes. Central Mexican symbolism commonly paired jaguars and eagles, the most pow-

erful sky creature and the most powerful land animal. Felines are some-
times shown with birds, and snakes and birds lend themselves to designs
for woven textiles and make a natural pairing. Snakes eat small birds;
large birds eat snakes. Sometimes birds and snake heads are woven in the
same design (fig. 7); in a bag from Pachacamac, a bird textile was attached
to a fabric with an abstract snake head motif (fig. 8). Another textile from
Pachacamac shows multiple condors and snakes and a black vulture
pecking at the head of a monkey (fig. 9).

**Figure 4**

Ceramic vessel with water
birds and fish in low relief.
Peru, north coast. Chimú-
Inca, A.D. 1300–1500.
H. 20.5, D. 14 cm. Florida
Museum of Natural
History, University of
Florida, 101427.

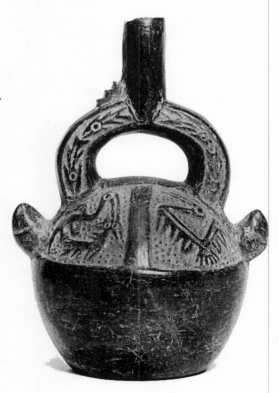

**Figure 5**

Ceramic vessel, fish with pelican at the spout. Peru, central coast, Pachacamac, Sun Temple, Cemetery of the Sacrificed Women. Inca period, A.D. 1300–1500. H. 16.5, W. 5.5, D. 21 cm. University of Pennsylvania Museum, Philadelphia, 31120 (Max Uhle expedition, 1896).

**Figure 6**

Ceramic vessel, gastropod with a monkey at the spout and a bird at either side. Peru, north coast. Chimú, A.D. 900–1470. H. 25.5, W. 23, D. 13 cm. Florida Museum of Natural History, University of Florida, 102234.

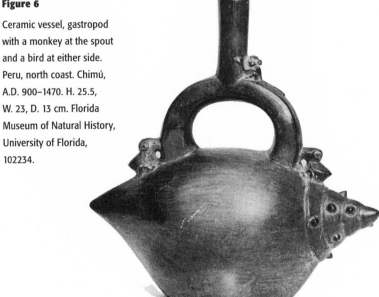

**Figure 7**

Textile with birds that form a feline (?) head at the juncture. Peru, central coast. A.D. 900–1500. H. 24, W. 20 cm. Florida Museum of Natural History, University of Florida, 96024C.

**Figure 8**

Textile bag with birds and a design that can be read as snake or cat heads. Peru, central coast, Pachacamac, Gravefield I. A.D. 900–1470. H. 25.5, W. 20.5 cm. University of Pennsylvania Museum, Philadelphia, 30076 (Max Uhle expedition, 1896).

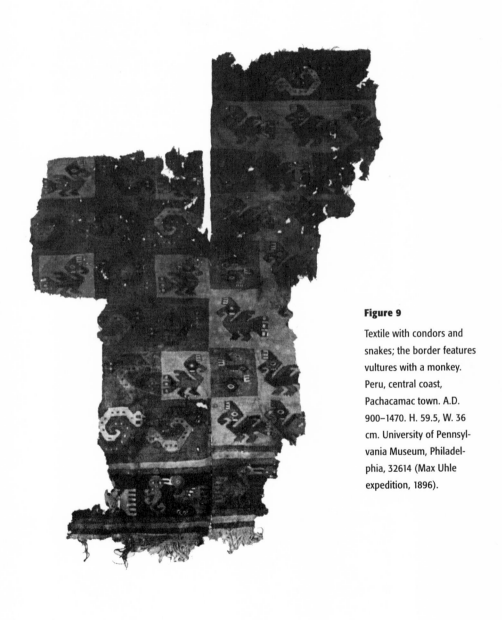

**Figure 9**

Textile with condors and snakes; the border features vultures with a monkey. Peru, central coast, Pachacamac town. A.D. 900–1470. H. 59.5, W. 36 cm. University of Pennsylvania Museum, Philadelphia, 32614 (Max Uhle expedition, 1896).

Some combinations may summarize a narrative or a ritual—the monkeys and foxes, for example, in figure 10 or a jaguar standing on a huge bivalve (fig. 11). Vessels from the coast of Peru sometimes present a man with a monkey on one shoulder and a bird on the other (fig. 12). The men usually have a wad of coca in the cheek. The coca plant has been sacred in the Andes for at least two millennia. In the past a few leaves of the plant were chewed with a little powdered lime on special occasions, and this is still done today in the highlands. The coca chewers with a bird and a monkey may well refer to a myth about the origins of coca.

Pre-Columbian deities are not well known. Although we speak of a monkey god and a jaguar god, there were probably no animal deities as such—that is, people did not worship jaguars or monkeys. Ancient peoples may have viewed mythic animals as beings in a supernatural realm parallel to the everyday world. Animals had supernatural personas or identities, and a god might have one or more animal manifestations or avatars. Gods often had animal attributes that distinguish them in art from ordinary mortals. In myth, a god or culture hero could take on appropriate animal forms to accomplish a certain task—as Old World gods did. Moreover, animals could be intermediaries with the gods. They were alter egos or *nahuals*, familiars of human beings, into which a human being might transform him or herself.[20] Numerous recent accounts tell of a human's being killed or injured at the same time that an animal was killed or injured in the same way. The animal is the *nahual* of the person; what happens to one happens to the other.

Transformation is an important theme in the Americas. There are many recent accounts of rituals in which a shaman, taking a psychoactive drug, is transformed into an animal: that is, he behaves in ways that are unnatural for a man, and he is perceived as transformed by the participants in the rite. In myth a character can be spoken of as an animal and later as a man or a woman—the shift is natural and often unexplained. In origin myths that tell of a marriage between an animal and a human, the human mate often does not know that he/she is married to an animal until he/she catches the mate unawares, for these animals can choose not to look like animals. There are also marriages between different orders of animals—jaguar and toad, for example.[21] Here it would

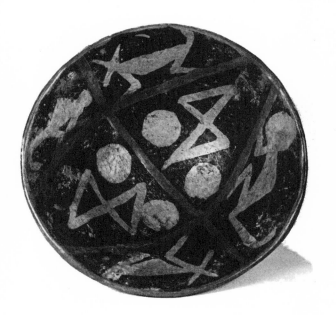

**Figure 10**

Ceramic pedestal bowl
with monkeys and foxes.
Ecuador, north highlands.
Cara phase, A.D. 500–1300.
H. 8.5, D. 20 cm. University
of Pennsylvania Museum,
Philadelphia, 29-51-130.

**Figure 11**

Black ware vessel, jaguar
standing on a bivalve shell
(*Choromytilis chorus*).
Peru, north coast,
Lambayeque. Chimú-Inca,
A.D. 1300–1500. H. 11, W.
18 cm. Carnegie Museum
of Natural History 17043-4.

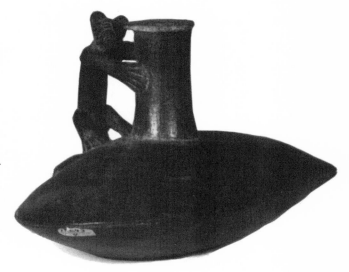

**Figure 12**

Ceramic vessel, human
figure with condor on left
shoulder, monkey on right.
Peru, central coast.
Chancay, A.D. 900–1400.
H. 52, W. 36, D. 27. Florida
Museum of Natural
History, University of
Florida, 101432.

seem that certain human social traits have been transformed to animal metaphors.

Belief that animals were once people is prevalent. Also, ancestors of people were animals: specifically, animals were progenitors of ancient culture heroes and groups of people. Animals may be called by kin names, and groups may be known as People of the Jaguar or People of the Bat. Different groups of people identified with different animals. Such designations exist today. In the past, individual people, places, and gods were named for animals. A great king of the Maya site of Yaxchilan was named Bird-Jaguar. The Aztec god Huitzilopochtli, who was named for a hummingbird, was born at Coatepec, "Snake Hill." Constellations might

have animal names, as they do in many other places in the world, and days in Mesoamerican calendars often bore animal names.

In folklore and art, similar themes recur through time and space—they are sometimes surprisingly close over great distances—but the variations are infinite. Similar subjects concern man at certain stages of development and knowledge, and he responds to them in similar ways; but his imagination in adapting to them is infinitely various.

Knowing how people perceive and relate to animals is a way of understanding people, especially the beliefs and customs of people who, for the most part, lacked writing. Much of the symbolism depends on the animal's behavior. Natural history, plus art, lore, and literature about animals, gives insight into human interaction with nature, concepts of the cosmos, myth, religion, ritual, and social structure. We are more remote from nature today than peoples were in the past and than many people in less populated parts of the earth are today.

Of the wonderful wealth of Neotropical species, many are now extinct and others threatened. A few thrive in some places because they can adapt to modern environments. The white-tailed deer ranges from Canada well into South America, surviving too well for its own good in much of its northern range but endangered from overhunting in its southern range. The nine-banded armadillo and the giant toad are generally doing well, and their range is spreading; but some of their relatives have disappeared. The glorious days of Pre-Columbian animals are over, as surely as the life of Pre-Columbian peoples has disappeared, except for the enticing remnants they left behind.

# 3    Domesticated Animals

Dogs have shared man's life in close association for thousands of years. *Canis familiaris* must surely have been in the Americas for as long as man has, having probably accompanied early hunters who came across the Bering Strait and populated this hemisphere. Dogs figure in many Latin American origin myths. In the dim past of a Mataco narrative, from the Gran Chaco, deep in South America, the culture hero had a dog.[1] He gave the dog's puppies to the people and taught the people how to hunt with dogs as one of the first steps in civilizing them. In many narratives, dogs used to talk; but at some critical moment in myth, they ceased to speak.[2]

Various narratives from the Americas connect dogs and water. Dogs are natural swimmers. In a Toba myth from the Gran Chaco, a god turned into a mangy dog to warn of the coming great flood.[3] Only the daughter of a chieftain recognized what the dog was and treated him well; only her family was saved. Many origin myths tell of the destruction of the world by a great flood, after which the tribe was founded by survivors. In some tales, people became dogs or dogs became people after the flood. In a number of Mataco and other flood myths, the only survivors were a man and a dog.[4] The man constructed a house and went out to the fields to work; when he came home, he found that his tortillas had been prepared. He did not know who was doing this for him until he returned early one day and discovered that the dog was a woman. She then became a woman permanently. Like most creatures who have water associations, dogs are also related in myth to fire. The Maya Codices

Dresden and Madrid show dogs panting in tropical heat or holding a torch in each forepaw.

At the time of the Spanish conquest in the sixteenth century, and probably long before, dogs were widely offered to various deities as sacrifices.[5] In some areas a virtually hairless dog was fattened and eaten, usually on special, ritual occasions. In Mexico, Friar Diego Durán was saddened to see quantities of dogs for sale in the market, not because of a fondness for dogs but because it meant that the people were clinging to their pagan customs. Pre-Columbian canine depictions often have the wrinkled faces of dogs who lack hair to cover skin furrows (figs. 13 and 14). There are still hairless dogs in Mexico and Peru.[6] Early Spanish observers wrote of barkless dogs as well.

Dogs, of course, were also pets. An incentive for taking good care of dogs was the widespread belief that a dog was a guide for the recently dead across a body of water to the underworld.[7] Archaeological, ethnohistoric, and ethnographic evidence throughout much of the Americas supports this. From Idaho through Peru, dog remains and dog effigies— mostly ceramic vessels—have been found in human burials dating since ca. 9000 B.C. until modern times. Many dog vessels come from Colima (fig. 15), in western Mexico, where they were found in shaft tombs dat-

**Figure 13**

Ceramic vessel, dog wearing a necklace. Mexico, Oaxaca, Zimatlan district, Roalo village. Zapotec, A.D. 300–900. H. 16.5, W. 18, D. 16.5 cm. University of Pennsylvania Museum, Philadelphia, 29-31-719.

ing 100 B.C.–A.D. 400. Dogs were also prominent in Peru (fig. 16). They take many poses. Sometimes they are playful. The dog in figure 15 holds what seems to be a stick, but it may be something like a staff of office. Often dogs have human accessories: some Colima dogs wear human masks; other dogs wear necklaces (fig. 13). Today it is often a hunting dog that is buried with its owner, and this was probably true in the past. In modern burials, dog substitutes are usually makeshift effigies, fashioned from palm leaves or crudely worked clay.

The dog's association with the dead is almost worldwide. The Egyptian god Anubis, who took care of the dead, was doglike. The Greek dog Cerberus guarded the crossing at the River Styx. Medieval European tomb sculpture often shows a dog at the feet of the portrait of the deceased.

Dogs are appropriate escorts for the dead. They walk with their noses to the ground. They dig in the earth, bury bones, and hunt in burrows. They eat carrion and make themselves smell of it. They have night vision; they howl at night; they know what is there in the darkness. Relating to the earth, to dead things, to sounds and smells that are imperceptible to humans, dogs have esoteric knowledge and special connections with the underworld. They are shown in underworld scenes on Classic Maya vases.

Modern Maya narratives tell of a man who has overhunted deer or peccary or who has not made the proper arrangements with the underworld or earth lords, the "owners" of game.[8] His dog leads him into a deep cave or an armadillo burrow, where the hunter has been summoned by these lords. After some cautionary lecture, chastisement, or frightening adventure, the hunter is usually released. Sometimes it is a year before he reappears.

The Aztec god Xolotl was a skeletal, dog-faced or dog-bodied god who was probably an avatar of Venus as Evening Star and the twin of, or an aspect of, Quetzalcoatl ("Quetzal-Serpent"), the important deity who was Venus as Morning Star.[9] On Codex Borgia page 65, Xolotl is pictured enthroned. After a destruction of the world, Xolotl and/or Quetzalcoatl went to the underworld to acquire maize for mankind or to shed their godly blood on the bones of humans in order to found a new creation of man. Xolotl also guided the setting sun to the underworld.

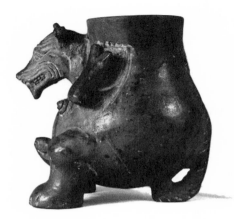

**Figure 14**

Plumbate ware vessel, dog.
Guatemala. Post-Classic,
A.D. 900–1200. H. 19,
W. 15.5, D. 20 cm.
University of Pennsylvania
Museum, Philadelphia,
L-83-1396.

**Figure 15**

Ceramic vessel, dog with
stick. West Mexico, Colima.
100 B.C.–A.D. 400. H. 15,
W. 12, L. 29 cm. University
of Pennsylvania Museum,
Philadelphia, 60-7-9.

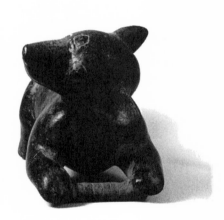

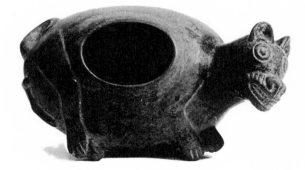

**Figure 16**

Ceramic bowl, reclining
dog. Peru, north coast.
Chimú, A.D. 900–1450.
H. 9, D. 15 cm. Florida
Museum of Natural
History, University of
Florida, 101425.

Dogs are seen with gods on Moche vases in scenes that likely have astronomical meaning.[10] A dog accompanies a god who is probably a solar deity. A Mataco myth tells that the sun changed into a dog to collect the bones of his brother, murdered (eclipsed?) Moon, so that he could revive him.[11] Although dogs are strongly underworld-related, in native astronomy/astrology, a dog chases birds into the sky and becomes a constellation.[12] We too have Canis constellations.

The llama (*Lama glama*), the alpaca (*L. pacos*), the guanaco (*L. guanacoe*), and the vicuña (*Vicugna vicugna*), small, humpless relatives of the camel, were hunted from very early times.[13] The llama was probably domesticated some six thousand years ago in southern Peru.

Life in the Andes would have been much more difficult, and probably less developed, had it not been for the llama (fig. 17). The llama and its relatives had a role in agriculture, for example. Pastoralism and agriculture developed together in the Andes. The cultivation of the potato, a basic native food and the most important high-altitude crop, was dependent on the use of camelid manure.

The llama was the only pack animal in the Americas in Pre-Conquest times (fig. 18). On a short trip, it carried, in bags on its sides, up to about 45 kilograms (100 pounds), less on a longer trip. In Inca times, pack trains of five hundred or more llamas transported goods on state-controlled roads, often through the highlands down to the coast.[14] Llamas, which are minimally affected by altitude change, have a long history on the coast of Peru.[15] Llama remains have been found in Moche burials, and many Moche vessels depict llamas, always quite realistically; some show a llama mother with her young, indicating that they were bred on the coast. A llama presence was also evident in other coastal cultures; either skeletal remains were found or images in clay or cloth were made (pl. 1).[16] In Inca times, llamas were controlled by the state, and the Incas expanded the range of llama herding widely, north into Ecuador and south into Chile.[17]

**Figure 17**

Ceramic vessel, llama head. Peru, north coast. Moche, A.D. 300–500. H. 22, W. 12, L. 19.5 cm. University of Pennsylvania Museum, Philadelphia, 34423.

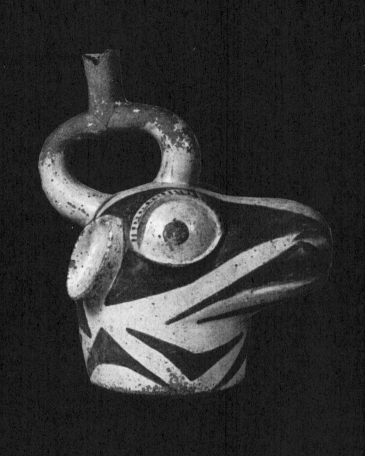

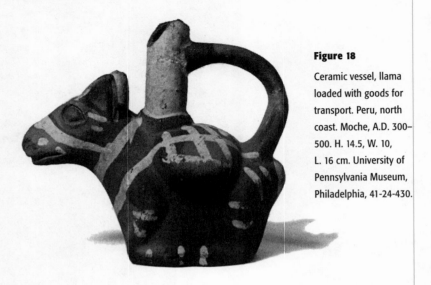

**Figure 18**

Ceramic vessel, llama
loaded with goods for
transport. Peru, north
coast. Moche, A.D. 300–
500. H. 14.5, W. 10,
L. 16 cm. University of
Pennsylvania Museum,
Philadelphia, 41-24-430.

Llamas were shorn for wool to make clothing and objects such as the
sling and the *quipu*, the Andean counting device made of knotted strings.
Llama sinews were made into thongs and thread. The hide could be used
for blankets and roofing; and cord, sandals, drums, and other accessories
and practical articles could be made from it. Sometimes the dead were
wrapped in hide for burial. Tools and ornaments could be produced from
llama bones. Llama fat was burned for light and for offerings, and llama
dung provided fuel. There was probably no part of a llama that was not
used.

Alpacas, also domesticated, have finer, longer hair than the llama's.
Alpaca hair can grow to 75 centimeters (30 inches) if not sheared regu-
larly. Alpacas, which are not used as pack animals, are restricted to high
altitudes; their ideal elevation is about 4,500 meters (14,000 feet). The
finest wool is that of the wild vicuña, which also lives only at high alti-
tudes. The wool of the wild guanaco, an animal that is ancestral to the
others, is coarser than that of any of its descendants. Like the llama, it can
live in a wide range of altitudes.

The meat of all these camelids can be eaten fresh or dried. In high

altitudes it is dried by being successively frozen at night and thawed in the hot daytime sun. This dried llama meat is called, in the Quechua language of the Incas, *charqui*—the source of the English word "jerky," for dried meat.

Llamas served as royal gifts to commanders who had successfully waged Inca military campaigns. Herds of llamas were owned also by *huacas*—sacred objects or places or mummies of dead kings, to whom gifts were given or offerings made. Llamas are still valuable gifts in the highlands.

In Inca times the llama was the prime sacrificial animal. Early Spanish accounts state that a white llama was sacrificed every morning at the Temple of the sun in Cuzco and that specified quantities of llamas of prescribed colors were offered at various seasonal rites; omens were sought from the way the llamas died and from examination of their entrails.[18] (Spanish chroniclers often referred to llamas as "sheep"; sheep, of course, were not indigenous to the New World.)

At the April calendrical rite in Cuzco, a pure white llama was dressed in a red tunic and gold ear ornaments.[19] Representing the first llama after the destruction of the world by the great flood, this llama, along with a standard, or pennant, was a symbol of royal Inca authority. This llama sometimes accompanied the ruler in his travels. It had special human attendants, other llamas were sacrificed in its name, and life-sized camelid effigies of gold and silver were carried in procession on litters. The white llama was allowed to die naturally—although its death may have been hastened by the maize beer and coca leaves with which it was fed.

Small stone Inca vessels in the shape of a camelid contained llama fat and blood to be presented to the gods (fig. 19). The vessels were placed in pastures to ensure fertility of the herds, as offerings and/or as a kind of sympathetic magic. Stone llama fetishes are still used in a number of rites, especially herd-fertility ceremonies.

Guaman Poma illustrates the Inca ruler singing with a llama in a ritual for rain.[20] Llamas are still associated with rain, which may have something to do with their propensity for spitting, a reputation that is said to have been exaggerated. Llama sacrifices are performed today in

**Figure 19**

Stone llama-shaped container. Peru. Inca, A.D. 1300–1500. H. 6, W. 4, L. 11 cm. University of Pennsylvania Museum, Philadelphia, 43527.

the Andes on certain occasions, and llama fertility and decorative-ear-marking rites are still important festivals in many highland locations.[21] In the past, llamas were identified by threads or cloth pulled through holes in their ears, and this goes on today. Among other things, it is a way of letting the supernatural owners of the animals know that the animals are well cared for. Even sheep and goats are sometimes earmarked.

Today llamas have been largely replaced by sheep in the Andes except at altitudes too high for sheep. Llamas have, however, become popular as pets and mountain pack animals in the United States and elsewhere. They are being raised from Maine to California. There may now be more llamas in the United States than in Peru.

The guinea pig, cavy, or cuy (*Cavia porcellus*) is a domesticated Neotropical rodent, one of seventeen species of its order, with wild relatives throughout much of South America.[22] Modest in appearance, manner, and symbol value, it was depicted only late in the Pre-Columbian sequence in the Andes and not very often. It is always portrayed realistically. Guinea pigs were sacrificed, and they were cooked as festive food; they are still eaten today, usually on special occasions. Guinea pigs were used in divination and in folk medicine, as they still are.[23] There are many variations in this use: often the animal is rubbed over the patient and then examined either for diagnosis by "guinea-pig x ray" or in a belief that the animal has removed the illness from the patient.

The Muscovy duck (*Cairina moschata*) was domesticated and was widely used for food and feathers.[24] White feathers from it were probably used in Chimú featherwork; the ducks may even have been bred for maximum whiteness of feathers,[25] although today this duck has only a few prominent white wing patches, and depictions of it suggest that this was true in the past. Its metallic dark feathers may also have been desirable.

There were many wild ducks. The numerous ducks that Sahagún described for the Aztec world are all migratory or at least wild; the Muscovy duck is not identified in his list.[26] It is not likely to have been found in the highlands, for its preferred habitat is lowland forest. In the Andes, wild Muscovy ducks are usually found east of the mountains.

Ducks filled symbolic as well as practical roles, primarily as water birds, for bodies of water were thought to be entrances to or exits from the underworld, and water was, of course, an essential ingredient for agriculture and survival. Ducks are seen in many contexts in Pre-Columbian art. Most of those depicted are probably wild species, but anthropomorphic Muscovy ducks appear sometimes in Moche art as warriors. This duck is a strong, swift flier and is large and aggressive. Its partly bare, wattled head relates it visually to the vulture and may give it added symbolic significance as a death- and underworld-associated creature. Ocarinas sometimes take the form of a duck (figs. 20 and 21). Whether the duck's role as a musical instrument was inspired by its quacking, its associations, or some totemic relationship with a group of people is not known.

**Figure 20**

Ceramic ocarina, duck. Costa Rica, Nicoya Peninsula, Las Huacas, burial XVI. 300 B.C.– A.D. 500. H. 6.7, W. 6.8, D. 5 cm. Carnegie Museum of Natural History 2793-56 (C. V. Hartman expedition, 1903).

**Figure 21**

Ceramic ocarina, duck.
Colombia, Magdalena,
Remolino. Tairona,
A.D. 700–1500. H. 4.5,
W. 6, L. 6.5 cm. University
of Pennsylvania Museum,
Philadelphia, 32-5-80
(Gregory Mason expedition,
1931).

Ducks are portrayed in Pre-Classic ceramics from central Mexico, and several small Olmec pendants or figures carved from jadeite or other green stone depict a duck mask or a man wearing a duck-bill mask over the lower part of his face. Monument 9 at the Olmec site of San Lorenzo, in Veracruz, is a large basalt bowl that was apparently part of a drainage system.[27] It seems to represent a duck—the head is now missing—with cloud symbols on it. It was called a "duck fountain" by an early archaeologist at San Lorenzo, and it may have been just that. The duck remains that were found in middens at that site were apparently not those of the Moscovy duck, but this species is now a permanent resident of the area and of much of Mexico and Central America.[28]

Two species of wild turkeys inhabit Mexico and Central America today: the ocellated turkey (*Agriocharis ocellata*), with a range in the lowland Maya area, and the wild or bronze or common turkey (*Meleagris gallopavo*), found mostly to the north, from the southern United States to Oaxaca, Guerrero, and Veracruz. It once ranged farther south.[29] The latter species is the ancestor of the turkey that was tamed in parts of Mesoamerica and Central America A.D. 900–1500. Evidence for the domestication of the common turkey was encountered at Cozumel, a Post-Classic Maya site off the northeast corner of Yucatán.[30] Sahagún describes the turkey as "savory, good-tasting, fat. It is a gobbler."[31] Being large and tasty birds, turkeys were a good food source.

A turkey is shown as a sacrificial offering in the Maya New Year's ceremonies in the Codex Dresden (pages 25–28) and tied to a tree on Codex Madrid (page 91). Depictions of turkeys are fairly rare in Pre-Columbian art, although, on Maya vases, a turkey appears sometimes with a toad, a monkey, a peccary, and/or another wild animal.[32] Pre-Columbian remains of the ocellated turkey have been found in the Maya area.[33] Turkey feathers may well be among the feathers shown on ornaments depicted on Maya vases. Feather fans are held by personages on Classic Maya vases, and turkey feather fans were carried by dancers performing as Maya nobility in a ritual dance in Yucatán in 1901.

Yucatán is well known for its stingless honeybees. Their honey was apparently an important trade item in former times. Bees are pictured principally in the Maya Codex Madrid, where a giant bee inhabits a house or temple. Occasionally bees appear on Classic Maya cylinder vases. In other regions beeswax was used for gold casting, but little is known about Pre-Columbian beekeeping.

# 4    Hunted Mammals

Mammals commonly hunted were deer, peccary, tapir, fox, rabbit, and coati. There are Colonial descriptions of Inca hunts,[1] and there are many references, both ethnohistorical and pictorial, to hunting procedures and ritual in many areas through time.

The deer hunt is a frequent theme on Moche vases.[2] The scenes show deer being driven with clubs into a netted area, where they are speared. Deer must have been fairly common in the cultivated river valleys that make green streaks in the coastal desert of Peru. Deer hunts appear also on vases from the lowland forest regions of the Late Classic Maya and in the Post-Classic Codex Madrid.[3] That deer hunting was a special, sacrificial ritual—even a mythic event—is indicated by the Maya and Moche scenes, where the major hunter is always elegantly dressed in special garments and sometimes is a god. Maya hunt scenes often depict the World Tree, the tree that stood at the center of the world and held the levels of the world in place. Such a tree also stood at each corner of the world.

In Oaxaca the original mythic Mixtec couple was named One Deer (a calendrical name). The Codices Vindobonensis and Bodley show that the original couple had thirty-two offspring, most of which were human; one was a deer. In an Aztec myth a two-headed deer fell from the sky, shot down by a hunting god, Mixcoatl. Forced to cohabit with him, she gave birth to the culture hero and deity Quetzalcoatl ("Quetzal-Serpent").

The deer was—and still is—associated with ancestors who hunted. A deer sometimes appears in myth as the aboriginal grandfather, and mod-

ern hunters in Mesoamerica may address a deer as "Grandfather" and apologize to the deer or to the earth lords for killing it. Some societies prohibit the killing and eating of deer because it is a relative. In other places, rituals and proscriptions accompany the hunting of deer and sometimes other animals.[4] The purpose is to ensure successful hunting, to prevent overhunting, and also to make contact with the sacred ancestors and propitiate the earth lords and/or the gods of nature so that they will provide abundant future game. Deer dances are performed in many places for the same purposes.

On Maya vases, deer are often accompanied by death symbols, and deer parts are depicted in offering vessels in the Maya codices. Archaeological remains and more recent evidence confirm the presence of deer in sacrificial rituals.[5] Deer were venerated as well as sacrificed, however. Colonial manuscripts and modern sources indicate that rituals were and are held for, and offerings made to, deer and that deer were once symbols of rulership.

The ball game of Mesoamerica, played with a rubber ball (rubber was indigenous in the Neotropics) was a sacrificial ritual related to celestial events.[6] Architecture and sculpture associated with the ball game are some of the finest in the region. Most centers of any size had at least one ball court. One of the mythic brothers—the Hero Twins—who played ball with the lords of the underworld in the Popol Vuh manuscript is shown on Classic Maya vases wearing a deer headdress.[7] A ball player figure carved from a gastropod shell (pl. 2) surely portrays this supernatural ball player. In origin myths the deer is often associated with the sun.[8] The culture hero—or one of the Hero Twins—often becomes the sun.

As hunters became settled farmers, the deer took on agricultural symbolism. The white-tailed deer (*Odocoileus virginianus*) was most often depicted.[9] This deer was one of the larger animals to be hunted and an important food for early man. The stag has branching antlers, which, in most environments, grow along with the seasonal growth of crops. The vegetation that usually appears in Maya and Moche deer hunt scenes seems to indicate that ancient peoples were aware of this synchrony. Moreover, the ears and tail of Moche deer are drawn to look leaflike. There are other associations between deer and vegetation. The

deer eats the farmer's crops, and vegetation gets entangled in the stag's antlers when it browses. Sahagún's informants noted that antlers look like forked tree branches.[10] In a recent myth from Brazil, a boy—a mythic trickster—holds a tree branch to his head and becomes a deer.[11] In this rather Freudian tale, he then charges and kills his father with the antlers.

Deer are depicted in many media: on Classic Maya vases, in gold objects from the Intermediate Area, on textiles from the coast of Peru (fig. 22), on Peruvian silver and copper. An anthropomorphic deer is one of the animals on Moche ceramics that can be a warrior or a ritual runner sprinting through a landscape[12] (see fig. 59, a hawk runner, and fig. 84, a snake warrior). The runners are likely to be warriors on an unarmed occasion. The deer is a good warrior because it has keen sight, hearing, and smell; it can run fast for short distances. Its antlers look like weapons. In nature, one stag challenges another with its antlers; sometimes the antlers become inextricably interlocked, and both deer may die. Generally, however, the deer's sharp hooves are more damaging weapons than antlers; they can be lethal to small animals.

The fox also appears in Moche runner or warrior scenes. Like the deer, the fox has good defenses; it also has good prey-catching techniques. It is sly; in myth it is a clever trickster—who often outsmarts itself. In one set of Moche scenes, human males are the runners; these men usually wear fox headdresses.[13] A number of sheet-gold fox heads that have been found were probably runner headdress ornaments or, in some cases, finials for litter poles.[14] Prominent Pre-Columbian people were often borne in litters. The running seems to have been a ritual activity related to warfare and the conquest of new land to plant. Both human and animal runners carry bags, which may have contained seeds or shamanic materials—rock crystal, for example. The fox can be a shamanic animal, a curer and a worker of magic.

Foxes were hunted because their pelts were valuable and because, in the high Andean altitudes, where food is scarce, they were predators who threatened crops, small game, wild vicuñas, and herds of llamas and alpacas. The mountains are very close to the coast, and foxes also frequented the coastal valleys. The common fox in these regions is the

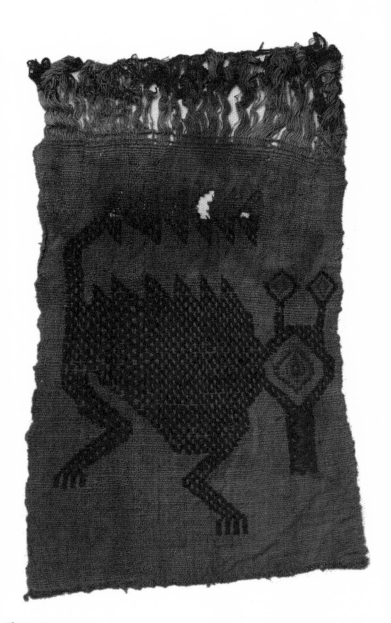

**Figure 22**

Embroidered textile with deer motif. Peru, central coast, Pachacamac, Gravefield I. A.D. 900–1470. H. 16, W. 27 cm. University of Pennsylvania Museum, Philadelphia (Neg. #T4-721), 30339 (Max Uhle expedition, 1896).

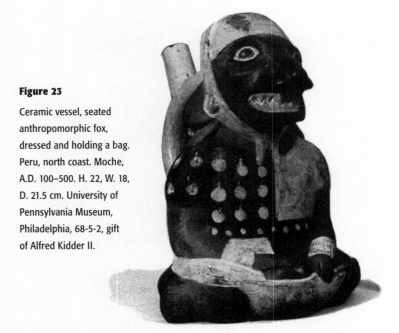

**Figure 23**

Ceramic vessel, seated
anthropomorphic fox,
dressed and holding a bag.
Peru, north coast. Moche,
A.D. 100–500. H. 22, W. 18,
D. 21.5 cm. University of
Pennsylvania Museum,
Philadelphia, 68-5-2, gift
of Alfred Kidder II.

Andean or South American fox (*Pseudalopex* or *Dusicyon culpaeus*),
which lives up to about 4,500 meters altitude.[15] It is more carnivorous
than most foxes, perhaps because vegetation is scarce in much of its
range. On the far northern coast of Peru and in southern Ecuador, the
somewhat smaller Sechuran fox (*P.* or *D. sechurae*) is found.

Foxes are particularly significant in art from the north coast of Peru in
the early centuries of our era. The Moche showed anthropomorphic
foxes in the poses of important men, wearing their garments, and hold-
ing their ritual objects (fig. 23). Foxes are also shown in portrait heads
like those made of Moche rulers (fig. 24). This indicates that foxes had
very special status. Deer can appear as full-figure humans, but deer por-
trait heads are rare or nonexistent. Also, it has been pointed out that the

**Figure 24**

Ceramic vessel, fox portrait head in headdress. Peru, north coast. Moche, A.D. 300–500. H. 22,
W. 18, D. 21.5 cm. University of Pennsylvania Museum, Philadelphia, 43369, collected 1893–94.

animal heads on many supernatural two-headed Moche objects—sky bands, rafts, litters, the belts of gods—seem to be those of foxes.[16] If this is so, the fox is everywhere in Moche iconography, and it plays very special roles.

Some two thousand years ago, on the south coast of Peru, fox hides were placed in burial bundles in the Paracas Peninsula desert, and figures wearing fox pelts were depicted on bright-colored Paracas embroidered textiles.[17] They appear also on slightly later Nasca polychrome pottery (fig. 25) and painted textiles, where the wearers are holding plants.[18] In the Colonial period, Guaman Poma shows men with fox skins on their heads when they guarded maize fields in the Peruvian highlands.[19] Young men are still appointed to guard potato fields in this region at certain times of the year.[20]

To send a human fox imitator to tend the crops or herds is to send an especially large fox to ward off foxes—someone who has a relationship to the foxes, who is, in a sense, one of them, a master of foxes who will control them; but someone who is also their enemy, disguised as one of them. It is a practical application of Andean concepts of duality and transformation.

A globular vessel from the Lambayeque region, on the north coast of Peru, has the head of the major deity of the region, the "Sican lord," as

**Figure 25**

Polychrome ceramic vessel, human head in a fox headdress. Peru, south coast. Nasca, A.D. 1–300. H. 13, W. 11, D. 17 cm. University of Pennsylvania Museum, Philadelphia, SA 3007 (William C. Farabee expedition, 1922–23).

**Figure 26**

Ceramic globular vase
with the head of a deity; a
fox sits on either shoulder.
Peru, north coast. Sican
(Lambayeque), A.D. 900–
1300. H. 22.5, W. 13,
D. 7 cm. Harn Museum of
Art Collection, University
of Florida, C-73-127.
Anonymous gift in honor of
Professor Phillip A. Ward in
appreciation of his kind
encouragement and interest.

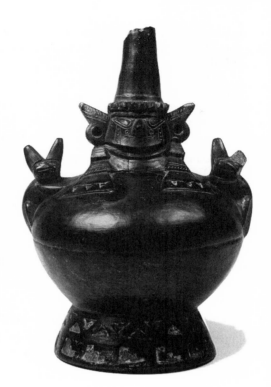

the spout (fig. 26). On each shoulder sits a fox with alert ears, looking like a watchman for the god. This composition may relate to the wearing of a fox skin on the head.

In the highlands near Cuzco, at the time of spring planting, a fox goes to the top of the sacred mountain.[21] If it howls loudly (foxes make a variety of vocalizations), there will be rain and a good crop; if the howling is weak, the year will be bad, with little rain. A mythic fox is often involved in the origins of agriculture in South American folk literature. A number of narratives tell that a fox is taken to the sky by a condor; the fox falls to the ground, and from his body vegetation sprouts.[22] The fox's underworld, earth, and agriculture connotations are enhanced by its use of burrows. In a town near Cuzco the fox is called "Son of the earth."[23] A group of Toba narratives from the Gran Chaco tell of a trickster fox who dies: he freezes to death, he dries up, he breaks his neck, he is torn up, he is cut into pieces and burned; but, like the plants he is affiliated with, he

is revived by water and rain.[24] "When he dies it rains, and he comes back to life. That's what the fox is like."[25] The fox is a metaphor for vegetation.

At the time of the Spanish conquest, fox symbolism seems to have been especially strong on the central coast of Peru, at the site of Pachaca-mac, which had been important in pre-Inca times as a ceremonial center and the locus of an oracle, and which continued to be a center of ritual activity.[26] Pachacamac was also the name of a god. Many animal depic-tions have come from the site of Pachacamac. A golden fox image was said to have been worshiped there, and a dead female fox was presum-ably found at the gate to the city. A carved wooden staff excavated at Pachacamac shows foxes among its motifs.[27]

In origin myths the god Pachacamac turned men into monkeys and women into foxes either after an unsuccessful attempt to create man or in punishment for disobedience that caused the sea to rise or that let loose a great flood. A ceramic vessel from Ecuador with monkeys and foxes paired on it may refer to this or a similar myth (fig. 10).

The common fox of Mesoamerica is the gray fox (*Vulpes* or *Urocyon cinereoargenteus*), found from Canada to Venezuela.[28] This fox can climb trees. It appears occasionally in art and myth, but it lacks the prominence of the fox in the Andes.

Mesoamerican folklore describes seeing not a man in the moon but a rabbit. Usually it is the cottontail rabbit (*Sylvilagus*).[29] Some narratives describe the rabbit's arrival on the moon during a great flood. In a Huastec Maya myth, a rabbit warned people of the coming flood that would destroy the world; the rabbit then boarded a boat.[30] When the del-uge came, the waters were so high that they carried the rabbit to the sky, where it disembarked on the moon. The rabbit was associated with the moon also in Classic Maya iconography, and many cylinder vases show the moon deity holding a rabbit.[31] In a ball game in the Popol Vuh, a rabbit aids the Hero Twins by hopping across the playing field like a bouncing ball to divert the attention of the underworld lords, against whom the Twins are playing.[32] The Hero Twins eventually became the sun and the moon.

A rabbit appears several times on Classic Maya cylinder vases in the company of an old male deity known as God L.[33] A prominent under-

world lord, this god wears the most complex godly garments—an elabo-
rately feathered, bird-headed hat and a cape that is sometimes a jaguar
skin. On one vase a very large rabbit, standing upright on a glyphic mon-
ster that personifies earth and rain, holds the clothing and accouterments
of this old god, who stands naked below the rabbit, making a gesture of
obeisance. Surely these are scenes from a myth that has astronomical or
calendrical meaning. God L may be a Venus god.

The rabbit has various associations with writing. A ceramic rabbit
from Veracruz has a design on its ear (fig. 27). A number of rabbits on
Maya polychrome vases have a glyphic element on the ear (pl. 3). One of
these rabbits, in the company of God L, is writing in a codex.[34] In this
instance the rabbit is small and is sitting at the feet of the enthroned,
elaborately dressed God L.

The Aztec related the rabbit to *pulque*, the beverage made from fer-
mented maguey juice, perhaps in part because rabbits burrow around the
roots of the maguey plant. The volcano rabbit (*Romerolagus diazi*) has a
very restricted range—the slopes of snow-peaked Popocatepetl and
Ixtacihuatl and the adjoining ridges above the Valley of Mexico.[35] Its

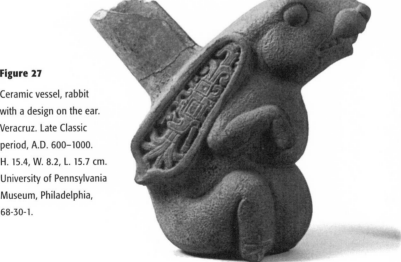

**Figure 27**

Ceramic vessel, rabbit
with a design on the ear.
Veracruz. Late Classic
period, A.D. 600–1000.
H. 15.4, W. 8.2, L. 15.7 cm.
University of Pennsylvania
Museum, Philadelphia,
68-30-1.

situation and its particularly complicated burrows may have emphasized the significance of lagomorphs for the Aztec.

The idol representing an Aztec god of the hunt, Camaxtli, was dressed on his festival day with silver bracelets, arrows, and, on his shoulders, like a fur stole, clusters of rabbit skins.[36] A great hunt was held in his honor, and game that was caught alive was placed before the idol and sacrificed, as if it were a human sacrifice.

Tapir (*Tapirus*) and peccary (*Tayassu*) were depicted in Pre-Columbian art, but less often than fox, deer, and rabbit.[37] They did not reach super-star status as symbols, although they were among the biggest animals and important for food. The tapir is hunted extensively for meat and for its thick hide.[38] It is a particularly primitive large mammal, with three species in the Neotropics. A solitary forest-dweller, it sometimes figures in hunting myths, usually in the slot reserved in most myths for deer. In many tales the tapir, which has particularly large genitals, is the seducer of a human woman, a role that is probably never assigned to deer, although deer are frequently involved with women in myth, and deer and women are seen together on Classic Maya vases.[39] Pig-like peccaries are group animals that are a favorite prey of jaguars and pumas. In a tomb at the Classic Maya site of Copán, Honduras, archaeologists found a peccary skull, which had made a fine surface for the incising of a date; also present were animals, including three peccaries, and other figures, one of which is a god blowing a shell trumpet.[40]

"It is just like the raccoon, but it does not have human hands," wrote Sahagún of the coati (*Nasua*).[41] The coati, a relative of the raccoon, is a diurnal omnivore—fond of fruit and insects—that can feed on the forest floor or high in tree canopy. It makes a constant whining sound, a possible reason that ocarinas were sometimes made in its image. Central American ceramic bowls often have three supports that take animal form. The animals are not always easy to identify, but in some cases they appear to be coatis who sometimes forage around the bases of trees (fig. 28); with its long nose down to the ground, the animal has the shape of a support.[42] The bowl in figure 28, with possible toucans sketched above the coatis, suggests a forest environment and perhaps a folk narrative.

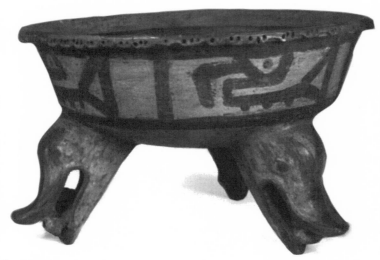

**Figure 28**

Ceramic bowl with painted, stylized birds (toucans?) above supports that may be coati (*Nasua*) heads. Costa Rica, central highlands. A.D. 600–1000. H. 16.8, D. 26 cm. Carnegie Museum of Natural History 2439-207.

By far the most significant animal hunted by Pre-Columbian peoples was the jaguar (*Panthera onca*).[43] The event surely took place as a particularly sacred—and dangerous—ritual, but, except for depictions of the god Mixcoatl spearing a jaguar in some of the codices known as the Borgia Group, the hunt is apparently not shown in ancient art nor described in early Spanish accounts. Special expeditions must also have gone out to acquire live jaguar cubs: into the forest, in the case of the lowland Maya; over the mountains, in the case of Aztec, Mixtec, or Moche. Such expeditions would also have been ceremonial events. There are indications that the captured felines would have been kept for ritual uses. Bernal Díaz wrote that the Aztec ruler kept "lions and tigers" (pumas and jaguars were so called by the early explorers) along with images of gods in a large space where human sacrifices were made and fed to these animals.[44] Maya and Moche art show small felines in human company. This may be a jaguar cub, but sometimes another small feline might be substituted in art and in ritual—an ocelot,[45] margay, pampas cat, or jaguarundi.

Human sacrifices were made to jaguars, and jaguars, in turn, were surely sacrificed.[46] At Copán the last great ruler of that Maya site sacrificed and made an offering of fifteen jaguars, one for each of his ancestors.[47] Feline pelts, and sometimes jaws, have been found in a number of Maya tombs—surely royal tombs. Disarticulated jaguar remains were among offerings in the Great Temple of the Aztec, along with seashells and coral.[48]

The largest cat in the New World, the jaguar is, for its size and weight, the most powerful feline in the world. It leaps for the head of its prey, a notable symbolic trait for human societies that practiced sacrificial beheading. As a hunter, it has model skills; it is a paragon for human hunters and warriors. A powerful, solitary predator of deer and peccary, caimans and turtles, it hunts day or night. A good swimmer and a tree climber, it often stalks prey along waterways or hunts from trees overhanging water. It sleeps in caves or crevices. Its eyes glow in darkness.[49]

The Desana, in Amazonian Colombia in modern times, believe that the jaguar was created by the sun; it represents the sun in this world, watching over the world and protecting it.[50] The sun-colored jaguar has a special fertilizing power. Its roar is the voice of thunder that is the voice of the sun. The sun-jaguar connection exists also for the Shipibo, in eastern Peru.[51] For the Maya, the jaguar had sun associations, but they were probably stronger for the night sun, the sun that has gone to the underworld, than for the day sun.[52]

Jaguars denoted powerful political, military, and religious status for Pre-Columbian peoples.[53] Gods wore jaguar pelts or displayed jaguar ears or feline canines. A major Aztec deity, Tezcatlipoca, had a jaguar guise as Tepeyollotl, "Heart of the Mountain."[54] The Jaguar Throne was a metaphor for Aztec power.[55] Maya gods and rulers sat on jaguar thrones, and Maya rulers are shown with huge supernatural jaguar protectors standing behind them.[56] Sacred Maya bundles were wrapped in jaguar skin. At Altun Ha, in Belize, three jaguar skins had served as wrapping for grave goods.[57] In Oaxaca, Zapotec rulers dress as jaguars,[58] and later Mixtec sacred ancestors, depicted in Codex Nuttall, set out to war in jaguar helmets and hides. The Maya elite wore jaguar-skin garments in combat and held jaguar-covered shields, and a top-ranking Aztec group comprised the Jaguar Warriors.[59] No ordinary person could wear a jaguar

pelt or associate with jaguars. "Jaguars are companion spirits of strong, fat, handsome people," say the modern Tzotzil Maya.[60]

A "companion spirit," an "animal other," a *nahual,* is a widespread concept; it is often a jaguar. A certain jaguar hieroglyph, *way,* was the Classic Maya word for alter ego or "coessence."[61] An underworld or otherworld jaguar, with a water lily emerging from its head, is frequently seen on Classic Maya vases; it is commonly denoted as the *way* jaguar. The words for "jaguar" and "shaman" (or priest) are the same in a number of languages. Many ethnographic accounts indicate that shamans are transformed into jaguars by donning jaguar skins or ritually taking psychoactive drugs.[62] They turn back into humans, but they are thought to become jaguars permanently at death. Surviving an attack by a jaguar—real or supernatural—can be a shamanic initiation. A shaman is a warrior when he takes on a jaguar or when he confronts the otherworld. Both the shaman and the jaguar cross boundaries between worlds, between sky, earth, and water, between life and death, the natural and the supernatural. In folklore the jaguar can be an intermediary in dealing with earth and sky gods, who often have feline attributes.[63] There are many shamanic animals, but the jaguar is at the top of the list.

Pre-Columbian jaguar-effigy vessels seem to have provided sacred space for sacred substances; hence the vessel itself was a sacred object. A stone mortar or bowl from the earliest civilization in Peru—that called Chavín—may have been used in preparing a psychoactive drug used in ritual (fig. 29).[64] There is some evidence at the site of Chavín de Huántar, and in contemporary artifacts, for the ritual use of such drugs. The drug would have been ground with a pestle in the hollow in the animal's back. The mortar has a straightforward animal form, but the body is covered with four-part cosmic designs abstracted from jaguar markings.

A ceramic bowl found in a cemetery under the temple at the sacred site of Pachacamac has four-fingered arms painted on a modeled four-legged jaguar body; the image surely represents a supernatural being or a transformed shaman (fig. 30).[65] Vessels sometimes take the form of a feline head. A Moche vessel has the shape of a jaguar headdress (fig. 31). Both the headdress and the vessel suggest the concept of enclosing sacred space. Headdresses with a jaguar visage on the front are frequently depicted on Moche vessels; they are worn by gods and sometimes by

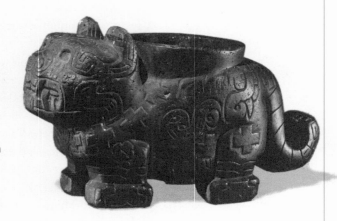

**Figure 29**

Stone bowl or mortar, feline. Peru. Chavín, 1500–100 B.C. H. 18.5, L. 33, W. 12.7 cm. University of Pennsylvania Museum, Philadelphia (Neg. #T4-132), SA 4627.

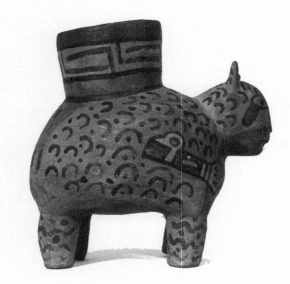

**Figure 30**

Polychrome ceramic vessel, feline with arms. Peru, central coast, Pachacamac, burial in cemetery under temple of Pachacamac. Huari style, A.D. 600–900. H. 20.5, W. 14, L. 21 cm. University of Pennsylvania Museum, Philadelphia, 26745 (Max Uhle expedition, 1896).

**Figure 31**

Ceramic vessel, jaguar headdress. Peru, north coast. Moche, A.D. 300–500. H. 19.5, W. 18, L. 23.5 cm. University of Pennsylvania Museum, Philadelphia, 54-13-1.

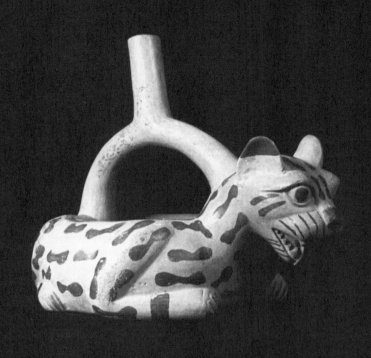

important mortals. At Tikal, Early Classic Maya cache vessels were surmounted by a guardian jaguar; stone Aztec vessels, carved in the form of a jaguar, held the hearts of sacrificial victims.[66]

Carved *metates,* stone tables for grinding maize, were some of the most elaborate sculpture made in Costa Rica (fig. 32). They may have been ritual seats for the leaders who were responsible for successful agriculture and the distribution of food.[67] This chiefly obligation is a common theme in Pre-Columbian art and life. The metate would have represented elite control over food production; it would also have symbolized a place of transformation, a liminal space. Metates have been found in burials. They take various animal forms; most commonly they represent jaguars or shamanic birds. This one has, at the edge, a woven motif, often a symbol of ruling power.

Relief sculpture felines stalked temple or enclosure walls in the Andes at the early site of Chavín and in Mesoamerica at Toltec sites; full-figure felines guarded or announced the entrances to special space at many sites, much as lions flank the doorways of early churches.[68]

There must have been many People of the Jaguar. Three millennia ago, the Olmec, in Veracruz, depicted human-jaguar images.[69] The Quiche Maya named the four First People, who were created from maize dough to found the Quiche lineage; three of them have Jaguar names.[70] The Kogi, the descendants of the great Tairona people, call themselves People of the Jaguar and proclaim that they live in the Land of the Jaguar, although their upland region is outside the usual range of the big cat. The Kogi believe that, at the beginning of time, a mythical jaguar gave them food plants.[71] A supernatural jaguar ancestor appears also in the lore of other groups. "The jaguar was the first human being," say the Mataco.[72] When a Desana approaches a cave where he believes a jaguar may lurk, he calls out, "Hey there, Grandfather!"[73]

In some places—notably highland areas—the dominant symbol was the puma (or cougar or mountain lion, *Felis concolor*), which likes drier, higher places. The Inca city of Cuzco, at some 4,000 meters, is said to have been laid out in the form of a puma. Today, near Cuzco, pumas are called a name that means "ancient male-female coparent."[74] The word "puma" is derived from a Quechua word for the animal. In Inca times, at certain rites in Cuzco, special important men wore puma hides over their

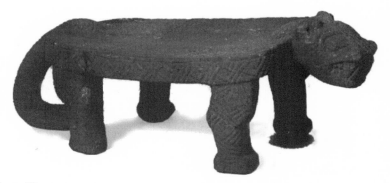

**Figure 32**

Stone *metate*, jaguar head and tail, woven motif on sides. Costa Rica, central highlands.
A.D. 1000–1500. H. 16.8, W. 21, D. 44.5 cm. Carnegie Museum of Natural History 2439-2992.

heads, as the fox skins were worn. In this region there are relationships
between pumas and foxes; the fox is often considered to be the younger
brother of the puma.

In Mexico the Aztec associated the puma with the earth and fertility.
In the Great Temple of the Aztec, puma remains were found, and, in one
case, a puma skeleton still had traces of red pigment on it and a green
stone bead in its mouth.[75] Green stone beads were sometimes placed in
human mouths for burial, and human burials were usually covered or
sprinkled with red pigment. In a nearby offering, a puma skeleton had a
flint sacrificial knife in its mouth. It is interesting, in terms of these buri-
als, to realize that *F. concolor,* by whatever local name it is called, has the
greatest natural distribution of any mammal in the Western Hemi-
sphere except *Homo sapiens.*[76]

Jaguars prefer moist forests, but they can exist in a wide variety of
climates. In the early part of this century, jaguars were sighted in the
southwestern United States. "Long ago, one could not walk along the
road because there were so many jaguars," begins a Chamula narrative
from the southern highlands of Mexico.[77] Today jaguars have been
overhunted, and their environments are being rapidly destroyed. Only a
few hundred survive in all of Mesoamerica.

# 5   Anomalous Animals

Animals that do not fit conventional patterns in nature are thought to have special power. The bat is the only mammal that truly flies (other "flying" mammals only glide); the fact that a bat sleeps and sometimes eats hanging upside down makes it even stranger. The armadillo is the only Neotropical mammal with a shell; its ability to walk across the bottom of a stream, under water, makes it additionally unconventional. Such uncommon traits give these animals special symbolic significance. In some Pre-Columbian depictions, odd creatures seem to be combined, as on a Costa Rican ocarina with a batlike head and an armadillolike shell (fig. 33).

The radarlike, echolocating ability of bats to sense objects and living things adds further to their anomaly, certainly in the real world and probably also in myth. The nose leaf, prominent on many Pre-Columbian bat images, is part of the sensing device of the family of leaf-nosed bats (Phyllostomidae). Insectivorous bats are especially adept at echolocation (their food is both small and moving). No bat is blind, but echolocation may be more important than vision.

In Neotropical rain forests there can be as many species of bats as of all other mammals combined.[1] There are more than nine hundred bat species worldwide; their populations are second only to those of rodents, to which bats are not kin. Many bats are now endangered, however, which is threatening to man, for bats are beneficial to man; they consume injurious insects, disperse seeds, and pollinate many plants. Some Neotropical bats, like those of northern latitudes, are insectivores. Other

bats eat, according to species, fruit, nectar and pollen, blood, fish, frogs, lizards, birds, and rodents.

Bats pollinate the calabash (gourd) tree; gourds are widely used as utensils and were used even more extensively in ancient times before pottery was made. The light-wood balsa tree, from which boats and model airplanes have long been made, and the maguey, which is used for fencing, fiber, and tequila, are bat-pollinated. A significant tree that bats—and only bats—pollinate is the silk-cotton, kapok, or ceiba tree, which provides timber for native canoes and special constructions as well as soft material for many uses. Both useful and sacred in many places, it is the World Tree, connecting underworld, middleworld, and sky. Many indigenous beliefs relate to the transit of bats between the land of the living and that of the dead. The observance of bats roosting in this tree would further the belief that the anomalous, nocturnal bat had traffic with the otherworld. Bats are shamanic creatures in many cultures.

The blood-lapping common vampire bat (*Desmodus rotundus*), endemic in the Neotropics, naturally symbolizes the ritual drawing of human blood. It is significant that, in the Maya highlands, the Tzotzil Maya word for vampire bat is *anhel*, which also means "angel" or "earth lord,"[2] and that pollen- and nectar-eating bats are also seen as sacrificers

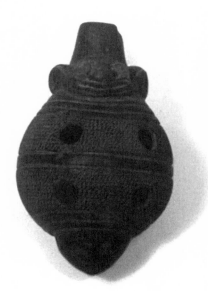

**Figure 33**

Ceramic ocarina with bat head and armadillo-like body. Costa Rica, Nicoya Peninsula, Las Huacas, Burial IX. Marbella, 300 B.C.–A.D. 500. H. 9, D. 5.5 cm. Carnegie Museum of Natural History 2793-21 (C. V. Hartman expedition, 1903).

and sorcerers; they drink nectar from a flower as a vampire drinks blood from a mammal.

Anthropomorphic bats are common in Pre-Columbian art (fig. 34). In Moche art and in Central Mexican codices, they perform human sacrifice.[3] Many Maya cylinder vases depict "killer bats," which often have crossed bones or pulled-out eyes on their wings and scrolls like vegetation coming from their mouths (fig. 35).[4] These may illustrate an event in the Popol Vuh, when one of the Hero Twins, spending a night in the underworld in the House of Bats, looked out of his hiding place to see if day had dawned, and was decapitated by a bat.[5] At the great Maya city of Copán, archaeologists have recently identified a House of Bats, adorned with bat sculpture, which may be a recreation of the mythic house.[6] A bat-head glyph was a sign for the place and/or a title for the Copán lineage lord. Other cities were named for the bat, and bat insignia appear also at other sites. The Tzotzil Maya are People of the Bat, for *tzotz* means "bat."

Bats were prominent motifs in Oaxaca, Mexico, where the bat is the avatar of a beneficent deity related to maize (figs. 36 and 37).[7] Bats are also prominent in Veracruz (fig. 38). Fine gold objects from Central America and Colombia depict bats, and pendants of gold or precious jade from around the Caribbean basin have a bat as the central element; the outspread wings can show the heads of crocodilians or composite monsters (fig. 39).[8] These "ornaments" combine several powerful creatures from nature and/or myth.

**Figure 34**

Ceramic ocarina, leaf-nosed bat. Costa Rica, Nicoya Peninsula, Las Huacas. 300 B.C.–A.D. 500. H. 7, W. 6.5, D. 4.5 cm. Carnegie Museum of Natural History 2438-2078.

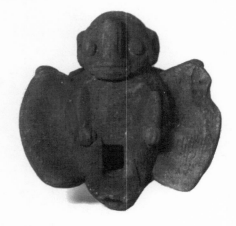

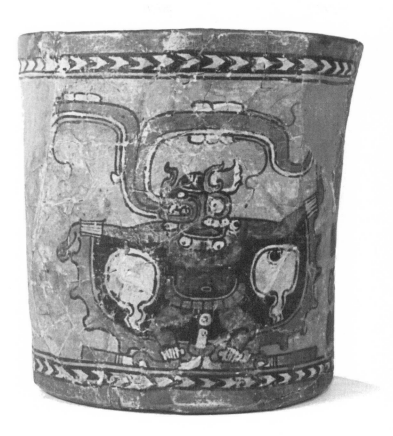

**Figure 35**

Polychrome ceramic vase with anthropomorphic bat. Guatemala, Chamá. Late Classic Maya,
A.D. 600–900. H. 20, D. 18.5 cm. University of Pennsylvania Museum, Philadelphia, NA 11222
(Robert Burkitt expedition, 1920).

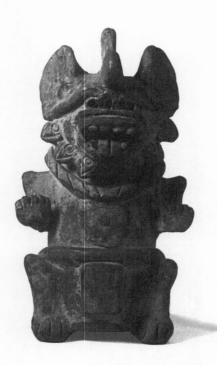

**Figure 36**

Ceramic censer,
anthropomorphic bat.
Mexico, Oaxaca. Zapotec,
A.D. 300–900. H. 22.5,
W. 12, D. 10 cm. University
of Pennsylvania Museum,
Philadelphia, 29-41-701.

**Figure 37**

Ceramic urn with four bat
heads. Mexico, Oaxaca,
Guila. Zapotec, A.D. 600–
900. There are snakes
around the lower flange.
H. 37.5, D. 36 cm. University
of Pennsylvania Museum,
Philadelphia, 29-41-741.

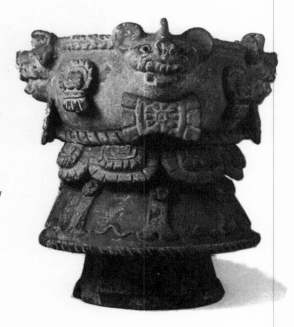

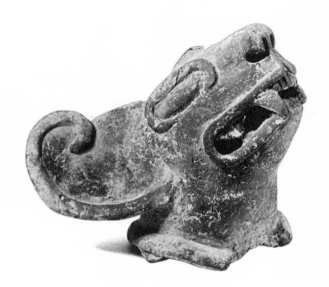

**Figure 38**

Ceramic bat head. Mexico, Veracruz. A.D. 600–1000. H. 15.7, W 13, D. 19.7 cm. Harn Museum of Art Collection, University of Florida, C-82-113. Gift of Lawrence J. Cassard, M.D.

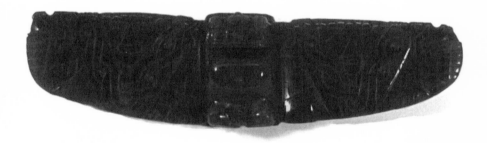

**Figure 39**

Jadeite pendant, spread-wing bat (Phyllostomidae) with faces at the side. Costa Rica, Nicoya Peninsula, Las Huacas. 300 B.C.–A.D. 500. H. 4.1, W. 15.3 cm. Carnegie Museum of Natural History 2939-1181 (C. V. Hartman expedition, 1903).

**Figure 40**

Ceramic armadillo with
hands holding the nose.
Costa Rica, Nicoya
Peninsula, Las Huacas. 300
B.C.–A.D. 500. H. 6, W. 5.6,
D. 9.6 cm. Carnegie
Museum of Natural History
2438-2065.

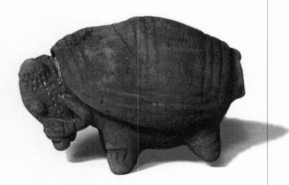

The armadillo is an American mammal that lives in an articulated shell
and eats chiefly ants and termites.[9] The "little armored one" is a remark-
ably rapid and efficient digger into the earth or underworld. Armadillos
sleep and raise young in burrows. In the Maya area, armadillo burrows
are sometimes thought of as the equivalent of graves; they are so inter-
preted in dreams.[10] In myths from lowland South America, whenever a
digger is needed to prepare a burial, the services of the armadillo are en-
gaged.[11] In some folk literature the armadillo's digging causes floods and
creates rivers.[12] The digging associates the armadillo also with agricul-
ture. A Mataco myth tells that the armadillo cut off the end of his granu-
lar tail and planted it; from it grew the first maize.[13] The tail does re-
semble a maize ear. In a Chorti Maya narrative a farmer was digging his
field when a rainstorm came.[14] Despite the warnings of his neighbors, he
kept on digging; after a while, his back was struck by lightning, which
made it hard like bone. He became an armadillo, who still digs in the rain.

The "humanness" of the armadillo is indicated by the example in fig-
ure 40, which, in addition to its four animal legs, has arms and hands
holding its snout; the "hands" may be those of a coati rather than hu-
man.

The armadillo, which makes little noise—only grunts and hisses—is
widely associated with music. On Maya vases an armadillo is shown as a
drummer.[15] In the Popol Vuh the Hero Twins performed an armadillo
dance in the underworld, sometimes depicted on Classic Maya cylinder
vessels.[16] The Kogi, in Colombia, still perform an armadillo dance.[17]

**Figure 41**

Ceramic ocarina, armadillo
(Dasypodidae). Costa Rica,
Nicoya Peninsula, Las Huacas.
300 B.C.–A.D. 500. H. 4, W. 3.5,
D. 5 cm. Carnegie Museum of
Natural History 2438-2066.

Music was an integral part of Pre-Columbian life. Many Pre-Columbian objects were sound-making: there are rattles, bells, whistles, trumpets, drums, and conch shell trumpets. Ocarinas, played in Central American rituals, represented significant animals; they often take the form of a bat (fig. 34) or an armadillo (fig. 41). Musical instruments—a trumpet, for example—could be made in part from an armadillo shell.

Armadillos are hunted for their shells, which can be useful as containers, as well as for their meat, which is succulent. Hunters sometimes set a dog on them in their burrows. Sometimes they are caught in stone traps; the Codex Madrid shows such a trap. In the Maya highlands the shell can be a seat for a god, usually the earth god.[18] In Colombia a shaman's wooden bench is carved in the form of an armadillo.[19] The person who sits on it can "deepen himself" quickly, like the armadillo, who digs rapidly into the earth.

There is in South America a giant armadillo (*Priodontes maximus*) of impressive size. The Bororo believe that a clan ancestor claimed the right to use the great armadillo's physical and spiritual characteristics and that the clan has exclusive rights to use armadillo materials and to represent the animal.[20]

Some armadillo species have become extinct in the last five hundred years, but the nine-banded armadillo (*Dasypus novemcinctus*) is thriving and has extended its range well into the United States. The three-banded armadillo depicted on Maya vases and codices and Costa Rican ocarinas (fig. 41) no longer inhabits Mesoamerica or Costa Rica; today a

three-banded armadillo (Tolypeutes) is found only from southeastern Bolivia south.[21] It can roll itself up into a spherical ball, rather like a base-ball; this is an escape mechanism, for it lacks the digging ability of most of its relatives. Folk narratives often mention this. In one tale the armadillo makes itself into a ball and wins a downhill race against a weasel.[22]

Monkeys can be called anomalous because they look and act so much like people.[23] "It has human hands, human feet, nails, real nails," said one of Sahagún's informants of a monkey; "it sits like a man."[24] In New World origin myths, monkeys are often the result of a failed attempt to create mankind, or they are human beings turned into monkeys because they did not obey the gods.[25] Myths about a great flood or other natural disaster and the origins and transformations of humans and animals that took place at that time are widespread; monkeys often appear in these. In a reversal of this pattern, a Bororo narrative tells of a monkey who lived alone and created people to end his solitude.[26]

Scribes and artists ranked high in Maya society.[27] In Maya art and folklore, the black-handed spider monkey (*Ateles geoffroyi*) and the larger howler monkeys (*Alouatta palliata* and *A. pigra*) are artists and patrons of the arts. They are shown on Classic Maya vases painting, writing, dancing (fig. 42), and making music, and the Popol Vuh describes them thus.[28] The Hero Twins turned their artistic older brothers into monkeys, perhaps in an expression of sibling jealousy, perhaps to point out that artists are pushed aside by activists. Howler monkeys have a remarkable voice and a range of vocalizations, which may account for musical associations. The acrobatic spider monkey, exceptionally agile in trees, can leap 40 feet from tree to tree. It can hold a branch with its prehensile tail while using its four limbs for eating and grooming. The white-faced capuchin (*Cebus capucinus*), a particularly dexterous tool user (sometimes engaged today to help the handicapped), is another candidate for a prominent role in the arts. Its range now begins at the southern edge of the Maya area. Figure 43 and plate 4 probably represent *Cebus* monkeys.

"Monkey" was the name of a day in the Aztec calendar. Those born on that day were fated to be like actors and merry singers, graceful and

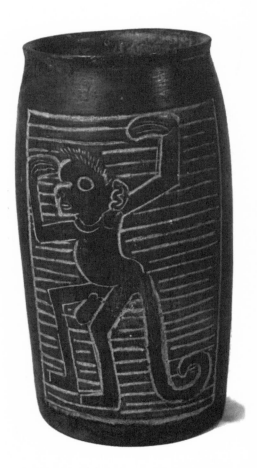

**Figure 42**

Ceramic vessel with two
incised dancing monkeys.
Guatemala. Late Classic
Maya, A.D. 600–900. H. 20,
D. (bottom) 10 cm.
University of Pennsylvania
Museum, Philadelphia,
42-36-16, collected by Lilly
deYongh Osborne, 1942.

clever. On certain festival days artisans danced in monkey (and other
animal) costumes.[29]

A monkey was a guise of Ehecatl-Quetzalcoatl, the Aztec wind god.[30]
Both wind and monkey are restless and unpredictable. They rustle tree
leaves as they move through branches. In Central Mexican cosmology,
as depicted in Codex Vaticanus A, a great hurricane destroyed the world
at the end of one of the ages of mankind. Only one couple was left; they
were turned into monkeys. A related idea appears in recent Lacandon
Maya belief: when the last Lacandon dies, the world will be destroyed by
strong winds that will blow the monkeys out of the trees.[31]

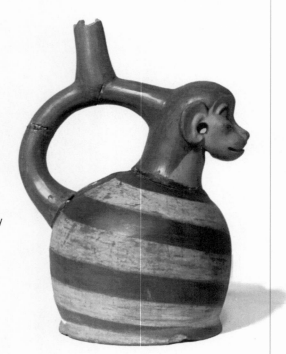

**Figure 43**

Ceramic vessel with
horizontal stripes around
the globular body, large
monkey head at the top.
Peru, north coast. Moche,
A.D. 300–500. H. 24.5,
W. 13, D. 15 cm. Carnegie
Museum of Natural History
4291-678.

Many monkey effigy vessels were carved in stone, the *tecalli* (onyx marble) of Central Mexico (fig. 44), and monkey pendants were cast in gold in Panama (fig. 45). Frequently, in these examples, the monkey is holding its raised tail as if it were clinging to a tree limb. The gold pendants are sometimes elaborated with snakes. Monkeys appear in ceramic work both as full-round figures and as bowl or vase decoration (pl. 4).

Monkey remains on the desert coast of Peru suggest that monkeys were kept there as pets or for use in ritual events.[32] Scores of Moche vessels depict humans engaging in the ritual in which leaves from the sacred coca plant were chewed with powdered lime (fig. 98); although the rite was widespread, it seems to have been particularly important to the Moche.[33] Gastropod trumpets were blown in the ritual. A number of

**Figure 44**

Onyx marble (*tecalli*) vessel, monkey. Mexico, central highlands, probably Puebla. Early Post-Classic, A.D. 900–1200. H. 13.8, W. 9.2, D. 9.8 cm. University of Pennsylvania Museum, Philadelphia, NA 6362.

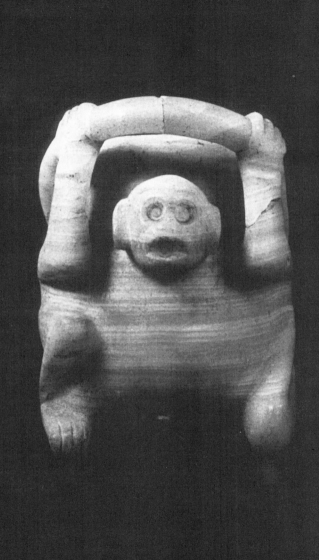

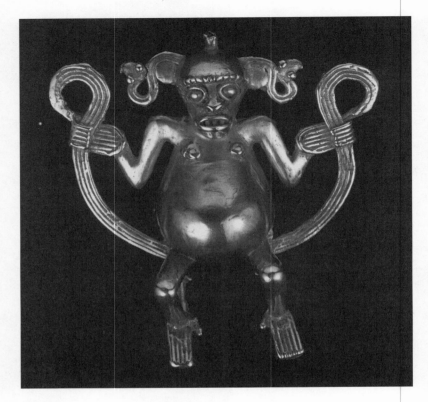

**Figure 45**

Cast-gold pendant rattle, monkey holding its tail at either side; hook for suspension. Panama, Veraguas Province. A.D. 1000–1500. H. 7.5, W. 7.5, D. 3.5 cm. University of Pennsylvania Museum, Philadelphia (Neg. #T4-716), SA 2781.

Moche pots show a monkey, or twin monkeys, with a coca bag around the neck, sometimes holding a lime gourd and wearing the pendant-disk ear ornaments seen on human participants. This association must have gone far back in time, for a pre-Moche effigy vessel depicts a monkey holding a gastropod shell; he has the fanged mouth seen on figures of sanctity or high status.[34] Monkeys and coca came originally from the same region, the moist forests of the Amazon basin on the other side of the Andes. There was probably an origin myth that linked monkeys and coca. A figure of a coca chewer with a monkey on his shoulder very likely

refers to this myth (fig. 12). Twin monkeys are reminiscent of the Popol Vuh brothers. Brothers and/or twins are as prominent in South American ethnography as they are in the Mesoamerican literature.

Monkeys often appear at the juncture of the spout and the "stirrup" on Chimú vessels (fig. 6), perhaps in reference to the coca rite, which is not depicted on Chimú pottery, perhaps as an allusion to a creation myth or simply as an observation about the high places in which monkeys travel.

Because they live in trees and eat fruit and foliage, monkeys are associated with vegetation and with sky and sun.[35] They are often depicted holding fruit or maize, as does a monkey on a Moche vessel, which is probably a common squirrel monkey (*Saimiri sciureus*), which ranges just over the mountains from the north coast (fig. 46).[36] On Maya ves-

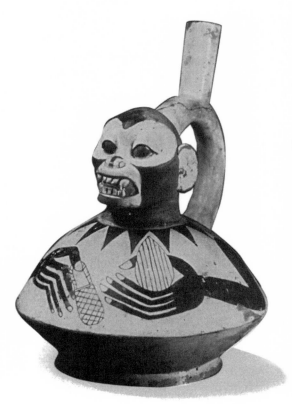

**Figure 46**

Ceramic vessel, monkey (Cebidae) holding maize ear and bag. Peru, north coast. Moche, A.D. 300–500. H. 23, W. 16.5, D. 21.5 cm. University of Pennsylvania Museum, Philadelphia (Neg. #T35-92), 39-20-35.

sels, monkeys are seen with cacao, the pods of the precious chocolate plant,[37] which was a high-status trade good in the past. The Aztec Codex Magliabechiano illustrates a group of dances for the gods of *pulque,* maize beer; a man dressed as a monkey performs before one of these gods.[38] Monkey-clad figures still appear in festivals and dances in many places; they are still performing as artists.

Monkeys are now hunted for food in many places, but they were not so depicted in the past. Because of their closeness to man, eating them may have been forbidden. It is possible that monkeys in the Maya region were sacrificed. They are not shown as offerings, and few monkey bones occur in ritual deposits, but monkeys are sometimes depicted on Classic Maya vessels wearing a "death-eye" collar or the scarf identified with a sacrificial victim.[39]

Most New World monkeys are now threatened or endangered. The Lacandon Maya, who have made a comeback from near-extinction themselves, may outlast the monkeys.

Another anomalous animal is the marsupial, largely nocturnal opossum (*Didelphis marsupialis,* a relative of the northern *D. virginiana*).[40] Its ability to "play possum" may be a reason that, in the New Year's pages in the Maya Codex Dresden, this animal is a metaphor for the dying and reviving year. Opossums are rarely recognizable in Pre-Columbian depictions and not often present in folklore, perhaps because, according to one naturalist, they are "slow-witted, sluggish ... of unattractive appearance and uninspiring habit."[41]

Spiders and scorpions (Arachnida) can also be classed as anomalous.[42] Spiders weave in wondrous ways, as no other creature can do, with different species creating various forms of web architecture. In myth, spiders are widely associated with weaving and with teaching the first women to weave. They can also be venomous and death-dealing, and in Chavín and Moche art, they are sacrificers, anthropomorphized and holding knives and human trophy heads.[43] Scorpions are distant relatives of spiders; they too are nocturnal hunters, some of which are venomous.

Spider and scorpion were primary ingredients in "Food of God," a mixture placed before the idol of the Aztec snake-footed god Tezcatlipoca and rubbed on the bodies of attendants. It was also used as a medicine. Durán described it unpleasantly and likened it to "the ointment used by witches,"[44] who, all over the world, have always been drawn to anomalous creatures.

# 6   Birds

Land, shore, and water birds abound in Latin America: enormous condors and tiny hummingbirds; drab birds and vivid birds with brilliant, multicolored plumage. High-flying eagles and hawks, darting hummingbirds, and yellow, red, blue, and green parrots, macaws, and toucans were often associated with the sun (figs. 47 and 48). Macaws have particularly strong associations with the sun and with fire, in the Maya realm and also in South America.[1] They flash like fire as they fly, bearing the strong colors of objects in bright sunlight. Macaws and parrots carved from stone decorate ball courts in Mesoamerica, where the ritual game, patterned on celestial movements, was played. Freshwater birds, shore birds, and sea birds, herons, flamingos, and storks, pelicans, cormorants, and frigate birds—birds that dive into or dip below the surface of water—were associated with fish, fecundity, and the underworld (figs. 4, 6, 49, and 50).

Birds were frequent motifs in ceramic, textile, and stone art of every culture in the Americas from the earliest times to the latest. Bird attributes—beaks, wings, crests, claws—were used in abstract designs (fig. 51 and pl. 5). Costa Rican "axe gods," vertical knife-shaped pendants of jade or a similar stone, are notable for their bird traits, which are often mixed with elements of humans, monkeys, bats, and snakes (figs. 52 and 53).[2] Their purpose is unknown, but they must have been worn as special-status ornaments, and they may have been employed in sacrificial rites; some of their blades are dulled.

Some birds were hunted for food and feathers with blowguns, arrows, or traps; some birds were simply part of the ambiance; others were kept

in captivity, often brought from other regions and plucked at appropriate times; some were probably pets.[3] Archaeological remains suggest that women tended the captive birds on the central coast of Peru in the late period, and this is true of the macaws kept today by the Bororo in central Brazil.[4] Parrots, macaws, and toucans are all tamable—and at least somewhat talkative. The fact that birds could talk was surely significant.

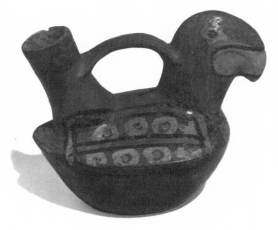

**Figure 47**

Ceramic parrot effigy vessel. Peru, south coast. Nasca-Huari, A.D. 600–800. H. 19, W. 14, L. 21.5 cm. Florida Museum of Natural History, University of Florida, 102236.

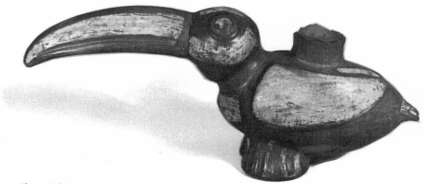

**Figure 48**

Ceramic vessel, toucan. Peru, north coast. Moche, A.D. 300–500. H. 14, W. 8.5, L. 31.5 cm. University of Pennsylvania Museum, Philadelphia, 43456.

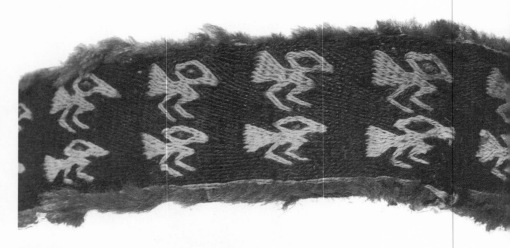

**Figure 49**

Textile headband with repeated bird design. Peru, central coast.
Late Intermediate, A.D. 800–1400. H. 3.8, L. 38 cm. Florida
Museum of Natural History, University of Florida, T95.1.

**Figure 50**

Ceramic vessel, crested
bird. Peru, north coast,
lower Santa Valley. Moche,
A.D. 300–500. H. 28,
W. 14.5, D. 22 cm.
University of Pennsyl-
vania Museum, Philadel-
phia, 34295 (Max Uhle
expedition, 1897).

**Figure 51**

Ceramic dish of Inca form
with projecting bird head.
Peru, central coast,
Pachacamac, Sun Temple,
Cemetery of the Sacrificed
Women. Inca, A.D. 1300–
1500. H. 6, D. with head,
20.5 cm. University of
Pennsylvania Museum,
Philadelphia, 31109 (Max
Uhle expedition, 1896).

**Figure 52**

Blue-green jadeite "axe
god," owl with human
hands. Costa Rica, Nicoya
Peninsula, Las Huacas. 300
B.C.–A.D. 500. H. 7.8,
W. 3.8, D. 8 cm. Carnegie
Museum of Natural History
2939-532.

**Figure 53**

Serpentine "axe god" with long beak and probable snake heads on headdress. Costa Rica, Nicoya Peninsula, Las Huacas. 300 B.C.–A.D. 500. H. 18.9, W. 3.2 cm. Carnegie Museum of Natural History 2438-278.

**Figure 54**

Light-brownish stone pendant, profile bird, probably a great curassow. Costa Rica, Nicoya Peninsula, Las Huacas. 300 B.C.–A.D. 500. H. 8.6, W. 0.9, D. 2.4 cm. Carnegie Museum of Natural History 2939-594.

Feather work was an important Pre-Columbian craft.[5] When examples of it were taken to Europe in the sixteenth century, it so impressed European craftsmen that, for a brief time, they imitated it, composing intricate religious pictures with feathers. Some Pre-Columbian feather work still exists, mostly that found in caches and burials in the desert sands of the south coast of Peru. Little is left from Mesoamerica, but sculpture and pottery indicate that there were abundant feathers on the garments and accessories of lords and supernatural beings, symbolizing both shamanic qualities and the status of people who could afford such luxury goods.

The brilliant plumage of the extraordinary birds of the Americas made eye-catching attire for important people. Colorful feathers were tied into or sewn onto cloth to adorn headdresses, ear ornaments, pectorals, capes, tunics, feathered backracks, armbands, and shields for rulers, priests, and warriors. They were similarly incorporated into wall hangings for palaces and temples. A Colonial reference mentions a house whose walls were covered with red and yellow feathers.[6] Sacred bundles, bags for precious objects, and implements for drawing blood were feathered, as were official staffs, fans, and rattles. In regions where arrows were used, they were fletched; fletched arrows travel more accurately than unfletched ones.[7] Bird feathers are still used on ritual costumes and paraphernalia, especially in South America.

Mealy parrots (*Amazona farinosa*), a source of feathers in ancient Peru, were probably maintained on the coast; their feathers have been identified in Chimú and Paracas garments.[8] The domesticated Muscovy duck also provided useful feathers, as did the great curassow (*Crax rubra*), a large bird with a crest of forward-falling feathers along its crown (fig. 54).[9] This impressive bird forages for fruit that has fallen on the forest floor as well as feeding in trees; it has the best of both worlds. Egret, flamingo, cormorant, tanager, various macaws and parrots, and other birds also contributed feathers for garments and special objects.

The colors of feathers may often have been more significant than the birds they came from.[10] The telling of how the birds got their colors is a common plot of myth.[11] Nature was bountiful with bright-feathered birds, but some groups of Indians have altered the colors of living birds by applying resins or secretions from frogs and other animals to the plucked skin of live birds.[12] According to ethnographic accounts from lowland South America, feather colors convey symbolic meaning, which, of course, differs with different groups.[13] Yellow feathers can evoke the sun, energy, fertility, and semen. Red, a more important color for some, can stand for goodness, power, and fertility; it can also signify the blood of battle, sacrifice, and sexuality. In some South American narratives, the sun god lives in a shelter of yellow and red macaw feathers or lights the world with the feathers of his crown. Blue can symbolize sky (this sky color is also sun-associated), water, ritual incense, and communication.

Green indicates vegetation. Black feathers can be associated with high rank and power, but black also can be negative. White seems to have been a shamanic color for some, a rather unimportant color for others.

Birds have long been important in everyday, ritual, and mythic life. They are shamanic characters, especially certain birds, among them owl, hummingbird, harpy eagle, and king vulture.[14] Birds fly through different levels of air, as the shaman travels in his spirit journeys to the otherworld. Birds help the shaman on his journeys in a number of narratives. A green stone pipe in the form of a bird, from a burial in Colombia, was probably used for psychoactive snuff by a shaman in a ritual that would enable him to travel to the otherworld (fig. 55). Bird remains and effigies have been placed as offerings in caches and burials from ancient to modern times in many regions—in Panama, Costa Rica, and the Maya region, for example.[15] Remains of parrots, recovered from Pachacamac and other coastal sites in Peru, were sometimes carefully wrapped in a miniature mummy bundle.[16]

Today in Brazil the Bororo keep live birds in their village.[17] When a Bororo Indian's pet macaw dies, it is wrapped in a fiber mat and buried

**Figure 55**

Green stone pipe in the form of a bird. Colombia, Santa Marta region, Gairaca. Tairona, A.D. 700–1500. H. 8.5, W. 3.5, D. 2.9 cm. Carnegie Museum of Natural History 2005-268 (Herbert Huntingdon Smith expedition, 1896–98).

behind the house. The Bororo believe that their legendary heroes created the ritual objects for the lineages of the village; they have carefully pre-scribed ways of applying feathers to those objects. After a major Bororo ceremonial cycle, most of the birds in the village are nothing but flesh and bone, alive but featherless.

The Bororo believe themselves to be essentially macaws; they were turned into birds by their culture hero, who became the sun. The Bororo do not kill macaws because of this identity and because the birds are fa-vorite dwelling places for spirits of the ancestors. In Costa Rica the Bribri believe in an ancestral female parrot.[18] There are a number of instances of the burial of macaws with important Bribri people, continuing at least into the seventeenth century.

The Cashinahua people, in southeastern Peru, on the other hand, come by their decorative feathers with quite a different method and motivation. When asked why they made feather-decorated objects, they said they did so because they hunted birds and because feathers are beautiful.[19]

Macaws have quite long tail feathers. Feathers of the scarlet macaw (*Ara macao*) are probably depicted in the murals at the Maya site of Bonam-pak.[20] The actual feathers have been encountered on many archaeologi-cal objects; scarlet macaw feathers were braided into the human hair of a mummy bundle from the south coast of Peru, for example.[21] This widely distributed macaw ranges from Veracruz and Oaxaca through much of South America.[22] It is easily tamable and can say a few words. The blue-and-yellow macaw (*Ara ararauna*), found from Panama through Ama-zonia, is a frequent pet today.[23] Its feathers have been found on Chimú headdresses. The red-and-green macaw (*Ara chloroptera*), another pet macaw, is also found over much of South America. Although macaws still range from Mexico to the Gran Chaco, some species are extinct.

In a very limited cloud-forest range in the Maya area and adjacent Oaxaca dwells the resplendent or Guatemalan quetzal (*Pharomachrus mocinno*). It is the Guatemalan national bird, although it is now virtu-ally extinct there. The male has very long, green upper-tail coverts, which adorned regal headdresses and sacred objects belonging to kings

and shamans—staffs of office, bundles, bloodletters; these are pictured on sculpture and pottery.[24] The founder of the Copán royal dynasty in the fifth century A.D., Yax K'uk Mo (K'uk means "quetzal"), wears the bird perched on his headdress in a late portrait on a Copán altar.[25] Quetzal feathers were important trade items on the route to central Mexico, where they appear in the art of Teotihuacán, Xochicalco, and the Aztec.[26] An elaborate headdress, described as having belonged to the Aztec emperor Moctezuma (it was taken to Europe in the sixteenth century), has some five hundred quetzal feathers in it.[27] Some quetzals were kept in the aviaries of the emperor, where many rare birds were kept, bred, and plucked.[28] The bright-green color of the long tail coverts is reminiscent of young maize plants. In the Pre-Columbian past, killers of quetzals were put to death. Today the resplendent quetzal is seriously endangered, mostly by the destruction of cloud-forest habitat and by souvenir sellers who hawk its beautiful carcass.

Feathers and folklore were contributed also by water birds, who are depicted in many Pre-Columbian pottery scenes. The Aztec place of origin was a presumably inland site called Aztlan, "Place of the White Heron." The white heron is apt to be an egret since white herons are rare.[29] A white heron or egret was deposited in an offering in the Great Temple of the Aztec at Tenochtitlán.[30]

The jabiru stork (Jabiru mycteria; fig. 56), ranging from Central America southward, inhabits tropical marshes, lagoons, and coastal estuaries, where it preys on young caimans and crocodiles.[31] A very large white bird with a huge beak, it has a bare head and neck like those of a vulture. It is sometimes a character in South American lore, and it can occasionally be recognized in Pre-Columbian art.[32]

Along the coast of Peru sea birds were a source of guano, which has been used for fertilizer certainly from Inca times and probably before.[33] A century ago guano was Peru's most important export. Islands off the coasts of Peru and Chile are still inhabited by thousands of birds, and guano is still being collected (see fig. 4). The "guano trio" consists of the guanay cormorant, Phalacrocora bougainvillii; the Peruvian booby, Sula variegata; and the Peruvian/Chilean pelican, Pelecanus (occidentalis)

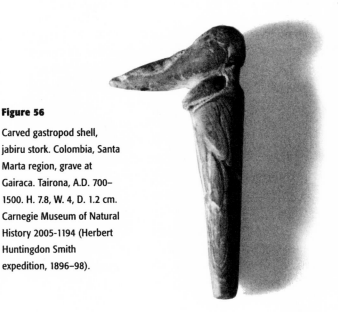

**Figure 56**

Carved gastropod shell,
jabiru stork. Colombia, Santa
Marta region, grave at
Gairaca. Tairona, A.D. 700–
1500. H. 7.8, W. 4, D. 1.2 cm.
Carnegie Museum of Natural
History 2005-1194 (Herbert
Huntingdon Smith
expedition, 1896–98).

*thagus,* which may be a subspecies of the brown pelican (fig. 6).[34] The guano birds are depicted in art from the coast of Peru, where it is often hard to distinguish them; a textile design probably shows boobies (fig. 49). Breast feathers of the guanay were used in Chimú feather work.[35]

Eagles, hawks, falcons, owls, and hummingbirds stood for military power, especially among the Aztec and the Moche. These birds have other powers as well.

Hummingbirds, a solely Neotropical family of more than three hundred species, have many suggestive qualities.[36] Their movements are anomalous. Some species hibernate or go into torpor when it is cold; they awaken when the spring rains come. "It rejuvenates itself," wrote Sahagún of a hummingbird.[37] After the Spanish conquest, the hummingbird became a symbol of resurrection because of its apparent death and revival.

Hummingbirds are creatures of the sun. They are diurnal, and they have iridescent feathers; when they dart back and forth, they look like glints of sunlight. In the myths of many cultures, the sun—or the young

man who will become the sun—is a hunter and/or a warrior. Humming-
birds, small and pretty as they are, have qualities needed by young war-
riors. Hummingbirds are territorial and aggressive. They attack not only
each other but large birds—owls and falcons or hawks (fig. 57). They
outmaneuver predators. They can fly backward and up-
side down. The long, sharp beak of many hummingbirds resembles a
weapon or a sacrificial implement. The birds' flight is like that of an ar-
row, and they are sometimes invoked by archers seeking a surer aim.
Like falcons, hummingbirds appear in Moche battle scenes, where they
can be shown naturalistically, flying among Moche warriors, or as an-
thropomorphic warriors themselves.[38]

The tribal god of the Aztec, Huitzilopochtli, was both a warrior and a
sun god.[39] He wore a hummingbird helmet, and his name means "Hum-
mingbird on the Left [of the sun's path]." His mother, Coatlicue ("Ser-
pent Skirt"), was made pregnant with him by a ball of feathers, probably

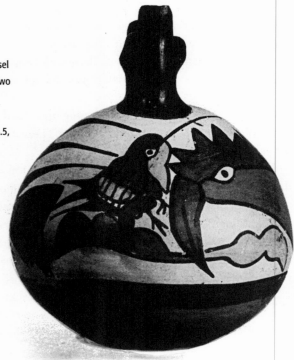

**Figure 57**

Polychrome ceramic vessel
with hummingbird and two
large birds with pods in
beak. Peru, south coast.
Nasca, A.D. 1–300. H. 16.5,
D. 13 cm. University of
Pennsylvania Museum,
Philadelphia, 54-14-11.

those of a hummingbird, that fell into her bosom. He was born at dawn, full-grown and armed, and he destroyed his siblings, the beings of the night sky.

Two Classic Maya cylinder vases from a burial at Tikal show a hummingbird-man sitting facing the enthroned ruler.[40] The bird-man may represent an ancestor spirit. Hummingbirds are often thought of as ancestral spirits in both Mesoamerica and South America. It is the ancestral animal of the Desana; all Desana are designated Sons of the Hummingbird.[41]

In modern lore, dead hummingbirds or parts of them are often carried as talismans or eaten to enhance physical strength or to bring success in love.[42] Sometimes they appear as messengers between the real world and the otherworld.

Daytime-soaring eagles, hawks, and falcons also are often manifestations of the sun. The Aztec god Huitzilopochtli told his people that they should found their city where they saw an eagle perched on a cactus.[43] The eagle of Aztec myth, seen on the modern Mexican flag, is the golden eagle (*Aquila chrysaetos*).[44] Sahagún's informants described the golden eagle as fearless, brave, and daring; "it can gaze into, it can face the sun."[45] Once found throughout the northern hemisphere, it is now absent or endangered in much of its former range, although it is still tamed for use in hunting in Eurasia, as occasional newspaper or magazine photographs show. The golden eagle likes dry, mountainous regions. It is a splendid flier and hunter, and its quarry is predominantly mammalian.

The golden eagle symbolized military might. The people of Teotihuacán, near Mexico City, depicted mythical eagles with shields.[46] Later the top-level Aztec soldiers were Eagle and Jaguar Warriors.[47] The entrance to a shrine of the Eagle Warriors in the Great Temple was flanked by a pair of life-sized ceramic warriors in eagle garb. Eagle Warriors took captives for sacrifice. Aztec offerings, especially the hearts of sacrificial victims, were collected in "eagle boxes," *cuauhxicalli*. Mesoamerican relief sculpture depicts eagles eating human hearts, and an eagle-man hovers above a sacrificial victim in a ball court sculpture at El Tajín, in Veracruz.[48] Feeding the eagle with sacrificial offerings was a way of nourishing the sun.

The Aztec exacted eagles as tribute from various parts of their do-main.[49] One complete golden eagle and bones of others were found in a major offering in the Great Temple, and many Aztec vases show the golden eagle.[50]

The harpy eagle (*Harpia harpyja*), a Neotropical crested eagle with facial disks that resemble those of an owl, is the largest and strongest bird of prey in Central and South America, the world's heaviest bird of prey, and probably the most powerful eagle in the world (fig. 58).[51] The harpy eagle is cryptic in a forest, where its gray, black, and white plum-age blends with dead wood and foliage. A dramatic presence, a superb predator with a regal appearance, the harpy eagle weighs up to 18 pounds and has a 7-foot wing span. Its talons and tarsi are immense for its size. It nests in the sacred ceiba trees in deep forest, about 100 feet above the ground, and hunts in and under the forest canopy, preying on monkeys and other small mammals as well as on parrots and other birds. A high percentage of its prey is arboreal. Its wings are short and broad to allow it to navigate between branches. It hunts in swift snatches. It is a power-ful shaman and sorcerer, a protector, a warrior, a legendary bird.[52] It was surely the inspiration for all or part of many ancient power images. There are other crested eagles that may have been substituted, but the harpy eagle is at the top of the list. A Chavín "eagle box" or ritual mortar is carved in the shape of a bird, probably a harpy eagle.[53]

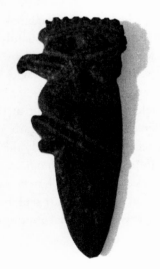

**Figure 58**

Gray stone pendant, profile harpy eagle. Costa Rica, Nicoya Peninsula, Las Huacas. 300 B.C.–A.D. 500. H. 7.5, W. 3.1 cm. Carnegie Museum of Natural History 2793-95 (C. V. Hartman expedition, 1903).

In recent times harpy eaglets have been raised in many Indian villages in South America. The feathers, gathered at the annual molting, are used for sun-associated crowns and arrows that are believed to be especially swift and accurate. But the bird is now endangered, as its habitat and its prey are disappearing.

The aplomado falcon (*Falco femoralis*) and the sparrow hawk, or American kestrel (*F. sparverius*), are prominent on the coast of Peru.[54] Feathers of the aplomado falcon were used in Paracas feather work, and images of the bird appear on embroidered textiles; Moche anthropomorphic warriors and runners sometimes take the form of a falcon or a hawk (fig. 59).[55] Such birds were also significant in the Andean highlands (fig. 60). In later times in Peru one or two falcon feathers were worn by all descendants of the Inca rulers.[56]

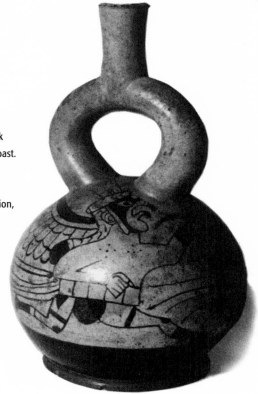

**Figure 59**

Ceramic vessel with anthropomorphic hawk runners. Peru, north coast. Moche, A.D. 200–500. H. 23, D. 12 cm. Harn Museum of Art Collection, University of Florida, University Gallery purchase, C-71-7.

**Figure 60**

Vase (*kero*) with eagle-
hawk image. Peru,
southern highlands. Late
Huari, A.D. 700–900.
H. 15.5, D. 14 cm.
Florida Museum of
Natural History 101422.

A falcon has a role as messenger in the Popol Vuh.[57] The Twins shot at
it, which explains why the laughing falcon (*Herpetotheres cachinnans*)
has a black patch at its eye. (It resembles a domino mask.) The falcon had
swallowed a snake that had swallowed a toad that had swallowed a louse
that had swallowed a message from the Twins' grandmother, telling the
ball-playing boys that they had been summoned to the underworld. The
food chain is well expressed in this sequence. The laughing falcon is one
of the most renowned snake-eating hawks in Mexico and Central
America.[58]

Stone mace heads from the Nicoya Peninsula, in western Costa Rica,
were sometimes carved as the head of a harpy eagle (fig. 61) or that of an
owl, appropriate for the war symbolism of these birds.[59] The maces, at-
tached to a wooden shaft, could have had both military and ritual use.

The owl was a military symbol also at Teotihuacan, where it is pictured in murals holding a shield and weapons.[60]

A large anthropomorphic owl was the chief Moche supernatural warrior or war god.[61] Owl accessories—headdress adornments, necklaces, nose ornaments—are worn by powerful (and probably specifically military and priestly) Moche people as well as by gods. There may have been a cult dedicated to the activities of the owl warrior, or the owl may have been particularly prominent with certain families or places. Virtually every metal figure discovered at the Moche site of Sipán wears an owl necklace.

A splendid—probably unique—Moche ceramic vessel shows an owl warrior on a balsa raft, supported at each corner by a small human figure, with aquatic life below (pl. 6). Balsa rafts, used by later peoples, are rare in Moche art. In colonial times Garcilaso described a balsa raft of great size, and there is a report of river crossings on gourd rafts, propelled by four swimming men; at least one Moche vessel depicts such a raft, with a human man on the raft.[62] Moche gods and people are normally shown traveling at sea in rafts made of bundles of reeds. Similar reed rafts are still made today at the seaside. Owl images, often with military connotations, are found among the offerings buried in guano on the offshore islands, which were the site of sacrificial rituals, sea lion hunting, and guano collecting and also served as fishing stations.[63] The owl shown on a raft on a pot illustrated here may have symbolized the conquest of a new valley or depicted part of a water myth.

**Figure 61**

White quartz mace head, harpy eagle or owl head. Costa Rica, Nicoya Peninsula, Las Huacas. 300 B.C.–A.D. 500. H. 7.5, W. 8.3, D. 12 cm. Carnegie Museum of Natural History 2793-80 (C. V. Hartman expedition, 1903).

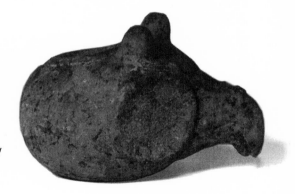

The Moche warrior owl—or a similar owl—is also the main sacrificer of war captives.[64] This anthropomorphic figure is shown in supernaturally large size, either decapitating a small human captive or holding a knife and a trophy head. The owl can be pictured enthroned or standing on a stepped platform; only important figures are shown on raised surfaces. In some instances where this owl is not on a platform, he is clearly a man wearing an owl mask. This is the only instance in which a Moche potter clearly showed that the figure is a man imitating another order of animal. (Barn owls naturally look as if they were wearing a mask.) Moreover, the imitator holds only the head, not the sacrificial knife. He is not the sacrificer; he is only imitating him. The Moche tend not to show themselves as sacrificers but to leave such a deed to a supernatural.

The owl sacrificers at Sipán are presumably all deity-faced, human-bodied spiders, but they wear owl necklaces and an owl head on the headdress.[65]

Moche owls have many roles. Probably no other creature in Moche art is shown so variously. There are naturalistic depictions of barn owls (Tytonidae) or typical owls (Strigidae) (fig. 62).[66] Sometimes a large, mostly naturalistic owl apparently carries a small sacrificial victim to the otherworld (fig. 63); this owl has human hands holding the rope that attaches the victim to its back. It is probably the burrowing owl (*Speotyto cunicularia*), which is found throughout the Western Hemisphere and is depicted often in Moche art. Another owl common in the Pre-Columbian region is the spectacled owl (*Pulsatrix perspicillata*). Anthropomorphic owls can be shamans or curers; sometimes they are women. This owl (fig. 64; Strigidae) wears a scarf, which may contain seeds or divinatory material and holds a staff or digging stick.

Owls have been prominent symbolic motifs from the earliest Moche times and even back into the Chavín/Cupisnique period. A stirrup-spout vessel from that period is composed of four owl heads that seem to refer to the four world directions (fig. 65).

Owls are widely associated with death and presagings of death.[67] The Maya related the nocturnal bird to underworld gods, one of whom wears an owl-like bird on his headdress. (This is the god whose clothing was confiscated by a rabbit.) In the Popol Vuh, owls are messengers of the underworld lords, inviting the Hero Twins to play ball.[68] The owl's mys-

**Figure 62**

Ceramic vessel, pair of realistic owls. Peru, north coast, lower Santa Valley. Moche, A.D. 300–500. H. 23, W. 13, D. 16.5 cm. University of Pennsylvania Museum, Philadelphia, 34296 (Max Uhle expedition, 1897).

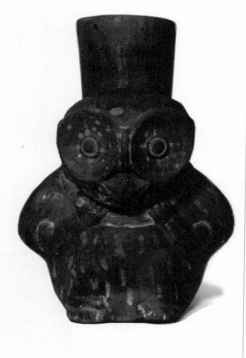

**Figure 63**

Ceramic vessel, largely realistic owl (Strigidae) with hands holding a cord at the neck. Peru, north coast. Moche, A.D. 200–500. H. 24, W. 16.5, D. 16 cm. Carnegie Museum of Natural History 4291-674.

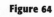

**Figure 64**

Ceramic vessel, anthropomorphic owl (Strigidae) with capelike wings. Peru, north coast. Moche, A.D. 300–500. H. 23.3, W. 16, D. 16.5 cm. Carnegie Museum of Natural History 4291-680.

**Figure 65**

Ceramic vessel with four owl heads. Peru, north coast, probably Chicama Valley. Cupisnique, 1500–1000 B.C. H. 185, D. 17 cm. University of Pennsylvania Museum, Philadelphia, 54-19-1.

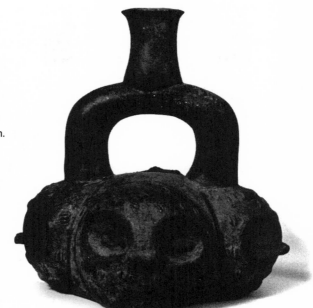

terious nocturnal call, its marvelous night vision, and its ability as a swift-flying predator in darkness reinforce its roles as harbinger of death, warrior, sacrificer, and bearer of the sacrificed to the otherworld.

Owls live in very varied environments. Many can live in a desert if there is some nearby water source. Some hunt diurnally as well as nocturnally. Most eat small mammals and birds, lizards and snakes.

In Maya art the owl depictions appear to be the great horned owl (*Bubo virginianus*) and the screech owl (*Otus guatemalae*), but the owl usually found offered in caches is the ferruginous pygmy owl (*Glaucidium brasilianum*).[69]

Vultures are aerodynamically the best of the soaring land birds, riding majestically on air currents, rising on thermals, then gliding.[70] They are related to eagles. On the ground, vultures are important to human health. Where there is no plumbing, they provide sanitation services.

Cleaning the earth of rotting flesh and excrement, they consume and transform death and waste. In a Maya narrative, a black vulture describes himself as a mason who spreads lime to plaster the houses and make them white and beautiful.[71] Vultures are much more positively thought of elsewhere in the world than they are in our culture.

Latin America has black vultures (*Coragyps atratus*) and turkey vultures (*Cathartes aura*). The name *Cathartes* has the same root as "catharsis." Some of these birds migrate from the United States; some belong to year-round populations. (Turkey vultures breed from Canada to Tierra del Fuego.) There are also yellow-headed vultures with a more limited range. The large and showy king vulture (*Sarcoramphus papa*) has a wattled, multicolored head on a mostly white body. It is a resident bird within its range, where it is the *king* of the vultures. Lesser vultures defer to it at feeding time. It figures widely in myth.

Condors are the biggest birds of prey in the world. They take food alive and dead. (Lesser vultures have feet that are too weak to attack and hold most live prey.) Like the California condor, the superb Andean condor (*Vultur gryphus*) has a 10-foot wingspan and a white neck ruff like a regal ermine collar. The Andean condor roosts and breeds at 10,000 feet and upward, but it may fly from the high mountains to the seacoast for a meal. It is a highly symbolic bird.

Vultures' eating habits give them a natural connection with the world of the dead, and they sometimes play dead when injured or cornered. Vulture remains were placed in elite Pre-Columbian burials and caches. In an Early Classic cache at the Maya city of Tikal, the remains of four king vultures were found; a macaw had been placed with them.[72] Together they made a cosmic diagram, with the macaw perhaps representing the sun. Vulture burials have also been found at the Moche site of Pacatnamu.[73]

Since ca. 2500 B.C. condors have been a frequent theme in Andean art; they appear on textiles of that date from the north coast of Peru, the finest early examples of the textile art.[74] A much later textile from Pachacamac combines condors and vultures with snakes and monkeys (fig. 9). Lesser vultures are as prominent as condors, particularly on the coast. The cast-gold "eagle" pendants of Central America and Colombia, which attracted the attention of Christopher Columbus, probably depict vul-

tures.[75] In Central America and in the Maya region, small sculpture was carved from *copal* resin. One of these is a vulture from Sitio Conte, Panama, the site of a number of very rich burials with gold objects, dating before A.D. 1000 (fig. 66).[76] Veracruz sculpture that is related to the ritual ball game often depicts a vulture.[77] Important people wore vulture headdresses—Maya kings and the supernatural iguana companion of the major Moche god.[78] A Maya ruler may have a vulture perched on his elaborately feathered backrack, a kind of costume cosmogram of the ruler's supernatural attributes.[79]

Vultures appropriately adorn Peruvian knives used in ritual sacrifice. An Inca knife, or *tumi*, has two vultures on one side and a condor on the other; they peck on a supine human body (fig. 67). A condor or lesser vulture pecking at a human body is a common Moche variation; sometimes the body attacked is that of a god.[80] Nasca vessels sometimes show a condor with a human leg protruding from its mouth. Some Moche pots show an anthropomorphic vulture or vultures supporting a dead figure, often that of the major god, who is possibly being led to the underworld or being resuscitated.[81] The god may also be accompanied by a woman or by his iguana companion as well as a vulture. The birds in figure 68 do not look vulturine, but a number of examples of this theme show vultures, and probably no other bird plays this role.

Vultures take major roles in myth and art. Origin myths from the Maya area down into the Gran Chaco tell of a hero who hides under an

**Figure 66**

Carved resin vulture. Panama, Coclé Province, Sitio Conte. Coclé style, A.D. 500–900. H. 6.5, W. 4.5, D. 6 cm. University of Pennsylvania Museum, Philadelphia, 40-13-605 (J. Alden Mason expedition, 1940).

animal skin to attract the vulture in order to acquire the moon, the day, or fire—something bright—of which the vulture is the keeper.[82] In a Maya version, the hero, who was to become the sun, rode on a vulture to bring back his moon-wife, who had eloped with the king vulture. This myth probably diagrams a sky event, with the vultures having astronomical identity. In a Barasana myth from Colombia, the first man was the son of the primal sun and jaguar woman.[83] His wife was a big anaconda who bred fishes in her body. She sloughed off one skin and became a boa, sloughed off another and became a woman. She then eloped with the vulture chief. It is hard for us to imagine vultures as sexually attractive, but mythic vultures often become beautiful women, and human women often elope with a vulture.

Other Maya narratives tell of a lazy farmer who trades places with a vulture; the vulture then goes home to the farmer's wife.[84] In South American narratives various animals hitch a ride on a vulture—especially a condor—or the vulture teaches them to fly; the flight usually

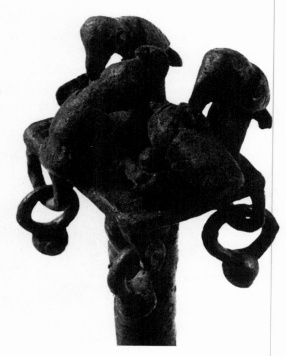

**Figure 67**

Bronze knife, or *tumi,* with loop danglers. Peru. Inca, A.D. 1200–1500. H. 16.5, W. 15, D. 3 cm. University of Pennsylvania Museum, Philadelphia, SA 2497.

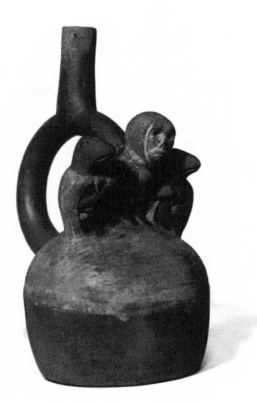

**Figure 68**

Ceramic vessel with caped birds supporting a skeletal figure. Peru, north coast. Moche, A.D. 300–500. H. 24, W. 11.5, D. 16.5 cm. Carnegie Museum of Natural History 4291-655.

ends in disaster and often results in the origin of agriculture.[85] Sometimes a culture hero rides to the sky on a vulture.

In many places in Latin America, especially Mesoamerica, fields are slashed and burned between reaping and planting. Vultures are associated with agriculture because they circle the burning fields to find groggy animals caught in the smoke and fires. (Vultures like fresh meat when they can take it.) Sometimes vultures are depicted with vegetation; two condors fly above a row of a vegetable, *pepino,* on a Nasca vase (fig. 69). Vultures are related to fire as well as agriculture in the Maya area and in lowland South America. In folklore the vulture is often the keeper of fire. Since the field burning occurs just before the rains begin, the vulture is associated also with water and rain.

The much depicted Principal Bird Deity of the Maya has vulture traits; it may well be based on the king vulture. This image, which ap-

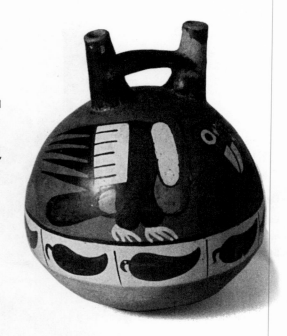

**Figure 69**

Polychrome ceramic vessel
with two condors. Peru,
south coast, Nasca district.
Nasca, A.D. 100–300. H. 21,
D. 17 cm. University of
Pennsylvania Museum,
Philadelphia, SA 2914
(William C. Farabee
expedition, 1922–23).

pears extensively in Maya art, probably represents a bird character of the
Popol Vuh who set himself up as a false sun at the beginning of time and
was defeated by the Hero Twins.[86] His name was Seven Macaw, and he is
the ancestor of scarlet macaws, but his appearance in Classic Maya art is
complex and partly vulturine. The image was important in Classic times,
for it appears at the top of most renderings of the World Tree. A similar
image is depicted on Zapotec urns from Oaxaca.

In nature, vultures of this hemisphere perform a courtship dance.
There is a long tradition of human vulture dances at fiestas in the Andes.[87]
Men with vulture headdresses appear in Classic Maya vase scenes with
dancing, music, sacrifice, and ball playing.[88] In Costa Rica the principal
god of the Cabecar people, Sibu, or Sibö, took the form of an anthropo-
morphic vulture to teach people what they needed to know to be civi-
lized.[89] He gave the people seeds to plant and taught them how to form
clans and how to dance.

# 7    Amphibians and Reptiles

Amphibians and reptiles are common Pre-Columbian animal images, symbolizing the earth or watery environments on earth; sometimes they signify rain and sky. Amphibians require water for reproduction and for other purposes.[1] A tadpole is fishlike; it undergoes transformation to become an adult. Frogs, which are more agile than toads, are also more water-dependent, although toad skin, too, desiccates in a dry environment. Toads are rougher-skinned than frogs, but they do not cause warts on humans, as North American folklore would have us believe.

Anurans—frogs and toads—were affiliated with the Aztec rain and storm god, Tlaloc; stone toad sculptures were placed on an altar on the Tlaloc side of the Great Temple, the large double pyramid in the sacred complex of the Aztec capital, Tenochtitlan.[2] Frogs, which croak after heavy rains, were especially associated with plants and agriculture— which also require water. Modern Maya rain-invoking rites include boys imitating frogs.[3] Frogs are the musicians, the voice, of the Maya rain god, Chac. Moche ceramic frog depictions often have vegetation painted on them (fig. 70). Frogs are sometimes portrayed in jade or other green stone, appropriate to their coloration and their associations with leafy habitats and water. The role of frogs and toads as water creatures is prominent in their frequent appearance in myth.[4]

Like many water-related creatures, frogs and toads appear also in myths about man's acquisition of fire.[5] They are the keepers, carriers, or donors of fire; sometimes they squirt water on a fire to put it out. All amphibians have some fire within, for they produce toxins. Some toxins are mild; others among the most powerful poisons known. Diurnal,

**Figure 70**

Ceramic vessel, effigy frog
or toad with vegetation.
Peru, north coast. Moche,
A.D. 300–500. H. 22.5,
W. 14, L. 22 cm. Uni-
versity of Pennsylvania
Museum, Philadelphia,
34416 (Max Uhle
expedition, 1986).

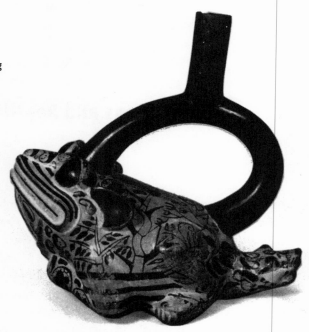

bright-colored *Dendrobates* and *Phyllobates* are frog genera from which
the Choco of Panama and Colombia and other indigenous hunters take
venom—dart or arrow poison—for fishing and hunting.[6] These frogs,
along with certain species of *Bufo* (fig. 71), a widespread toad genus, are
the most toxic.[7]

The American toad (*B. americanus*), the common toad east of the
Rocky Mountains in this country, is less toxic than some but can cause
central nervous system disorder in a dog who eats it. One of the most
toxic species is the largest Neotropical anuran, the marine or giant toad,
*B. marinus,* whose range now extends from central Brazil up into Florida.
This chiefly nocturnal toad appears at dusk near human habitations. It is
not at all aggressive, but a dog who bites into its parotid gland may die
within a few hours. A psychoactive drug can be made from the toxin of
this toad. Its manufacture may have been accomplished for ritual use, ca.
1000 B.C., by the Olmec on the Gulf Coast of Mexico, who left in their
middens many remains of this toad.[8] Other peoples may also have done

this. Four *Bufo* specimens were among offerings in the Aztec Great Temple.[9] Classic Maya depictions of the giant toad display, on the back, an image known as God C, which signified sacredness.[10]

Many cast-gold or *tumbaga* toad and frog effigies from the Intermediate Area escaped Spanish gold-melting ovens (figs. 72 and 73). These are usually pendants or beads, which often have a bifid tongue or a double-headed snake curving from the mouth.[11] Their tails may end in snake heads, as do some ceramic examples (fig. 70). Today there is a belief in Colombia that certain lakes in the northern highlands contain pure gold frogs and lizards. This may derive from past offerings of cast-gold objects to the lake, although in nature there are gold or other brightly colored frogs; these often have a strong toxin.[12] Many frogs have "flash colors" of bright red, yellow, or orange that are concealed when the frog is at rest and revealed in a gleam as a protective device to startle a predator. These flashing colors may enhance the fire connotation.

Their water relationship gives anurans earth and underworld relevance. Tlaltecuhtli, an Aztec earth deity or personified earth, is a compound monster that sometimes seems toadlike, sometimes reptilian.[13] In South American folklore, a frog's croaking can foreshadow death and the journey to the underworld.[14] The voices of anurans surely had many meanings.

Anurans were also used for medicine and magic, as they have been used in folk medicine and witchcraft in Europe and Asia.[15] And, as in

**Figure 71**

Utatlan ware vessel, toad, incised and painted red and black. Guatemala, highlands. Late Post-Classic Maya, A.D. 1250–1500. H. 10.5, W. 13, L. 15 cm. University of Pennsylvania Museum, Philadelphia, 12653.

**Figure 72**

Cast-gold frog with bifid tongue extension; two loops for suspension. Panama, Veraguas Province. A.D. 700–1500. H. 6.8, W. 4, D. 3 cm. University of Pennsylvania Museum, Philadelphia, SA 2901.

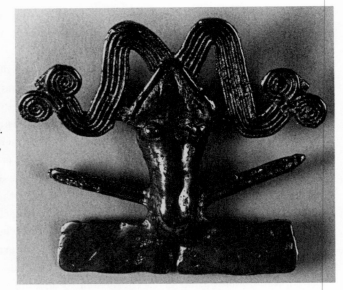

**Figure 73**

Cast-gold frog with double-headed snake in mouth; two hooks for suspension. Costa Rica, Diquís Peninsula. A.D. 700–1500. H. 6, W. 4.8, D. 1.5 cm. University of Pennsylvania Museum, Philadelphia, SA 2902.

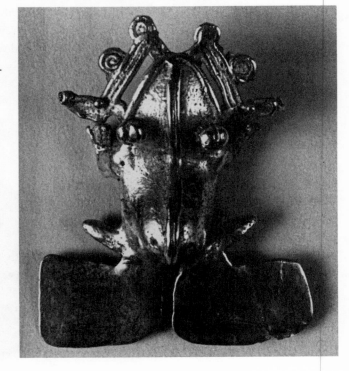

European fairy tales, people turn into frogs, and frogs turn into people. In the Neotropics, the frog is often an old woman who appears in myths with male twins or brothers.[16]

Many cultures believed that the earth rested on the back of a giant turtle or crocodilian floating in the cosmic sea. Both creatures can move on land and on sea. Both have surfaces that resemble rugged landscapes and relief maps. Both crocodilian and turtle remains have been excavated in Classic Maya burials and caches. Many Pre-Columbian groups pictured such an earth god or cosmic monster. Sometimes the monster holds up the earth, sometimes the sky; sometimes the image represents both earth and sky.

In the Codex Madrid (page 19), five gods are letting blood over a turtle altar, as if nourishing the earth with their blood, as humans do in some rites. Maya ceramic plates show a young lord emerging from a cracked turtle carapace; he is the maize god rising from the underworld, as the maize plant pushes up through the earth.[17] As the mythic First Father, he is reborn through the cracked carapace of a giant turtle that symbolizes the earth. A text on a sculpture at the Maya site of Quiriguá, Guatemala, states that the main event of the creation "was the appearance of this turtle shell,"[18] which may be a metaphor for earth, but it has astronomical meaning as well. Turtle is a constellation, perhaps Orion or Gemini.[19] A turtle with star signs on it appears in the sky level of the murals at Bonampak. Turtles live in and are symbols of earth and water, but they can also become sky beings.

Mythical "flying turtles" appear in the sky above ancestor portraits on Zapotec relief monuments and a tomb wall in Oaxaca. One of the earliest examples of these "cloud-ancestor" turtles is found on a panel dating to Monte Albán IV.[20] In the sixteenth century, later Zapotec people apparently saw the clouds from which their ancestors had descended as flying turtles. The sky turtles may also refer to storm and thunder.[21] In the Mixtec Codex Nuttall (page 19), a flying "Turtle Sacrificer" from Oaxaca has a half-masked human face and a turtle body and holds a sacrificial knife in each hand.[22] The turtle is a motif also in Mixtec gold work, in necklace beads with bells attached.[23]

Late Classic Maya stone altars at Copán and Itzimte are sometimes

made in the form of a turtle. The ruler portrayed on Stela C at Copán stands behind a two-headed turtle altar so that, from a certain view, it looks as if he were standing on the turtle altar. Certain Aztec gods sat on turtle seats. Stone turtles were a common sculptural form in the Post-Classic Yucatec city of Mayapan; turtles may have been considered ancestral to the Maya there.[24]

Given the associations with earth, burials, and ancestors, it is not surprising that the Lacandon Maya believe that a dream of a turtle signifies a stone seen when one is digging a grave.[25]

There are sea turtles, river turtles, pond turtles, mud turtles, and land turtles (tortoises) throughout Latin America.[26] The turtle's shell is both a portable house and a suit of armor. Turtle carapaces resemble rocks, which are often believed to be sacred. Carapace designs suggest cosmic diagrams to some peoples—the Desana, for example.[27] Shells of mud turtles and slider turtles were encountered in Aztec offerings in the Great Temple.[28] The Mexican red or painted wood turtle (*Rhinoclemmys pulcherrima*), a fairly terrestrial slider, has a reputation as one of the world's most beautiful turtles. In the wet season it can be seen moving brightly in marshes, fields, and woodlands; it is not seen in the dry season.

Turtles, like anurans, are generally water-dependent and so connote fertility and abundance. In the Codex Madrid (page 17) a turtle stands in the rain; and in Codex Dresden (page 37) a god in a turtle shell is shown in the rain. Archaeological remains of actual turtles have been found in Yucatán as offerings to the sinkholes—*cenotes*—in the limestone that have long been precious water sources for the Maya of the riverless northern region.[29]

Turtle and turtle eggs have traditionally been delicacy food. Remains of seven species of turtle were found in Olmec deposits at San Lorenzo, and turtle was found also in Maya sites.[30] Predation by man and other animals for food is one of the reasons that many turtle populations, especially those of sea turtles, are endangered. The green turtle (*Chelonia mydas*) is a well-known edible turtle with seriously declining populations. Commercial use of the shell has caused population decline in the hawksbill turtle (*Eretmochelys imbricata*), a sea turtle that is the source of tortoiseshell.

Turtle shells were used as musical instruments in the past, struck as a

drum with a stick or an antler in a way that may have imitated thunder. Musicians with turtle shells are presented in the Bonampak murals.[31] The instruments may have been played in funerary processions and then deposited in the grave. Turtle shells, often with a hole drilled for a cord, have been found in Maya tombs and in Aztec offering caches. Turtle shell drums, struck with maize cobs, are used today by the Tzotzil Maya; the turtle shell is the earth lord's musical instrument.[32] Turtles also lent their form to ocarinas. The one in figure 74 has a monkeylike face under the shell.

The turtle is a rare motif in the art of the Central Andes. It was not part of either the landscape or the major iconographic structure. A Chancay ceramic urn from the central coast of Peru, however, presents a figure that appears to be a humanized turtle resting atop the vessel (fig. 75). The Chancay urn might well depict the earth floating atop the cosmic sea, or perhaps a sky turtle.

A monument in Peru, from the early Chavín culture, is incised with a cosmic diagram in the form of a double caiman.[33] A male underworld god, identified by the edible root or tuber crops that surround it, is carved on one side; a female sky deity, with fruits that grow above ground, is depicted on the other. These symbolized human sustenance, the "gifts of the caiman." In a complicated composition, serpents and a shell adorn the first side, an eagle the second.

The very early Maya pictured the World Tree growing from a crocodilian on a stela from Izapa, on the Pacific coast of southern Mexico.[34] The carving on the top of Altar T at Copán shows a spread-out caiman.[35]

**Figure 74**

Ceramic ocarina, turtle; two loops for suspension. Costa Rica, Nicoya Peninsula, Las Huacas. 300 B.C.–A.D. 500. H. 3.6, W. 5.5, D. 7 cm. Carnegie Museum of Natural History 2438-2058.

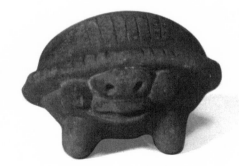

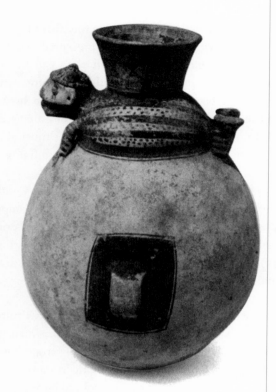

**Figure 75**

Ceramic vessel with turtle-
man on top. Peru, central
coast. Chancay, A.D. 900–
1400. H. 28, D. 21.5 cm.
Florida Museum of Natural
History, University of
Florida, 102227.

At Tikal, Guatemala, skeletons of crocodilians were found in two caches and a tomb.[36] In Central Mexico the Aztec associated crocodilians with Tlaloc, and crocodilian remains have been excavated in the Great Temple, usually on the Tlaloc side of the structure; a crocodile skull was found in one offering there.[37] These animals would have been brought from the lowlands. Their ability to live on land and in water surely gives them special significance as cosmic monsters.

A small ceramic composition from the Nicoya Peninsula, Costa Rica, may picture a similar theme (fig. 76).[38] A large figure, holding a small one, is seated on a bench that has at either end an apparent crocodilian head with a long, stylized snout. This probably portrays a godly figure of supernatural size—the face does not look human—although it may depict an important mortal holding a child and seated on an earth-monster throne. A ceramic bowl in the form of a caiman or crocodile may also express the earth-monster concept (fig. 77).

In Latin America there are crocodiles (several species of *Crocodylus*), generally brackish-water creatures, and several genera of caimans, which prefer fresh water.[39] Although "alligators" are referred to in many writings, there are no alligator species in Latin America. The American crocodile (*C. acutus*) is about 12 feet long; the black caiman (*Melanosuchus niger*) can be more than 20 feet long. These are impressive predators who will eat virtually anything; their consumption of human beings is rather rare, although Sahagún did write, "It is a swallower of things, of people whole."[40] Various Pre-Columbian images show a crocodilian with the remains of a human in its mouth.[41] A caiman can rest in a river, absolutely still, like a log, then suddenly charge to the bank for its prey. Crocodilians usually kill prey by drowning, a significant trait in a belief system in which water leads to the underworld. A caiman can kill a jaguar if the jaguar attacks it. Any animal that can kill a jaguar earns respect from man and other animals.

Crocodilians have existed on earth in more or less their present form for some two hundred million years. They are the last survivors of the giant reptiles that once dominated the planet. But because of modern methods of hunting and habitat destruction, the species are largely endangered.

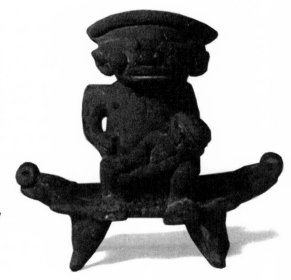

**Figure 76**

Ceramic (Guinea Incised ware) figure seated on a crocodilian throne and holding a small figure. Costa Rica, Nicoya Peninsula, Las Huacas, Burial VIII. 300 B.C.–A.D. 500. H. 10.6, W. 10.3, D. 7.1 cm. Carnegie Museum of Natural History 2793-19 (C. V. Hartman expedition, 1903).

**Figure 77**

Ceramic bowl, caiman
or crocodile. Costa Rica,
Nicoya Peninsula, Las
Huacas. 300 B.C.–A.D. 500.
H. 4, W. 6.6, D. 11 cm.
Carnegie Museum of
Natural History 2438-2034.

In the Popol Vuh a crocodilian monster claimed to be the maker of
mountains and the creator of the world.[42] (He was the son of the bird
monster who claimed to be the sun.) Itzamna, the chief god of the Maya
pantheon, appears in caiman guise, or in the mouth of the earth caiman,
in the Codex Dresden (pages 4–5). His name has been thought to derive
from a word for caiman, iguana, or lizard, and his avatar has often been
called an iguana rather than a caiman.

It is often difficult to tell whether a crocodilian, an iguana, or a lizard
is being depicted in Pre-Columbian art, and the mythology also confuses
the orders. Iguanas can be transformed to lizards or to crocodilians, or
crocodilians can produce iguanas or lizards.[43] Snakes can be progenitors
of fish; an iguana had a snake for a mother; a crocodilian had a fish for a
daughter.[44] In one narrative a woman who was previously a fish per-
suaded her crocodilian father to bring cultivated foods to the village
where she was living, because it had none. Thus agriculture was begun.
There were indigenous taxonomies, but they were not Linnaean. Prob-
ably many of us share similar confusion: we know that these animals
belong to different orders, but we tend to mix and group them, not al-
ways properly. In ancient art, even when the depiction is quite clear, rep-
tiles are often paired—lizards and snakes, for example. A Moche vase
alternates lizards and snakes (fig. 78).

**Figure 78**

Ceramic vessel with alternating snakes and lizards. Peru, north coast. Moche, A.D. 300–500.
H. 25.5, D. 16.5 cm. University of Pennsylvania Museum, Philadelphia, L-83-1402, on loan
from American Philosophical Society.

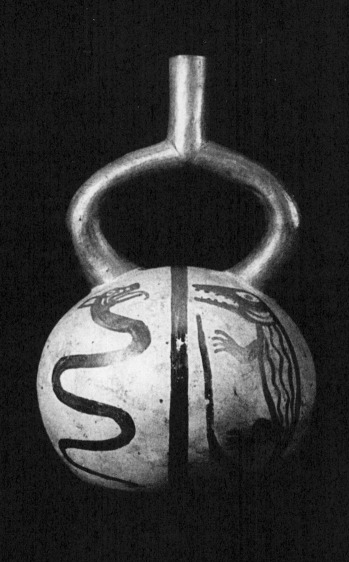

In nature, lizards and iguanas are closely related. Some iguanas and lizards climb trees and stretch out on limbs; some inhabit burrows and crevices; others live at the edge of the sea. They are associated with all levels of the world. Many lizards change color to blend with their backgrounds. Their behavior is highly symbolic. They are important for practical reasons as well. Iguanas are hunted and eaten today by Maya, Cuna, and other groups, and it was surely so in the past.

The common iguana (*Iguana iguana*), which can grow to about 6 feet long, has an eerie resemblance to man in its limbs and "hands." In Moche art an anthropomorphic iguana is a companion of the major god; the iguana is always watching the god, appearing to be applauding him. This iguana, who wears a vulture headdress, was surely a well-known character with a name and a role in various narratives. In Cuna myth, from Panama, Iguana-Chief was a powerful man who challenged the solar culture hero and was defeated.[45] One wonders if the deference shown by the Moche iguana to his god comes from a similar myth. Lizards also appear in Moche art (fig. 79).

The basilisk (*Basiliscus basiliscus*), an elaborately crested, large Central American lizard, can run across the surface of still water.[46] It has very large hind feet with something like webbing between the digits, and it can run very fast. This ability enables it to capture prey and to escape predators. It has been argued that this species is the source of a mythic being depicted in Panamanian art, often called a crocodile god.[47] Basilisks, iguanas, and crocodilians are all in the Panamanian environment, the folklore, and the art, but since they are rarely represented realistically and their traits are often combined with those of other creatures, including man, it is not easy to sort them out. They are more easily distinguished in Moche art, where they are treated in more direct ways.

While it is often the larger and more impressive reptiles who figure in iconography, a small tree lizard (*Plica plica*) is the Master of Animals in the Vaupés region of northwest Amazonia.[48]

Two-headed monsters, double-headed dragons, bicephalic serpents—these are some of the terms used for Pre-Columbian motifs that combine elements of crocodilian, iguanid, snake, and often other animals—

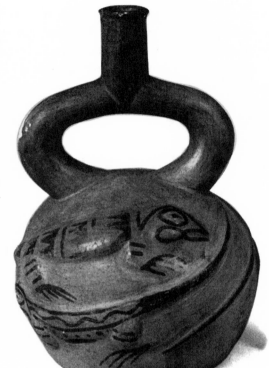

**Figure 79**

Ceramic vessel with low-relief lizards. Peru, north coast. Moche, A.D. 200–300. H. 22, D. 15.5 cm. University of Pennsylvania Museum, Philadelphia, 39-20-59.

many of them are horned.[49] These creatures are especially prominent in Mesoamerica and particularly common in Classic Maya art.

Like other reptiles, snakes can be metaphors for the cosmos and guardians of sacred space. A ruler may be depicted inside, or emerging from, a reptilian monster to show that he exists within the supernatural world as well as in the natural one. Olmec rulers can be encased in such a creature.[50] Maya lords are often portrayed inhabiting cosmic monsters: on Tikal Altar 12 a ruler sits in the mouth of an elaborate reptilian monster; on Yaxchilan lintels, rulers are shown inside a cosmic ophidian.[51] The bloodletting ritual performed by Maya and Olmec rulers evoked a sacred ancestor enclosed in a divine serpent. In a variation on this theme, several monuments at Quiriguá portray a ruler enclosed in a turtlelike or froglike cosmic creature.[52]

Snakes and other reptiles can define the environment of a scene. Maya building facades may resemble faces of reptilian monsters.[53] The doorway is the mouth leading into sacred space. The people of Teotihuacan, the Toltec, and the Aztec closed off sacred spaces with serpent walls; temple staircases were marked with snake columns and balustrades (usually feathered for sky connotations).[54] The murals of Cacaxtla and Teotihuacan sometimes have serpent borders that frame murals of revered images.[55]

Snakes carved on a large Inca stone bowl may define its interior as sacred space (fig. 80). The snakes give notice that the object should not be used casually. (Indeed, its weight alone would preclude such use.) All effigy snake vessels may have been used in special rites, by certain groups, or in a certain type of burial (fig. 81). The same may be true for containers with snakes painted on the outside (fig. 82) or with projecting serpent heads.

The word for snake and the word for sky are often homonyms in Maya languages. In mythic and ritual scenes of many Pre-Columbian peoples, a double-headed serpent can be a sky band, which defines a sky phenomenon or marks off the space between two worlds. The sky band can represent the Milky Way or the change between the middleworld (earth) and the upperworld (sky). It has been argued that a mythic snake known as the Chicchan Serpent is depicted in the Codex Madrid as the Pleiades.[56]

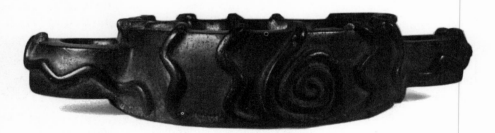

**Figure 80**

Stone bowl with serpents. Peru. Inca, A.D. 1300–1500. H. 12, W. 41, L. 66 cm. University of Pennsylvania Museum, Philadelphia, SA 4681.

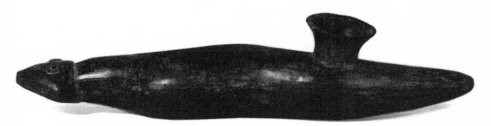

**Figure 81**

Black ware snake-effigy vessel. Peru, north coast, Tutumi or Muchimu, near Lambayeque. Sican (Lambayeque), H. 9, W. 9, L. 40 cm. University of Pennsylvania Museum, Philadelphia, 34751 (Max Uhle expedition, 1897).

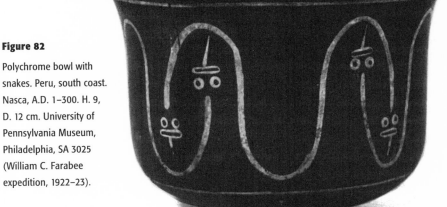

**Figure 82**

Polychrome bowl with snakes. Peru, south coast. Nasca, A.D. 1–300. H. 9, D. 12 cm. University of Pennsylvania Museum, Philadelphia, SA 3025 (William C. Farabee expedition, 1922–23).

On Maya monuments, some rulers hold in both hands an object like a sky band. It is a staff of office, a ceremonial bar that may end in serpent heads.[57] It probably derived from a snake; a few early versions curve or twist, as real snakes do.[58] Some Maya gods, notably the rain god and the creator god, hold in one hand a serpent staff.[59] The Aztec had a similar carved rod, like a serpent scepter, which mythic beings sometimes held.[60]

In the Andes also, at Chavín and at Tiahuanaco, in Bolivia, deities hold serpent staffs; moreover, serpents may emerge from the heads of the gods, or snakes may serve as hair.[61] The cord on the end of a Moche sacrificial knife ends in a snake head. Chavín, Paracas, and Moche gods, as well as a ruler from Oaxaca, wear a "belt" with snake-headed extensions.[62] In painting and sculpture, streams of blood can also end in snake heads.[63] In ball court sculpture in Mexico, blood spurts from the necks of decapitated ball players and turns into snakes amid flowering vegetation. Hair and blood symbolize vitality, and snakes are metaphors for them.

A Chimú globular vessel has a head that looks human, but its hair ends in snake heads in the back (fig. 83). In the front, a snake comes down at either side from the headdress flaps. The shoulders are modeled like mountains, and a long two-headed snake curves through them. This is not an ordinary mortal but a personification of some aspect of nature.

An Aztec earth goddess, Coatlicue ("She of the Serpent Skirt"), who gave birth to the Aztec solar god, Huitzilopochtli, had a head composed of two serpent heads and a skirt of woven snakes.[64] The rattlesnake was her symbol.

Some mythic characters have a snake foot. A Tairona figure, carved from bone, is seated on a throne (fig. 1). It has a human body; its head is probably inspired by that of a crocodilian; it has a snake foot. The most famous snake-footed personage is Tezcatlipoca, the Aztec god of rulers, warriors, and sorcerers.[65] Tezcatlipoca lost his foot while battling the earth monster. The Maya god of rulership (God K) also has a snake foot.[66]

Snakes have many symbolic qualities. They stand for regeneration because they shed their dead skins and appear fresh and new-looking. They represent the life-giving energy of the earth that produces new growth. Some snakes are green; some are earth-colored. Some live in caves and crevices; some climb trees and disappear in foliage. Most can swim. They slither under surface cover. They move between worlds in

**Figure 83**

Ceramic globular vessel with a
spout that is a human head;
snake heads on the body. Peru,
north coast, Piura area. Chimú,
A.D. 900–1400. H. 36, D. 28 cm.
Florida Museum of Natural
History, University of
Florida, 102231.

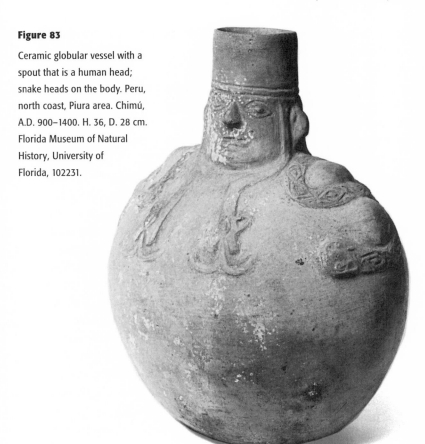

distinctive ways. Their undulating bodies can symbolize water; they look like rivers. They are associated with moving water, caves, and sky.[67] In Peru, Amaru is a serpentiform male spirit who lives at the entrance to the mountains and grows to maturity in caves.[68] Caves are sacred places, sometimes sources of water.

In the Huasteca, in eastern Mexico, people throw rocks into water during heavy rains to keep water snakes down because, when water snakes rise to the sky, they cause cloudbursts and landslides.[69] A goddess in the Maya codices wears a snake headdress when she is watering the earth. The Chorti Maya believe in an immense snake that produces rain.

It symbolizes both earthly and celestial fertility. The rainbow is its body; the thunder is its roar. Lightning is a snake in many narratives, and a rainbow is often a snake.[70]

For many reasons, snakes have shamanic status. Their ability to swallow their prey whole may have caught the interested attention of ancient peoples, as well as the fact that some nonpoisonous snakes protect themselves by having the coloration of venomous snakes. Snakes have many anomalies.

Snakes can be death-dealing, which gives them special power.[71] Pit vipers are venomous predators. Most of the twenty-six species of *Crotalus* rattlesnakes are found in Mexico. The tropical rattlesnake, or cascabel (*C. durissus*), appears intermittently from Mexico to Brazil and Paraguay. The genus *Bothrops*, lanceheads, are venomous predators with thirty-one species of varying habits in a wide distribution, mostly in South America; *B. asper* is the Mexican–Central American species. The deadly bushmaster (*Lachesis muta*), in Central America and northern South America, is the only member of its genus and the world's longest viper, normally more than 2 meters in length. There are also less venomous coral snakes (*Micrurus*), with fifty species distributed over Latin America. Anacondas (*Eunectes*) are huge constrictors that take their prey in a tight embrace. Boas and other large constrictors abound.

A snake is one of the animals in the Moche repertoire of anthropomorphic-animal warriors (fig. 84). It has proper attributes for a warrior.

Dances with snakes have been performed in recent times by Maya in highland Guatemala. They were also performed in the sixteenth century and surely back in Classic times.[72] Late Classic vase scenes show snakes wrapped like boas around the shoulders of certain mythic beings.[73] The snakes are suspended supernaturally, but they suggest the art of snake handling. The sheet-gold Nasca object with projecting snakes was probably a dance wand (fig. 85). It may have been used in ritual dances with or without real snakes. Because the metal is thin on the edges, it would have wavered and shimmered in torchlight, or even in sunlight, so that the snakes would be seen moving.

In art, a snake can appear as a major motif or a minor one. It may be a single motif, but it is more likely to be shown with another figure or as an attribute of a god or accessory of a ruler.

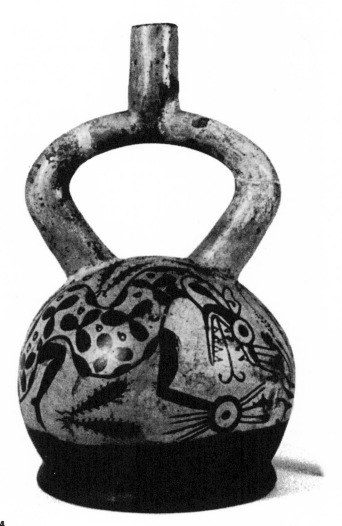

**Figure 84**

Ceramic vessel with two painted snakes with weapons; cacti and tillandsia in scene. Peru, north coast. Moche, A.D. 300–500. H. 17, D. 16 cm. University of Pennsylvania Museum, Philadelphia, 51-14-2.

A feathered serpent is an ancient motif in Central Mexico. It is per-
haps itself a cosmic diagram of earth and sky. It is also a diagram of evo-
lution, for reptilian scales did eventually evolve to feathers. The great
Toltec god-king was Quetzalcoatl, "Quetzal-Feathered Serpent." He was
a Venus god, whom the Aztec took over as the patron deity of their
priesthood.[74] Many Aztec sculptures depict rattlesnakes or feathered
snakes with rattler tails.[75] Architectural sculpture at the pre-Aztec Cen-
tral Mexican site of Xochicalco is dominated by a feathered snake.[76] In
the Popol Vuh, Sovereign Plumed Serpent was one of the gods in the
primordial sea who joined with sky gods to create the Quiche Maya cos-
mos at the beginning of time.[77]

Sahagún depicts more snakes than any other animal. In the midst of a
page of recognizable snake species, his Florentine Codex illustrates a
feathered serpent.[78]

**Figure 85**

Hammered and cut gold dance wand with projecting snakes. Peru, south coast. Nasca,
A.D. 100–600. H. 31.5, W. 20.5 cm. University of Pennsylvania Museum, Philadelphia
(Neg. #T4-715), 60-4-5.

# 8     Fish, Crustaceans, and Mollusks

Fish were essential to livelihood and the development of most early civilizations in the New World. Because there were few domesticated animals, fish were a particularly important protein source. Before people were settled farmers, they fished in rivers and lakes and gathered mollusks and crustaceans at shores. Anchovies have been judged to be an important early coastal food source.[1] When men began to make reed-bundle or balsa rafts, dugout canoes, or other boats, they went out on larger bodies of water. Fish were caught with nets, hooks, and harpoons. Hooks of cactus spines were made in very early times; later, some were made of copper. Gold fishhooks from Colombia indicate use that was ritual or symbolic (probably as grave goods).[2] Cotton was one of the first plants domesticated in South America, before 2500 B.C.; its principal early use was surely for fishing nets. Earlier nets (from 7000 B.C.) were made from cactus fiber.

Fish were plentiful off Pacific and Caribbean coasts as well as in rivers and lakes. The cold waters of the Humboldt Current, flowing northward off the coasts of Peru and Chile from the Antarctic, normally produce one of the world's richest fishing grounds. Fish are more prolific in cold water than in warm. Occasionally the flow of the warm Niño Current southward into the Humboldt disrupts fishing as well as the bird life that depends on the fish. There may well have been special rituals at times of Niño events, invoking supernatural help to restore fish to the offshore waters.

Fish are prominent motifs in virtually all Pre-Columbian art. They are depicted on ceramic vessels (figs. 86, 87, and 88; pl.9), gold pendants (figs. 89 and 90), and textiles (pls. 7 and 8).

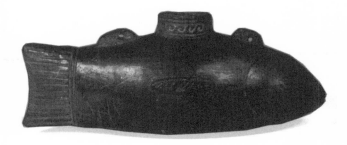

**Figure 86**

Ceramic vessel, fish; two hooks on top. Peru, north coast. Chimú-Inca, A.D. 1400–1550. H. 9.3, W. 9, L. 23 cm. Carnegie Museum of Natural History 14678-7.

**Figure 87**

Ceramic vessel, fish. Peru, north coast. Moche, A.D. 1–300. H. 21.5, W. 10, L. 22 cm. University of Pennsylvania Museum, Philadelphia, 39-20-38.

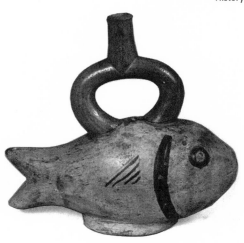

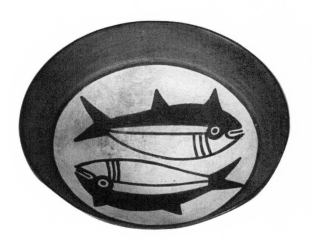

**Figure 88**

Polychrome ceramic bowl with two fish (sharks?). Peru, south coast. Nasca, A.D. 100–300. H. 7, D. 23 cm. University of Pennsylvania Museum, Philadelphia, 76-14-2.

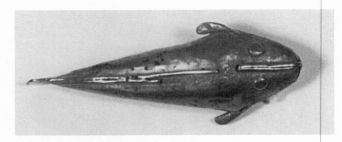

**Figure 89**

Fish, made from sheets of gold. Colombia, Santa Marta region, urn burial at Gairaca. Tairona, A.D. 700–1500. H. 1.7, W. 1.8, L. 4.5 cm. Carnegie Museum of Natural History 2005-153b (Herbert Huntingdon Smith expedition, 1896–98).

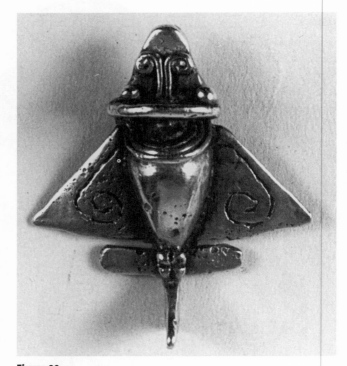

**Figure 90**

*Tumbaga* flying fish, with hook for suspension. Panama, Veraguas Province. A.D. 700–1500. H. 4, W. 3.5, D. 1.3 cm. University of Pennsylvania Museum, Philadelphia, 55-19-2.

A ceramic effigy-fish vessel with a pelican at the spout was found by Uhle in an Inca cemetery at Pachacamac (fig. 5).[3] The success of Pachacamac as a city must have depended on its function as a fishing port and a trade center as well as on its oracle and its religious activities. Part of its religious importance may have developed from its relationship with the sea. Along the coast, dried fish were transported inland, surely over a long period and over great distances. Fish were important not only for practical reasons but also as elements of myth and ritual. Fish are still consumed as ritual food.[4]

Much of Moche myth took place at sea or at the edges of the sea, to judge from the high percentage of vases that have sea iconography, often with deities fishing or combating mythical water creatures.[5] Fish monsters with a human leg and an arm holding a knife may express the dangers or demons of the deep for Moche fisherman—sharks, perhaps—or they may personify the sea (fig. 91). Moche reed rafts in pottery representations have sometimes been transformed into fish.[6] In Nasca and Chimú art as well, fish and fishing scenes are frequent (pl. 9).[7]

Classic Maya vases also show fish and boats.[8] Maya depictions of canoes surely portray the underworld voyage of the people or other creatures in them. Fish represent the watery underworld; they also symbolize fecundity, as they do in many places in the world. Bodies of water and water creatures were important in iconography and cosmic schemes, and fish-related rituals had to do with the resources of the earth as well as with fishing activity. In the Maya area, fish have been found in the remains of ancient rituals in caves. Caves are often wet, often have water and strange water life in them; to venture into cave darkness is like venturing into the unknown underworld. Maya burials and caches also contain quantities of marine organisms, and fish bones occur more frequently in such contexts than in refuse found at the sites.[9]

Offerings in the Great Temple of the Aztec, especially on the Tlaloc side, included quantities of marine fauna—fish, shells, coral, and turtle shells—along with objects of green stone, the color of water.[10] It is interesting that poisonous fish predominated in the offerings at the Great Temple; these were clearly not simple food offerings but presentations of a much more complex symbolism.

A common motif on pottery and textiles is a ray (fig. 92 and pl. 8). In

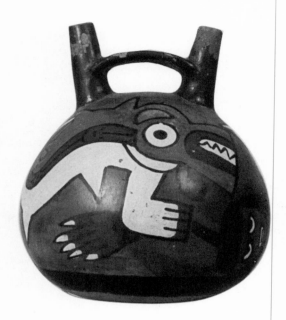

nature, a large manta ray (Mobulidae) in the water seems to be flying; it also leaps spectacularly out of the sea into the air. The spine of a stingray (Dasyatidae) was used by Maya rulers and many other peoples in blood-letting rites, in which the precious liquid was offered to the earth for its enrichment or to gods or ancestors with whom the self-sacrificer wished to communicate.[11] The spine is a common motif in Classic Maya art. Maya and Olmec burials contain both real spines and replicas in jade and other materials. The use of the spines for bloodletting was still being re-ported in sixteenth-century Oaxaca and seventeenth-century Panama.

The stingray has an erose, toxic spine attached to its long, slender tail, which it whips at any being that disturbs it, slashing the spine into flesh with sometimes fatal results. As a bottom feeder, lurking in shallows, stingrays have special underworld connotations. The Pacific angel shark (*Squatina californica*) greatly resembles a ray and may be the source of some images usually called ray.[12] Probable portrayals of an angel shark were found by Uhle on the walls of Pachacamac.[13]

Rays, sharks, and sawfish (remains of which have been found in exca-vations in the Great Aztec Temple and also in offerings at Tikal, among other places) are all cartilaginous fishes (Chondrichthyes).[14] Sharks,

threatening fishermen in simple boats and people gathering food near shores, also were often depicted by Pre-Columbian artists, particularly on the south coast of Peru (fig. 88). There has been considerable argument about whether a common Peruvian south-coast motif depicts a shark or a killer whale (*Orcinus orca*).[15] Both are probably present.

Fish headdresses or masks (one assumes that they were not made of real fish) appear on figures on pottery: examples come from the Maya; from Colima, on the west coast of Mexico; and from the south coast of Peru, both Paracas and Nasca.[16] These may sometimes depict sharks (or killer whales). On a Classic Maya cylinder vase, a man blowing a shell trumpet wears a huge fish, probably a catfish, as a headdress; it is as long as he is.

The same composition is seen in early Nasca figures who wear a huge shark with its head above the wearer's, its body down his back. A similar motif appears in Paracas art, but here it is not obvious that the man and the fish are separate entities; the being may be an anthropomorphic fish.[17]

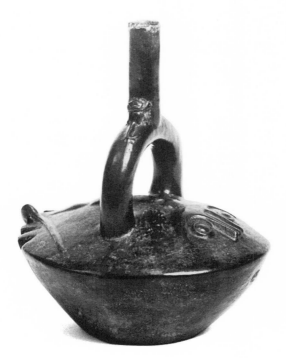

**Figure 92**

Ceramic vessel, ray. Peru, north coast, Piura Valley. Chimú, A.D. 900–1400. H. 23, D. 19 cm. Florida Museum of Natural History, University of Florida, 101429.

Two brothers in Bororo origin myths became Sun and Moon; in the course of their adventures before they rose to the sky, the trickster Sun turned into a fish.[18] In the Popol Vuh the Hero Twins were killed by the underworld lords, and their bones, ground to dust, were thrown into a river; but in the river they turned into catfish before destroying the lords and rising to the sky to become Sun and Moon.[19] Catfish remains are present in burials at the Maya sites of Altar de Sacrificios and Tulum; catfish are frequently shown on Classic Maya pots, and a Maya god of the "Palenque Triad" is identified in part by his catfish barbels.[20] There are more than thirty families of catfish (Siluriformes) worldwide.[21] Most inhabit freshwater rivers and streams; more than half are native to South America. They have many significant traits. Some are "armored" with heavy scales. Some "hibernate" in dry spells. Some live in mud holes or swamps; some live in caves. Some are tiny; some weigh hundreds of pounds. Some can stay out of water for considerable lengths of time if they are moist. These anomalies and idiosyncrasies make them appropriate for use as human metaphors.

Crustaceans and mollusks provided food for early, primitive gatherers, as excavations from middens of some six thousand years ago demonstrate.[22] Later, shells were placed in quantity in burials and offering caches.

Crustaceans appear as motifs in the art and iconography of many peoples. Crabs, lobsters, shrimp, and crayfish, realistic or personified, are part of the complex Moche sea iconography; they occur also in the art of the Chimú and other Peruvian coastal peoples (fig. 93).[23] A Moche god takes the form of a crab (fig. 94).[24] The crab figure may be a marine god, or it may be the major god (or mythic culture hero) who becomes a crab in order to do battle. The depictions are varied. Sometimes the crab god battles the fish monster; sometimes the major god is about to decapitate the crab god. Some modeled pots show the major god and the crab god together in what appears at first to be combat; but the crab god, on closer

**Figure 93**

Ceramic vessel with shellfish, or langostino. Peru, north coast. Moche. H. 19, D. 12.5 cm.
University of Pennsylvania Museum, Philadelphia, 34307 (Max Uhle expedition, 1897).

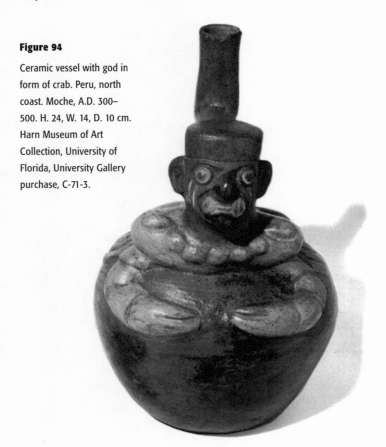

**Figure 94**

Ceramic vessel with god in form of crab. Peru, north coast. Moche, A.D. 300–500. H. 24, W. 14, D. 10 cm. Harn Museum of Art Collection, University of Florida, University Gallery purchase, C-71-3.

inspection, seems to be supporting the major god and could be rescuing him from the sea in illustration of an unknown myth, which may be similar to the myth in which vultures escort the same god in another situation (fig. 68).

Cast-gold crab pendants from Panama (fig. 95); hammered-gold lobsters, crabs, and crayfish from the north coast of Peru; and crab ceramic vessels from Panama and Colima are among the representations of these animals.[25] In the Late Classic Maya murals at Bonampak, next to a group of musicians—trumpeters on one side, turtle shell drummers on the other—stand what must be ritual dancers.[26] One wears a caiman mask over his head; one has a mask and a headdress topped by a water lily with a carp nosing into it; the most prominent figure wears an elaborate mask

and raises arms encased in green crayfish claws. Indeed, the elements of the costumes of these aquatic creatures are all mostly green, the color of water.

Two types of mollusks are prominent in Pre-Columbian art and iconography.[27] Gastropods are snails (Gastropoda), spirally coiled univalve shells: conchs, welks, helmets, and so on. Bivalves (Bivalvia) are oysters, clams, and the like. Both orders provided food and also material for fine ornaments for the sophisticated elite. Jewelry was made from shell, and shell decorations were sewn on garments. Gastropod shells were cut and often inlaid to make various ornaments (fig. 56 and pl. 2).[28] Cut gastropods, or ceramic imitations of them, were sometimes used as pigment containers.

A gastropod shell is a Maya symbol of the interior of the earth and of water and probably also of rebirth.[29] An old Maya earth lord (God N) is

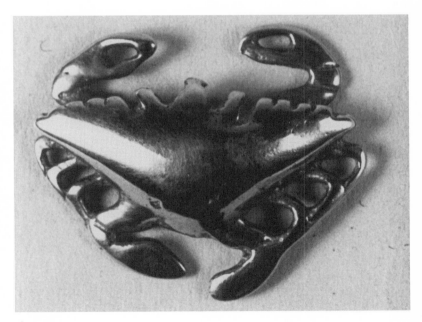

**Figure 95**

Cast-gold crab. Panama, Veraguas Province. A.D. 700–1500. H. 2.5, W. 2.8, D. .5 cm. University of Pennsylvania Museum, Philadelphia, SA 2778.

usually portrayed emerging from a gastropod shell: sometimes it is a seashell, sometimes a land shell; occasionally he appears in a turtle shell.[30] The shells of land snails are sometimes depicted in both Maya and Moche art.[31]

Gastropods have been encountered in the Great Temple of Tenochtitlan as offerings at the Tlaloc temple, and three colossal effigy conchs (*Strombus gigas*), carved of stone and nearly a meter long, were also found there.[32] The important Aztec god Quetzalcoatl wears a cut conch shell pendant, as does his dog-god twin Xolotl.[33] The Pacific species of conch, *S. galeatus*, which is not found south of Ecuador, was imported into Peru from very early times (fig. 96). It was also traded to inland Mesoamerica, where both species are found archaeologically.

Gastropod trumpets have had similar use over wide areas of the Americas, perhaps in part because they are a natural musical instrument—an inflexible one, but one with a compelling, deep sound. In Mesoamerica and the Central Andes, trumpets of *Strombus* and other

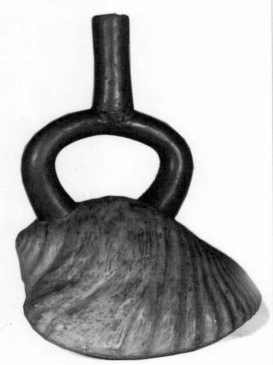

**Figure 96**

Ceramic vessel, great Eastern Pacific conch (*Strombus galeatus*). Peru, north coast. Moche, A.D. 300–500. H. 24.5, W. 18, D. 14 cm. Carnegie Museum of Natural History 4291-661.

**Figure 97**

*Strombus galeatus* trumpet. Peru, south coast. Nasca, A.D. 1–300. H. 20, W. 17.5, D. 10.5 cm. University of Pennsylvania Museum, Philadelphia, SA 3766 (William C. Farabee expedition, 1922–23).

gastropods were blown to announce and punctuate rituals, often by people in the mountains, far away from the sea (figs. 97 and 98).[34] In a Teotihuacan mural, in the highlands of Mexico, a feline in a feather headdress is blowing a shell trumpet.[35] The Aztec and the Inca used them for various ceremonies; Inca runners (*chaskis*) announced their arrival with a trumpet call. In the lowlands, the Maya blew the trumpets in ritual deer hunts.[36] Moche participants in the coca-chewing rite are shown with them (fig. 98).[37] Ground shell was sometimes used for the lime, which may explain, in part, the association of the trumpet with this rite. Sometimes it is a god who uses the trumpet. Figure 97 is a trumpet of *Strombus galeatus* from the south coast of Peru. Often these trumpets were decorated with incised designs, inlay, and/or painting. They have been found in many excavations, some of these at the late Maya site of Mayapan, where various shell objects have turned up.[38] Shell trumpets are still used in many places to begin fiestas or to make announcements.

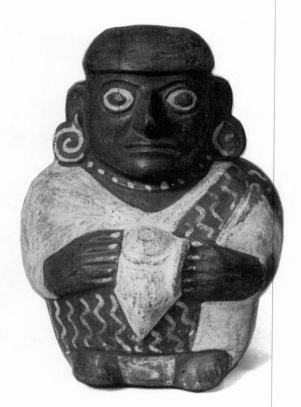

**Figure 98**

Ceramic vessel, man
holding shell trumpet.
Peru, north coast. Moche,
A.D. 200–300. H. 18.5,
W. 14, D. 18 cm. University
of Pennsylvania Museum,
Philadelphia, 39-20-18.

Gastropods were imitated in clay, gold, and stone (fig. 96); in Colombia such a shell might be sheathed in gold.[39] A gastropod shell is featured in a ceramic vessel from Ecuador (fig. 99). A Chimú stirrup-spout vessel is made in the shape of a huge gastropod shell with tiny pelicans pecking at the spout (fig. 6), giving a shorthand depiction of a sea scene.

A "conch monster," a mythical creature with varying animal elements attached to a gastropod shell, is a theme in Moche art.[40] The significance of the monster is not clear, but it is an excellent example of a mysterious hybrid.

On the far side of the Andes from the sea, at the early Peruvian site of Chavín de Huántar, a deity with snake hair, a fanged mouth, a snake waistband, and clawed feet holds in one hand a gastropod shell with a

face on it; in the other hand he holds a bivalve, the spiny oyster (*Spondylus*).[41] Both shells have been found in very early remains in Peru.[42]

The spiny oyster is a deep-water shell; divers may have to go down as far as 60 feet for it.[43] Like *Strombus galeatus, Spondylus princeps,* a Pacific species, is normally found no farther south than Ecuador, but it was traded to Peru and elsewhere for more than three millennia of Pre-Columbian history. It has many extraordinary features. One notices immediately its long, spiny thorns and the range of vivid color on its shiny interior—from white to pink to deep red to purple. The spiny oyster is the only mollusk that has eyes capable of forming an image. The ancients could not have known this, but they would have seen the eyes: there may be as many as a hundred of them, and in a fresh specimen they shine brightly, surely a cause for wonder in the viewer. Twice a year, at the end of the dry season and at the end of the rainy season, streams of water wash toxic substances into the mollusk's tissue; these can be fatal to humans who eat them. It is at these times that bivalve offerings were made in the sixteenth century and are still made by contemporary practitioners. Here is another case of a toxic offering, clearly a very powerful offering.

The spiny oyster is widely depicted in the Andes at least from Chavín times on.[44] It was believed to be a means of communication with supernatural spirits, and it was the status symbol par excellence. More than two millennia after the first evidence of the trade of this gastropod into Peru, a Sican (Lambayeque) ruler, on the north coast, walked only on fragments of spiny oyster; the sole duty of one official of the royal

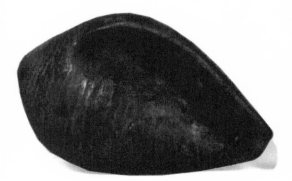

**Figure 99**

Ceramic effigy gastropod shell. Ecuador, Carchi, El Ángel. 500 B.C.–A.D. 500. H. 13, W. 14.4, D. 23.3 cm. Carnegie Museum of Natural History 5324-93.

household was to walk ahead of him, strewing the shell in his path. The ruler walked not only on precious material; he walked on a symbol of the bottom of the sea. He communed with the otherworld wherever he went. Slightly later Chimú vases were modeled in spiny oyster form. The example in figure 100 has a human head emerging from it as the spout. This concept is typical of Moche animism, in which all objects had a life that was thought of in human terms. Chimú craftsmen used the shell in elaborate beadwork jewelry.[45] Half of a shell was found with one particularly fine Chimú bib-shaped necklace of many colors, including spiny oyster red.

In the sixteenth century, in one south-coast valley, there were six thousand merchants who went by boat regularly to Ecuador to obtain spiny oyster and other goods.[46] Pizarro's Spanish army was astonished

**Figure 100**

Ceramic vessel, thorny oyster (*Spondylus princeps*), with human head as spout. Peru, north coast. Chimú, A.D. 900–1470. H. 26.5, W. 19, D. 14.2 cm. The Carnegie Museum of Natural History 4291-656.

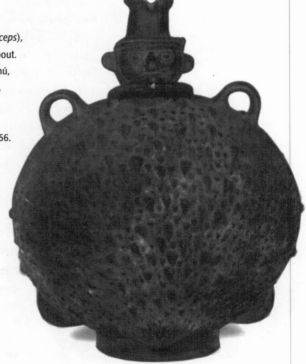

to find that the Indians valued this oyster more highly than gold. Other bivalves were used and appear in art, but the spiny oyster was by far the most precious.

Although the spiny oyster rarely or never appears in Moche art, the shells were found in the important burials at Sipán, often along with another imported shell, the gastropod *Conus fergusonii*.[47] Pieces of unidentified pink shell in other Moche excavations undoubtedly came from the spiny oyster.

In Mesoamerica both Atlantic (*Spondylus americanus*) and Pacific species of shells and objects made from them were placed in inland graves and offering caches of Maya royal families. The shells in Maya burials often serve as containers for precious small objects. Great quantities of shells were found at Tikal, with more *Spondylus* than any other shell.[48] Curiously, perhaps, there is little or no *Strombus* there. At Copán a spiny oyster shell was found with stingray and sea urchin spines in a cache under the great Hieroglyphic Stairway.[49] Ash and carbon inside a censer in the cache suggest the burning of incense, along with paper that had absorbed the blood in the king's self-sacrifice ritual. (The name of the ruler for whom the cache was placed was Smoke Shell.) Spiny oysters are associated with bloodletting in many Maya contexts, surely because of the spines and the deep red color that many of them have. They are frequently found in Maya offerings believed to be associated with ancestors, presumably because they symbolize not only ritual communication but also the primordial waters of the underworld. Maya rulers are portrayed wearing necklaces of spiny oyster shell.[50] Its perforated shells, found alongside a body in a tomb at the Maya site of Uaxactún, were interpreted as having been attached to a cotton garment, now deteriorated; a cape with shells attached is depicted on a Maya vase, and the murals at Bonampak show large spiny oyster shells attached to the robes of a row of lords.[51] Maya gods may have these shells placed over their ears or depicted in place of ears.

The Aztec emperor Moctezuma demanded at least 1,600 of these shells in yearly tribute in the early sixteenth century.[52] In the Great Temple in the Aztec capital, a spiny oyster shell was found with green stone beads inside (Offering 41).[53] Mother-of-pearl and the gastropod *Xanthus* were also found.

When the Spaniards arrived in Peru in the early sixteenth century, they found that the inhabitants worshiped the sea as the mother of all waters.[54] They sacrificed seashells, *Spondylus* and *Strombus*, making offerings to the springs, who were the daughters of the sea. The shells were offered whole, broken, or ground. Sometimes figurines were made from the ground powder; sometimes the offerings were burned. The sacrifice was made after the planting was finished so that the springs would not dry up but would flow with abundance to irrigate the fields to feed the people.

# 9    Conclusion

American origin myths sometimes seem as simple as Aesop's fables, but there are many complexities and depths, many accretions through time and the movements of peoples who impart certain cultural notions as they move and pick up new ones as well. Animal lore is always rooted in the obvious practical uses of animals for food and for pelt, shell, feathers, bones, antlers, teeth, claws, spines, and sinew—and in the case of the llama, for transport and wool. But the other side of the coin—the symbolic, metaphoric, mythical, supernatural, shamanic, otherworldly—is never far away. Animals are not just practical resources, not just neighbors; they represent a parallel world with which humans interact, through which animals play roles in the human world.

One provocative observation that demonstrates a complication in this structure is the fact that poisonous animals—toads, fish, snakes, and bivalves—are notable in iconography, in ritual, and in archaeological remains, both in offering contexts and trash middens. Some venoms might have been eaten safely with proper preparation. Some might have been converted to psychoactive drugs for ritual use. Some might be toxic only in certain seasons—which is precisely when the spiny oyster is offered. The quantity of such remains suggests that something more is involved than simple food offerings to the god or the dead or than presentations with modest symbolisms of fertility or contact with the otherworld. There is a dimension of risking death while promoting life, of offering a particularly powerful substance, of controlling poisons in positive use. People in some sense conquer or control animals by using them in hu-

man lore. It is another aspect of the dualism that is the basic structure of indigenous philosophy.

In another kind of observation, while looking at the art and reading the myths, it becomes apparent that the human being was the basic measure in the Pre-Columbian past, as it is in myths from Latin America today. Whatever involvement and sometimes apparent obsession with animals these peoples had, animals are still extensions of humankind's activities, metaphors for human behavior, wishes, social contracts, and laws. Something human is usually present in most beastly creatures with mixed traits, and where it is not, there appears to be a clear statement that it is human beings who put these aspects of animals together, that humans respect the animals but also manipulate them, both in the real world and in human cosmogonic schemes.

An interesting facet of the human point of view toward animals in myth and folktale, and sometimes in art, is that people seem to sense that they are relative newcomers in the world, that many animals—armadillo (often an old man in myth), crocodilian, turtle—are millions of years older than *Homo sapiens*. They represent the primordial earth, which man discovers and explores in myth. These old animals personify the ancestors of the tribe. They are ancestors because they were here before. It is usually an animal, or a god or culture hero in the form of an animal, who taught people how to plant, how to weave, how to make canoes and rafts, how to dance, how to give respect. The animals in myth were often there long before people were. These old animals give people a sense of time and scale and a framework within which to live as human beings.

# Notes

CHAPTER 1: INTRODUCTION

1. M. D. Coe, Snow, and Benson, *Atlas;* Townsend, *Ancient Americas.*
2. For illustrative material: Winning, *Pre-Columbian Art.* For a general book on Mesoamerica: Weaver, *Aztecs, Maya.*
3. For illustrative material: Lapiner, *Pre-Columbian Art.* For a general book: Moseley, *Incas;* see also Burger, *Chavín.*
4. *Arte Precolombino; Between Continents;* Bray, *Gold; Ecuador;* Hearne and Sharer, *River of Gold;* Helms, *Ancient Panama;* Reichel-Dolmatoff, *Goldwork;* Townsend, *Ancient Americas.*
5. M. D. Coe, *Maya Scribe;* Donnan, *Moche Art;* Kerr, *Maya Vase Book;* Kutscher, *Nordperuanische;* Reents-Budet, *Painting.*
6. Alva and Donnan, *Royal Tombs;* Lapiner, *Pre-Columbian Art,* figs. 346–407.
7. Garcilaso, *Royal Commentaries;* Murra, "Cloth"; Paul, *Paracas Art;* Paul, *Paracas Ritual;* A. P. Rowe, *Costumes*
8. M. D. Coe, Snow, and Benson, *Atlas,* 118–19.
9. M. D. Coe, *Maya Scribe,* no. 87.

CHAPTER 2: THE ANIMALS

1. W. R. Coe, *Excavations;* Cooke, "Birds and Men"; López Luján, *Offerings;* Pohl, "Maya Ritual"; Wing and Coe, in M. D. Coe and Diehl, *Land of Olmec.*
2. Tedlock, *Popol Vuh.*
3. Díaz del Castillo, *Discovery,* 212–13.
4. Garcilaso, *Royal Commentaries,* 254–55; Cobo, cited by Candler, in Reina and Kensinger, *Gift of Birds,* 10.
5. Anderson and Dibble, *Florentine Codex.*
6. Tozzer, *Landa's Relación.*

7. Peterson, *Precolumbian Flora*, 110–43; Reina and Kensinger, *Gift of Birds*; Saunders, *People of Jaguar*.

8. For South America: Lévi-Strauss, *Honey to Ashes*, *Jealous Potter*, and *Raw and Cooked*; Reichel-Dolmatoff, *Amazonian Cosmos*, *Goldwork*, *Kógi*; Roe, *Cosmic Zygote*; Urton, *Animal Myths*. For Mesoamerica: Gossen, *Chamulas*; Laughlin, *Great Tzotzil*, *Of Cabbages*; Thompson, *Maya Hieroglyphic*.

9. Burger, *Chavín*.

10. Kutscher, *Nordperuanische*, fig. 10.

11. M. D. Coe, *Maya Scribe*, no. 45; Reents-Budet, *Painting*, 357; Tedlock, *Popol Vuh*, 154–57.

12. Proulx, "Nasca."

13. Reichel-Dolmatoff, *Kogi*, 241.

14. Bray, *Gold*; Reichel-Dolmatoff, *Goldwork*; Zuidema, in Townsend, *Ancient Americas*, 244–57.

15. See Peterson, *Precolumbian Flora*; Seler, "Tierbilder"; Thompson, *Maya Hieroglyphic*; Urton, *Animal Myths*.

16. López Luján, *Offerings*, 320.

17. Pohl, "Maya Ritual," 100–101.

18. Burger, *Chavín*, 150–52; Reichel-Dolmatoff, *Amazonian Cosmos*.

19. Kerr, *Maya Vase Book*, III: 413; Miller, *Murals of Bonampak*, pl. 2.

20. Freidel, Schele, and Parker, *Maya Cosmos*; Miller and Taube, *Gods and Symbols*, 122–23.

21. Lévi-Strauss, *Honey to Ashes*, *Jealous Potter*, 40–41.

CHAPTER 3: DOMESTICATED ANIMALS

1. Fock, in Wilbert and Simoneau, *Mataco*, 104–5.

2. Gossen, *Chamulas*; Laughlin, *Of Cabbages*, 286–88.

3. Wilbert and Simoneau, *Toba*, 80–83.

4. Baus de Czitrom, *Perros*, 30; Wilbert and Simoneau, *Mataco*, 280–82.

5. Durán, *Book of Gods*, 278–79; Pohl, "Maya Ritual," 70–71, 91–94; J. H. Rowe, "Inca Culture," 281; Tozzer, *Landa's Relación*, 114–15 (n. 528), 165.

6. Cordy-Collins, "Unshaggy Dog."

7. Alva and Donnan, *Royal Tombs*, 159, fig. 174; Baus de Czitrom, *Perros*; Benson, "Chthonic Canine"; Gossen, *Chamulas*, 293; Laughlin, *Great Tzotzil*, 102; López Luján, *Offerings*, 234–35; Peterson, *Precolumbian Flora*, 66; Pohl, "Maya Ritual"; Thompson, *Maya Hieroglyphic*; Wing, "Human Use of Canids."

8. Alcorn, *Huastec Mayan*, 80; Benson, "Chthonic Canine," 100; Gossen, *Chamulas*, 290; Thompson, *Ethnology*, 140–41.

9. Nicholson and Quiñones Keber, *Art of Ancient Mexico*, 122–25; Seler, "Tierbilder," 474–94; Thompson, *Maya Hieroglyphic*, 78–79, 109.

10. Donnan, *Moche Art*, nos. 239, 240; Kuscher, *Nordperuanische*, figs. 267, 276, 299.

11. Métraux, in Wilbert and Simoneau, *Mataco*, 51.

12. Benson, "Chthonic Canine," 102–6; Métraux, in Wilbert and Simoneau, *Mataco*, 37; Wilbert and Simoneau, *Toba*, 39–48.

13. Flannery, Marcus, and Reynolds, *Flocks;* Macdonald, *Encyclopedia*, 512–15; Nowak, *Walker's Mammals*, 1353–57; Redford and Eisenberg, *Mammals*, 234–37.

14. Garcilaso, *Royal Commentaries*, 513–16; J. H. Rowe, "Inca Culture," 219, 239; see also Flannery, Marcus, and Reynolds, *Flocks*, 105–17.

15. Alva and Donnan, *Royal Tombs*, 160–61; Donnan, *Moche Art*, 112–15; Rostworowski, *Recursos*, 50–53; Shimada and Shimada, "Prehistoric Llama."

16. Proulx, "Nasca."

17. Murra, "Cloth," 711.

18. Cobo, *Inca Religion*, 113–16; Garcilaso, *Royal Commentaries*, 356–62, 412–16; Guaman Poma, *Corónica*, 240 [242], 254 [256].

19. Cobo, *Inca Religion*, 129.

20. Guaman Poma, *Corónica*, 318 [320].

21. Flannery, Marcus, and Reyolds, *Flocks;* Urton, in Urton, *Animal Myths*.

22. Nowak, *Walker's Mammals*, 907–14; Redford and Eisenberg, *Mammals*, 336–43.

23. Cobo, *Inca Religion*, 115.

24. Cooke, "Birds and Men," 243; Donnan, *Moche Art*, 39, 60. For natural history: Austin and Singer, *Birds*, 68–69; Blake, *Neotropical*, 254; Bolen, in Janzen, *Costa Rican*, 554–56; Davis, *Field Guide*, 15; Hilty and Brown, *Guide to Birds*, 85–86; Leopold, *Wildlife*, 163–68.

25. O'Neill, in A. P. Rowe, *Costumes*, 146.

26. Anderson and Dibble, *Florentine Codex*, bk. 11: 34–38.

27. M. D. Coe and Diehl, *Land of Olmec*, 314–15.

28. Wing and Coe, in M. D. Coe and Diehl, *Land of Olmec*, 378.

29. Austin and Singer, *Birds*, 98–99; Blake, *Neotropical*, 469–70; Davis, *Field Guide*, 35; Leopold, *Wildlife*, 268–79.

30. Pohl, "Maya Ritual," 82.

31. Anderson and Dibble, *Florentine Codex*, bk. 11: 29, 53.

32. Kerr, *Maya Vase Book*, II: 200, 208; Reents-Budet, *Painting*, no. 25, fig. 6.22; Pohl, "Maya Ritual," 82.

33. Pohl, "Maya Ritual," 82.

CHAPTER 4: HUNTED MAMMALS

1. Garcilaso, *Royal Commentaries*, 326.

2. Benson, "New World"; Kutscher, *Nordperuanische*, figs. 69–87.

3. Benson, "New World"; M. D. Coe, *Maya Scribe*, no. 66; Kerr, *Maya Vase Book*, I: 53, 101, 111, II: 307, III: 396; Pohl, "Maya Ritual," fig. 3.9; Reents-Budet, *Painting*, fig. 6.35, no. 79.

4. Alcorn, *Huastec Mayan*, 88; Reichel-Dolmatoff, in Urton, *Animal Myths*, 119–23; Urton, in Urton, *Animal Myths*, 258.

5. Alcorn, *Huastec Mayan*, 88; Alva and Donnan, *Royal Tombs*, 77–81; López Luján, *Offerings*, 257–58; Pohl, "Maya Ritual," 62–65, 74, 87–89, 91; Tozzer, *Landa's Relación*, 141.

6. Durán, *Book of Gods*, 312–19; Fash, *Scribes*, 85–86; Miller and Taube, *Gods and Symbols*, 22–24; Weaver, *Aztecs, Maya*.

7. M. D. Coe, *Maya Scribe*, no. 28; Kerr, *Maya Vase Book*, I: 53, 119, II: 193, 202, 307, III: 442; Tedlock, *Popol Vuh*, 139–60; Reents-Budet, *Painting*, 264–68, nos. 80, 81.

8. López Luján, *Offerings*, 257, 481 (n. 49), 482 (n. 120); Pohl, "Maya Ritual," 62.

9. Eisenberg, *Mammals*, 321–23; Emmons, *Neotropical*, 162–63; Janzen, in Janzen, *Costa Rican*, 481–83; Leopold, *Wildlife*, 507–13; Macdonald, *Encyclopedia*, 520–29; Nowak, *Walker's Mammals*, 1384–87.

10. Anderson and Dibble, *Florentine Codex*, bk. 11: 15.

11. Fabian, *Space-Time*, 24–27; Lévi-Strauss, *Raw and Cooked*, 37, 139; Wilbert and Simoneau, *Bororo*, 201, 202, 208.

12. Moseley, *Incas*, pl. 61.

13. Kutscher, *Nordperuanische*, figs. 132–47.

14. Alva and Donnan, *Royal Tombs*, fig. 199; Benson, in Townsend, *Ancient Americas*, fig. 14.

15. Macdonald, *Encyclopedia*, 68–71, 74; Nowak, *Walker's Mammals*, 1059–60; Redford and Eisenberg, *Mammals*, 147–49.

16. Bourget, "El mar."

17. Paul, *Paracas Ritual*, 39, 43; Peters, in Paul, *Paracas Art*, figs. 5.24, 7.43.

18. Benson, "Fox in Andes," fig. 4; Proulx, "Nasca," fig. 39.

19. Guaman Poma, *Corónica*, 859 [873], 1138 [1148], 1159 [1169]; Zuidema, in Urton, *Animal Myths*, 186–94.

20. Urton, in Urton, *Animal Myths*, 264–69.

21. Urton, in Urton, *Animal Myths*, 260–61.

22. Benson, "Fox in Andes," 8–9; Urton, in Urton, *Animal Myths*, 262.

23. Zuidema, in Urton, *Animal Myths*, 193.

24. Benson, "Fox in Andes," 11; Lévi-Strauss, *Honey to Ashes*, 93–107; Wilbert and Simoneau, *Toba*.

25. Terán ms., in Wilbert and Simoneau, *Toba*, 222.

26. Cobo, *Inca Religion*, 85–90; Garcilaso, *Royal Commentaries*, 379–81; Rostworowski, *Recursos*, 125; Uhle, *Pachacamac*.

27. Uhle, *Pachacamac*, xxxiii, fig. 4.

28. Eisenberg, *Mammals*, 267; Leopold, *Wildlife*, 408; Macdonald, *Encyclopedia*, 68–75; Nowak, *Walker's Mammals*, 1056–57.

29. Leopold, *Wildlife*, 352–58; Macdonald, *Encyclopedia*, 714–21; Nowak, *Walker's Mammals*, 550–51.

30. Alcorn, *Huastec Mayan*, 60–61.

31. Kerr, *Maya Vase Book*, I: 20, 81; Miller and Taube, *Gods and Symbols*, 142–43; Taube, *Major Gods*, 64–69.

32. Tedlock, *Popol Vuh*, 145–47.

33. Taube, *Major Gods*, 79–88.

34. M. D. Coe, *Maya Scribe*, no. 42; Reents-Budet, *Painting*, no. 89, figs. 2.4, 2.26.

35. Leopold, *Wildlife*, 358–61; Nowak, *Walker's Mammals*, 546–49.

36. Durán, *Book of Gods*, 143, 147.

37. Eisenberg, *Mammals*, 314–21; Emmons, *Neotropical*, 156–60; Janzen, *Costa Rican*, 496–98; Leopold, *Wildlife*, 488–500; Macdonald, *Encyclopedia*, 488–89, 504–5; Nowak, *Walker's Mammals*, 1319–22, 1344–47.

38. Reichel-Dolmatoff, in Urton, *Animal Myths*, 107–43.

39. Kerr, *Maya Vase Book*; Lévi-Strauss, *Raw and Cooked*; Reichel-Dolmatoff, in Urton, *Animal Myths*, 107–43.

40. Fash, *Scribes*, fig. 24.

41. Anderson and Dibble, *Florentine Codex*, bk. 11: 10.

42. *Ecuador*, pl. 143; Eisenberg, *Mammals*, 271–73; Emmons, *Neotropical*, 138–39; Kauffmann, in Janzen, *Costa Rican*, 478–80; Leopold, *Wildlife*, 432–37.

43. Eisenberg, *Mammals*, 285–86; Emmons, *Neotropical*, 153; Leopold, *Wildlife*, 464–87; Macdonald, *Encyclopedia*, 48–49; Nowak, *Walker's Mammals*, 1207, 1214–15; Redford and Eisenberg, *Mammals*, 170–72.

44. Díaz del Castillo, *Discovery*, 213.

45. Benson, in Townsend, *Ancient Americas*, fig. 9; *Ecuador*, pls. 130, 131; Peterson, *Precolumbian Flora*, no. 67.

46. Donnan, *Moche Art*, no. 45; Kerr, *Maya Vase Book*, I: 40; Kutscher, *Nordperuanische*, figs. 12, 122; Lapiner, *Precolumbian Art*, fig. 344; Peterson, *Precolumbian Flora*, no. 68; Pohl, "Maya Ritual," 71–74; Reents-Budet, *Painting*, fig. 6.21, no. 68.

47. Fash, *Scribes*, 128, 169–70.

48. López Luján, *Offerings*.

49. Saunders, *People of Jaguar*.

50. Reichel-Dolmatoff, *Amazonian Cosmos*, 28, 78.

51. Roe, *Cosmic Zygote*, 271.

52. Miller and Taube, *Gods and Symbols*, 103–4.

53. Saunders, *People of Jaguar*; see also Jones and Satterthwaite, *Monuments*, fig. 72; Miller, *Murals of Bonampak*; Miller and Taube, *Gods and Symbols*, 102–3; Pohl, "Maya Ritual," 71–74.

54. Nicholson and Quiñones Keber, *Art of Ancient Mexico*, 88; Thompson, *Maya Hieroglyphic*, 17, 74, 134.
55. Anderson and Dibble, *Florentine Codex;* Townsend, in Townsend, *Ancient Americas*, 44, fig. 15.
56. Culbert, *Ceramics*, fig. 84; Jones and Satterthwaite, *Monuments*, figs. 29, 70; Reents-Budet, *Painting*, figs. 2.32, 3.23, 5.2, 6.1, no. 11.
57. Miller, *Murals of Bonampak*, 71–72.
58. Flannery and Marcus, *Cloud People*, figs. 5.7, 6.7.
59. Miller, *Murals of Bonampak*, pl. 2; Anderson and Dibble, *Florentine Codex;* Durán, *Book of Gods*, 177–79.
60. Laughlin, *Great Tzotzil*, 84.
61. Freidel, Schele, and Parker, *Maya Cosmos;* Grube and Nahm, in Kerr, *Maya Vase Book*, IV: 686–715; Houston and Stuart, *The Way Glyph.*
62. Furst, "Olmec Were-Jaguar"; Hugh-Jones, *Palm and Pleiades*, 124–25; Reichel-Dolmatoff, *Goldwork;* Saunders, *People of Jaguar;* Zeidler, "Feline Imagery."
63. Hugh-Jones, *Palm and Pleiades*, 125; Roe, *Cosmic Zygote.*
64. Burger, *Chavín*, 157–59; Zeidler, "Feline Imagery."
65. Uhle, *Pachacamac*, 27–28, pl. 5–8.
66. Culbert, *Ceramics of Tikal*, figs. 22–24; Nicholson and Quiñones Keber, *Art of Ancient Mexico*, 30–31.
67. Easby and Scott, *Before Cortés*, nos. 209–12; Graham, in *Between Continents;* see also nos. 14–18, 72–78, 227, 229.
68. Burger, *Chavín*, 133–35; Easby and Scott, *Before Cortés*, fig. 35, no. 55.
69. Easby and Scott, *Before Cortés*, figs. 5–7, nos. 34, 35, 42–44.
70. Tedlock, *Popol Vuh*, 165.
71. Reichel-Dolmatoff, *Kogi*, 245–49.
72. Folk, in Wilbert and Simoneau, *Mataco.* 103; see also Hugh-Jones, *Palm and Pleiades*, 125.
73. Reichel-Dolmatoff, *Amazonian Cosmos*, 79.
74. Urton, in Urton, *Animal Myths*, 255.
75. López Luján, *Offerings.*
76. Nowak, *Walker's Mammals*, 1204–5.
77. Gossen, *Chamulas*, 289.

## CHAPTER 5: ANOMALOUS ANIMALS

1. For natural history: Eisenberg, *Mammals*, 73–232; Fenton, *Bats;* Hill and Smith, *Bats;* Janzen, *Costa Rican;* Nowak, *Walker's Mammals*, 190–393.
2. Laughlin, *Great Tzotzil*, 45; Benson, "Maya and Bat."
3. Benson, "Bats in South"; Seler, "Tierbilder."
4. M. D. Coe, *Maya Scribe*, no. 12; Kerr, *Maya Vase Book*, III: 452; Reents-Budet, *Painting*, 237–40, no. 60.

5. Tedlock, *Popol Vuh*, 44, 143–47.

6. Fash, *Scribes*, 28, 129–31; see also Easby and Scott, *Before Cortés*, no. 183.

7. Caso and Bernal, *Urnas*, 67; Easby and Scott, *Before Cortés*, no. 162; Miller and Taube, *Gods and Symbols*, 44–45; Peterson, *Precolumbian Flora*, no. 74.

8. Hartman, *Archaeological Researches*, pl. XLIV; *Between Continents*, nos. 36–38, 263–65, 272; Bray, *Gold*, nos. 443–46; Hearne and Sharer, *River of Gold*, pls. 18, 19.

9. For natural history: L. L. Smith and Doughty, *Amazing Armadillo*; see also Eisenberg, *Mammals*, 58–65; Janzen, *Costa Rican*; Leopold, *Wildlife*, 338–43; Nowak, *Walker's Mammals*, 515–21; Redford and Eisenberg, *Mammals*, 52–68.

10. Bruce, *Lacandon*, 136, 241.

11. Lévi-Strauss, *Raw and Cooked*, 49, 59, 113; Wilbert and Simoneau, *Bororo*, 59, 63, 84.

12. Terán ms., in Wilbert and Simoneau, *Toba*, 329–31.

13. Métraux, in Wilbert and Simoneaux, *Mataco*, 114.

14. Fought, *Chorti Texts*, 163–66.

15. Kerr, *Maya Vase Book*, III: 407; Miller, *Murals of Bonampak*, fig. 36; Reents-Budet, *Painting*, fig. 5.32, no. 61.

16. M. D. Coe, *Maya Scribe*, no. 15; Tedlock, *Popol Vuh*, 149–50.

17. Reichel-Dolmatoff, *Kogi*, 134.

18. Bruce, *Lacandon Dream*, 177, 289; Gossen, *Chamulas*, 339; Laughlin, *Great Tzotzil*, 104.

19. Reichel-Dolmatoff, *Amazonian Cosmos*, 111.

20. Calil Zurur, in Reina and Kensinger, *Gift of Birds*, 31.

21. Redford and Eisenberg, *Mammals*, 63–64.

22. Laughlin, *Of Cabbages*.

23. For natural history: Eisenberg, *Mammals*, 240–58; Emmons, *Neotropical*, 109–33; Janzen, *Costa Rican*; Leopold, *Wildlife*, 329–35; Macdonald, *Encyclopedia*, 340–69; Nowak, *Walker's Mammals*, 445–81.

24. Anderson and Dibble, *Florentine Codex*, bk. 11: 14.

25. Benson, "Multimedia"; Lévi-Strauss, *Honey to Ashes, Jealous Potter*; Miller and Taube, *Gods and Symbols*, 68, 117–18; Rostworowski, *Recursos*, 130; Thompson, *Maya Hieroglyphic*, 80.

26. Wilbert and Simoneau, *Bororo*, 77–79.

27. Reents-Budet, *Painting*.

28. Tedlock, *Popol Vuh*, 40–41, 105–6, 122–24; see also M. D. Coe, *Maya Scribe*, no. 25; Culbert, *Ceramics*, fig. 59; Kerr, *Maya Vase Book*, I: 15, 28, II: 247; Miller and Taube, *Gods and Symbols*, 135; Reents-Budet, *Painting*, 240–42; Thompson, *Maya Hieroglyphic*, 80, 143.

29. Durán, *Book of Gods*, 244, 295–96, 401.

30. Nicholson and Quiñones Keber, *Art of Ancient Mexico*, 126–28; Seler, "Tierbilder," 456.

31. Thompson, cited in Benson, "Multimedia," 137.
32. Moseley, *Incas*, 104; Peters, in Paul, *Paracas Art*, 284.
33. Bray, *Gold*, 133–37; Donnan, *Moche Art*, 116–19; Kutscher, *Nordperuanische*, figs. 125, 126, 129–31.
34. Lapiner, *Precolumbian Art*, fig. 239.
35. Bruce, *Lacandon Dream*, 153, 141, 302–3; Thompson, *Maya Hieroglyphic*, 143, 167.
36. *Ecuador*, pl. 128.
37. Kerr, *Maya Vase Book*, I: 112, IV: 593; Peterson, *Precolombian Flora*, nos. 31, 32.
38. Boone, *Codex Magliabechiano*, 55.
39. Benson, "Multimedia," fig. 3; Pohl, "Maya Ritual," 65.
40. Gardner, in Janzen, *Costa Rican*, 468–69; Leopold, *Wildlife*, 325–28.
41. Leopold, *Wildlife*, 326.
42. Preston-Mafham, *Book of Spiders*.
43. Alva and Donnan, *Royal Tombs*; Burger, *Chavín*.
44. Durán, *Book of Gods*, 115–17.

CHAPTER 6: BIRDS

1. Fash, *Scribes*, 125–29; Miller and Taube, *Gods and Symbols*, 131–33; Pohl, "Maya Ritual," 84; Reina and Kensinger, *Gift of Birds*; Roe, *Cosmic Zygote*, 271.
2. Hartman, *Archaeological Researches*, pl. XXIV, 1; *Between Continents*, nos. 19–35.
3. O'Neill, in A. P. Rowe, *Costumes*, 144–50; Reina and Kensinger, *Gift of Birds*.
4. Candler, in Reina and Kensinger, *Gift of Birds*, 10; Crocker, in Urton, *Animal Myths*, 33.
5. Lapiner, *Pre-Columbian*, figs. 557, 671; Nicholson and Quiñones Keber, *Art of Ancient Mexico*, 150–51; Candler, in Reina and Kensinger, *Gift of Birds*, 1–15; Greene, in Reina and Kensinger, *Gift of Birds*, 16–25; A. P. Rowe, *Costumes*, 144–84.
6. Candler, in Reina and Kensinger, *Gift of Birds*, 9.
7. Lyon, in Reina and Kensinger, *Gift of Birds*, 70–77.
8. O'Neill, in A. P. Rowe, *Costumes*, 146, 149; Paul, *Paracas Ritual*, 80–83. For natural history: Hilty and Brown, *Guide to Birds*, 215.
9. Amadon, in Janzen, *Costa Rican*, 569–70; Austin and Singer, *Birds*, 86–87.
10. O'Neill, in A. P. Rowe, *Costumes*, 146.
11. Lévi-Strauss, *Raw and Cooked, Honey to Ashes*; Pressman, in Reina and Kensinger, *Gift of Birds*, 78–91.
12. Reichel-Dolmatoff, *Amazonian Cosmos*, 187; Wassén, "Frog in Indian."

13. Helms, *Ancient Panama*, 94–95; Reichel-Dolmatoff, *Amazonian Cosmos*; Reina and Kensinger, *Gift of Birds*.

14. Lévi-Strauss, *Raw and Cooked*; Reichel-Dolmatoff, *Goldwork*; Reina and Kensinger, *Gift of Birds*; Roe, *Cosmic Zygote*; Wilbert and Simoneau, *Mataco*.

15. Cooke, "Birds and Men"; López Luján, *Offerings*; Pohl, "Maya Ritual," 83–84.

16. Candler, in Reina and Kensinger, *Gift of Birds*, 8.

17. Albisetti and Venturelli, in Wilbert and Simoneau, *Bororo*, 45; Calil Zarur, in Reina and Kensinger, *Gift of Birds*, 31, 35–37; Crocker, in Urton, *Animal Myths*, 13–47; see also Fabian, *Space-Time*, 17; Helms, *Ancient Panama*, 92–94.

18. Cooke, "Birds and Men," 248–51.

19. Kensinger, in Reina and Kensinger, *Gift of Birds*, 42–43.

20. Miller, *Murals of Bonampak*, 74, 137, 161.

21. Candler, in Reina and Kensinger, *Gift of Birds*, fig. 1.11.

22. For natural history: Hoppe, *World of Macaws*; Janzen, in Janzen, *Costa Rican*, 547–48.

23. *Ecuador*, 131, pl. 129; Greene, in Reina and Kensinger, *Gift of Birds*, 18; Hoppe, *World of Macaws*, 81; O'Neill, in A. P. Rowe, *Costumes*, 148; Pohl, "Maya Ritual," 83–84.

24. Jones and Satterthwaite, *Monuments*; Kerr, *Maya Vase Book*, II: 258, 259; Reents-Budet, *Painting*; Reina and Kensinger, *Gift of Birds*. For natural history: Austin and Singer, *Birds*, 172–73; Davis, *Field Guide*, 87.

25. Fash, *Scribes*, fig. 11.

26. Aveni, in Townsend, *Ancient Americas*, fig. 8; Berrin and Pasztory, *Teotihuacan*; Nicholson and Quiñones Keber, *Art of Ancient Mexico*, figs. 25b, 29; Pasztory, in Townsend, *Ancient Americas*, figs. 1, 10, 13; Anderson and Dibble, *Florentine Codex*, bk. 11: 19–20.

27. Miller and Taube, *Gods and Symbols*, 140–41; Nicholson and Quiñones Keber, *Art of Ancient Mexico*, 151.

28. Díaz del Castillo, *Discovery*, 212.

29. Hancock and Kushlan, *Herons*.

30. López Luján, *Offerings*, 312.

31. Austin and Singer, *Birds*, 56–58; Blake, *Manual*, 189–90; Hilty and Brown, *Guide to Birds*, 71–72; Janzen, *Costa Rican*, 388.

32. Lévi-Strauss, *Raw and Cooked* (see Mutum); Roe, *Cosmic Zygote*, 115.

33. Rostworowski, *Recursos*.

34. Harrison, *Sea Birds*, 287, 290, 300–301.

35. O'Neill, in A. P. Rowe, *Costumes*, 147.

36. For natural history: Greenewalt, *Hummingbirds*; Hilty and Brown, *Guide to Birds*, 249–300; Janzen, *Costa Rican*.

37. Anderson and Dibble, *Florentine Codex*, bk. 11: 24.
38. Kutscher, *Nordperuanische*, figs. 98–102, 165, 183, 189.
39. Matos Moctezuma, *Great Temple*, figs. 18, 59, 104; Miller and Taube, *Gods and Symbols*, 93–96; Nicholson and Quiñones Keber, *Art of Ancient Mexico*, 49.
40. Culbert, *Ceramics*, fig. 84.
41. Reichel-Dolmatoff, *Amazonian Cosmos*, 102, 192ff.
42. Benson, in Preuss, *"In Love,"* 3–8.
43. Matos Moctezuma, *Great Temple*, fig. 13.
44. Austin and Singer, *Birds*, 78–81; Brown and Amadon, *Eagles*, 660–69; Grossman and Hamlet, *Birds of Prey*.
45. Anderson and Dibble, *Florentine Codex*, bk. 11: 40.
46. Berrin and Pasztory, *Teotihuacan*, nos. 48, 49.
47. Matos Moctezuma, *Great Temple*, pl. VII, fig. 25; see also fig. 19; Nicholson and Quiñones Keber, *Art of Ancient Mexico*, frontispiece, no. 24, 84–85; Anderson and Dibble, *Florentine Codex*.
48. Easby and Scott, *Before Cortés*, no. 253; Kampen, *Sculpture of El Tajín*, fig. 21.
49. Berdan and Anawalt, *Codex Mendoza*, folios 31r, 55r.
50. López Luján, *Offerings*, 312; Nicholson and Quiñones Keber, *Art of Ancient Mexico*, no. 83; Peterson, *Precolumbian Flora*, no. 3.
51. Brown and Amadon, *Eagles*, 632–36; *Ecuador*, 148–49; Grossman and Hamlet, *Birds of Prey;* Hartman 1907, pl. I, 6.
52. Furst, in Reina and Kensinger, *Gift of Birds*, 106–8; Lévi-Strauss, *Raw and Cooked*, 274; Calil Zarur, in Reina and Kensinger, *Gift of Birds*, 36; Reichel-Dolmatoff, *Goldwork*, 28, 80–81, 128; Roe, *Cosmic Zygote*, 257–59.
53. Burger, *Chavín*, fig. 146.
54. For natural history: Brown and Amadon, *Eagles*, 768–76, 817, 825–27; Grossman and Hamlet, *Birds of Prey*, 396–97.
55. Donnan, *Moche Art*, no. 48; Kutscher, *Nordperuanische*, figs. 184–88; Lapiner, *Pre-Columbian Art*, fig. 399; Paul, *Paracas Ritual;* Peters, in Paul, *Paracas Art*, 265–68.
56. Betanzos, cited by Candler, in Reina and Kensinger, *Gifts of Birds*, 9–10.
57. Tedlock, *Popol Vuh*, 41–42, 132–33.
58. Grossman and Hamlet, *Birds of Prey*, 371.
59. *Between Continents*, no. 49; Easby and Scott, *Before Cortés*, no. 219; Hartman 1907, fig. 56.
60. Berrin and Pasztory, *Teotihuacan*, no. 126.
61. Alva and Donnan, *Royal Tombs*, figs. 143, 145, 146; Donnan, *Moche Art*, nos. 240–42, 248, 270, 271; Kutscher, *Nordperuanische*, figs. 190–91; Lapiner, *Pre-Columbian Art*, fig. 395.
62. Garcilaso, *Royal Commentaries*, 435–36; Donnan, *Moche Art*, 93.

63. Kutscher, *Nordperuanische*, figs. 88, 89, 270; Rostworowski, *Recursos*.

64. Benson, "Owl as Symbol," figs. 2a, 4; Donnan, *Moche Art*, fig. 205; Lapiner, *Pre-Columbian Art*, fig. 385.

65. Alva and Donnan, *Royal Tombs*.

66. For natural history: Austin and Singer, *Birds*, 154–59; Grossman and Hamlet, *Birds of Prey*, 409–66; see also Peters, in Paul, *Paracas Art*, 270, 271.

67. Alcorn, *Huastec Mayan*, 87; Benson, "Owl as Symbol"; Earle, in Preuss, "In Love," 15–21; Gossen, *Chamulas*, 255; Laughlin, *Great Tzotzil*, 183; Peterson, *Precolumbian Flora*, 90–91; Pohl, "Maya Ritual," 84; Reichel-Dolmatoff, *Amazonian Cosmos*, 102; Thompson, *Maya Hieroglyphic*, 75, 115.

68. Tedlock, *Popol Vuh*, 109–10.

69. Pohl, "Mayan Ritual," 84.

70. For natural history: Blake, *Manual*, 262–70; Brown and Amadon, *Eagles*, 175–92; Grossman and Hamlet, *Birds of Prey*; Peters, in Paul, *Paracas Art*, 271–73; Stiles and Janzen, in Janzen, *Costa Rican*, 560–62.

71. Fought, *Chorti Texts*, 180–83.

72. Pohl, "Maya Ritual," 83.

73. Rea, "Black Vultures."

74. Moseley, *Incas*, fig. 45.

75. *Between Continents*, nos. 248–53; Cooke, "Birds and Men"; Reichel-Dolmatoff, *Goldwork*, 88.

76. Hearne and Sharer, *River of Gold*.

77. M. D. Coe, Snow, and Benson, *Atlas*, 108.

78. M. D. Coe, *Maya Scribe*, no. 26; Kerr, *Maya Vase Book*, II: 258; Kutscher, *Nordperuanische*, figs. 155, 275, 276.

79. Kerr, *Maya Vase Book*, III: 403; Reents-Budet, *Painting*, 296–97.

80. Kutscher, *Nordperuanische*, fig. 121; Lapiner, *Pre-Columbian Art*, 267, 347, 373.

81. Donnan, *Moche Art*, 154.

82. Roe, *Cosmic Zygote*, 174; Thompson, *Ethnology*, 130–31; see also Lévi-Strauss, *Raw and Cooked*, 140, 141; Fock, in Wilbert and Simoneau, *Mataco*, 94.

83. Hugh-Jones, *Palm and Pleiades*, 295–96.

84. Gossen, *Chamulas*, 262, 314–15; Laughlin, *Of Cabbages*, 50–51, 152–53, 246–47.

85. Benson, "Fox in Andes"; Fabian, *Space-Time*, 22; see also Fought, *Chorti Texts*, 6–7.

86. Kerr, *Maya Vase Book*, I: 68, II: 241, III: 415; Miller and Taube, *Gods and Symbols*, 137–38, 182; Tedlock, *Popol Vuh*, 36, 89–101; Caso and Bernal, *Urnas*.

87. Paul, *Paracas Ritual*, 85–87.

88. Kerr, *Maya Vase Book*, III: 397; Reents-Budet, *Painting*, figs. 6.36, 6.37.
89. Ferrero, in *Between Continents*, 102–3.

CHAPTER 7: AMPHIBIANS AND REPTILES

1. For natural history: DeGraaff, *Book of Toad;* Dickerson, *Frog Book;* Janzen, *Costa Rican;* Ubertazzi Tanara, *World of Amphibians*, 6–79.
2. Matos Moctezuma, *Great Temple*, 73, fig. 43; see also Nicholson and Quiñones Keber, *Art of Ancient Mexico*, 115–16.
3. Freidel, Schele, and Parker, *Maya Cosmos*, 32–33; Thompson, *Ethnology*, 148–50.
4. Bruce, *Lacandon Dream*, 243; Fought, *Chorti Texts*, 149–50, 417ff.; Pohl, "Maya Ritual," 85–86; Wassén, "Frog in Indian."
5. Lévi-Strauss, *Raw and Cooked*, 140–41; Roe, *Cosmic Zygote*, 152–57, 211; Wassén, "Frog in Indian," 644–49; Wilbert and Simoneau, *Bororo*, 17–24; Wilbert and Simoneau, *Mataco*, 94–95.
6. Crump, in Janzen, *Costa Rican*, 396–98; Scott and Limerick, in Janzen, *Costa Rican*, 357; Wassén, "Frog in Indian," 617–22.
7. Zug, in Janzen, *Costa Rican*, 386–87.
8. Wing and Coe, in M. D. Coe and Diehl, *Land of Olmec*, 378–79.
9. López Luján, *Offerings*, 131.
10. Kerr, *Maya Vase Book*, II: 208, III: 461; Miller and Taube, *Gods and Symbols*, 146; Taube, *Major Gods*, fig. 11h.
11. *Between Continents*, nos. 286–88; Bray, *Gold*, nos. 51, 232, 289.
12. Scott and Limerick, in Janzen, *Costa Rican*, 358.
13. Nicholson and Quiñones Keber, *Art of Ancient Mexico*, 60–61, 66.
14. Wassén, "Frog in Indian," 625–26.
15. DeGraaff, *Book of Toad;* Wassén, "Frog in Indian," 617–27.
16. Lévi-Strauss, *Honey to Ashes;* Roe, *Cosmic Zygote*, 152–57.
17. M. D. Coe, in Kerr, *Maya Vase Book*, I: figs. 25, 26; Miller, in Townsend, *Ancient Americas*, fig. 1; Miller and Taube, *Gods and Symbols*, 69.
18. Freidel, Schele, and Parker, *Maya Cosmos*, 65, 80–82, fig.2:15.
19. Lévi-Strauss, *Raw and Cooked*, 228; Miller, *Murals of Bonampak*, 48–50, pl. 2; Thompson, *Maya Hieroglyphic*, 116.
20. Flannery and Marcus, *Cloud People*, 195, fig. 7.5.
21. Miller and Taube, *Gods and Symbols*, 175.
22. Nicholson and Quiñones Keber, *Art of Ancient Mexico*, 176–77, fig. 86a.
23. Nicholson and Quiñones Keber, *Art of Ancient Mexico*, 159–60.
24. Proskouriakoff, in Pollock et al., *Mayapan*, figs. 1, 2; Miller and Taube, *Gods and Symbols*, 175; Pohl, "Maya Ritual," 82.
25. Bruce, *Lacandon Dream*, 128.
26. For natural history: Alderton, *Turtles and Tortoises;* Ernst and Barbour,

*Turtles;* Janzen, *Costa Rican;* Obst, *Turtles, Tortoises;* Ubertazzi Tanara, *World of Amphibians.*

27. Reichel-Dolmatoff, *Amazonian Cosmos,* 167.

28. López Luján, *Offerings,* 311; Ernst and Barbour, *Turtles,* 72–91, 203–6.

29. Pohl, "Maya Ritual," 96–97.

30. Wing and Coe, in M. D. Coe and Diehl, *Land of Olmec,* 378–79; Pohl, "Maya Ritual," 81–82.

31. Miller, *Murals of Bonampak,* 80.

32. Laughlin, *Great Tzotzil,* 67.

33. Burger, *Chavín,* 150–52; Lathrap, "Gifts of Cayman"; Roe, *Cosmic Zygote,* 275–77.

34. Miller and Taube, *Gods and Symbols,* 49; Roe, *Cosmic Zygote,* 150–52.

35. Peterson, *Precolumbian Flora,* 43.

36. Pohl, "Maya Ritual," 81.

37. López Luján, *Offerings;* Matos Moctezuma, *Great Temple,* fig. 103.

38. Heckenberger and Watters, "Ceramic Remains," 117, figs. 14, 15.

39. For natural history: Dixon and Staton, in Janzen, *Costa Rican,* 387–88; Levy, *Crocodiles and Alligators;* Rue, *Alligators and Crocodiles.*

40. Anderson and Dibble, *Florentine Codex,* bk. 11: 67.

41. *Between Continents,* no. 262.

42. Tedlock, *Popol Vuh,* 36–37, 94–99; see also Miller and Taube, *Gods and Symbols,* 48.

43. Fock, in Wilbert and Simoneau, *Mataco,* 171–72; Helms, *Ancient Panama,* 182.

44. Burger, *Chavín,* 151–52; Gossen, *Chamulas,* 283–84; Reichel-Dolmatoff, *Amazonian Cosmos,* 207.

45. Helms, *Ancient Panama,* 182–83.

46. Van Devender, in Janzen, *Costa Rican,* 379–80.

47. Benson, in Hearne and Sharer, *River of Gold,* 22–31. Bray, in Hearne and Sharer, *River of Gold,* 32–46; Helms, *Ancient Panama,* 97–108, 180; Helms, in Townsend, *Ancient Americas,* 216–27.

48. Reichel-Dolmatoff, *Goldwork,* 67.

49. Fought, *Chorti Texts,* 110–13; Miller and Taube, *Gods and Symbols,* 45.

50. Easby and Scott, *Before Cortés,* no. 33.

51. Jones and Satterthwaite, *Monuments,* fig. 59; Freidel, Schele, and Parker, *Maya Cosmos,* figs. 4.3, 4.13, 4.23; Miller, in Townsend, *Ancient Americas,* fig. 12.

52. Weaver, *Aztecs, Maya,* fig. 6.49.

53. M. D. Coe, Snow, and Benson, *Atlas,* 127; Weaver, *Aztecs, Maya,* fig. 6.67; see also Kerr, *Maya Vase Book,* II: 285.

54. Berrin and Pasztory, *Teotihuacan,* cat. no. 3; Cabrera Castro, in Berrin and Pasztory, *Teotihuacan,* 105, fig. 3; M. D. Coe, Snow, and Benson, *Atlas,* 135;

Coggins, in Berrin and Pasztory, *Teotihuacan*, 143, fig. 2; Easby and Scott, *Before Cortés*, no. 252; Freidel, Schele, and Parker, *Maya Cosmos*, fig. 3.28; Matos Moctezuma, *Great Temple*, figs. 44, 45, 108, 109.

55. Berrin and Pasztory, *Teotihuacan*, nos. 50–52.
56. Milbrath, "Astronomical."
57. Jones and Satterthwaite, *Monuments*, fig. 1; Kerr, *Maya Vase Book*, II: 272; Miller, *Murals of Bonampak*, figs. 50, 51.
58. Easby and Scott, *Before Cortés*, no. 169.
59. Taube, *Major Gods*, figs. 5a and c, 6a and b, 14a–d.
60. López Luján, *Offerings*, 257–60, fig. 114; Matos Moctezuma, *Great Temple*, figs. 18, 117.
61. Burger, *Chavín*, figs. 125, 140, 142, 204, 207, 214; Moseley, *Incas*, frontispiece, figs. 69, 94, 95.
62. Burger, *Chavín*, figs. 176, 183, 204, 207, 214; Kutscher, *Nordperuanische*, figs. 225–33; Flannery and Marcus, *Cloud People*, fig. 6.7; Moseley, *Incas*, fig. 65; Paul, *Paracas Art*, fig. 5.9.
63. Tedlock, *Popol Vuh*, 138–39.
64. Matos Moctezuma, *Great Temple*, fig. 9; Miller and Taube, *Gods and Symbols*, 65.
65. Miller and Taube, *Gods and Symbols*, 164–65; Anderson and Dibble, *Florentine Codex*, bk. 6.
66. Freidel, Schele, and Parker, *Maya Cosmos*, 193–207.
67. Miller and Taube, *Gods and Symbols*, 149–51, 184.
68. Flannery, Marcus, and Reynolds, *Flocks*, 27.
69. Alcorn, *Huastec Mayan*, 141.
70. Roe, *Cosmic Zygote*, 121.
71. For natural history: Campbell and Lamar, *Venomous Reptiles;* Janzen, *Costa Rican;* U.S. Dept. of Navy, *Poisonous Snakes.*
72. Freidel, Schele, and Parker, *Maya Cosmos*, fig. 6.6; Kerr, *Maya Vase Book*, II: 210; Pohl, "Maya Ritual," 78.
73. Kerr, *Maya Vase Book*, II: 210, 228, IV: 545.
74. Miller and Taube, *Gods and Symbols*, 141–42; Nicholson and Quiñones Keber, *Art of Ancient Mexico*, 139–44.
75. Nicholson and Quiñones Keber, *Art of Ancient Mexico*, 129–38.
76. Aveni, in Townsend, *Ancient Americas*, 54, fig. 8.
77. Tedlock, *Popol Vuh*, 33–34, 71–75, 163–64.
78. Anderson and Dibble, *Florentine Codex*, figs. 276, 277.

CHAPTER 8: FISH, CRUSTACEANS, AND MOLLUSKS

1. Burger, *Chavín*, 28–42; Moseley, *Incas*, 92–94, 102–12.
2. Bray, *Gold*, nos. 81–90.

3. Uhle, *Pachacamac*, pl. 18–11.
4. Hugh-Jones, *Palm and Pleiades*, 34, 60, 95–96.
5. Bourget, "El mar"; Kutscher, *Nordperuanische*.
6. Benson, in Townsend, *Ancient Americas*, fig. 3; Donnan, *Moche Art*, 102–6.
7. Lapiner, *Pre-Columbian Art*, figs. 511–12; Proulx, "Nasca," figs. 26, 40.
8. Kerr, *Maya Vase Book*, III: 417.
9. Pohl, "Maya Ritual," 74–78.
10. López Luján, *Offerings*, especially 132; Matos Moctezuma, *Great Temple*, figs. 118, 119.
11. Benson, "Knife in Water"; Freidel, Schele, and Parker, *Maya Cosmos*.
12. Migdalski, Fichter, and Weaver, *Fresh and Salt*, 67.
13. Uhle, *Pachacamac*, figs. 8 and 9.
14. Grzimek, *Fishes*, 86–129; Migdalski, Fichter, and Weaver, *Fresh and Salt*, 43–84; W. R. Coe, *Excavations*, II: 301; López Luján, *Offerings*.
15. Moseley, *Incas*, 189; Paul, *Paracas Ritual*, fig. 7.9; Peters, in Paul, *Paracas Art*, 254–60; Proulx, "Nasca," figs. 12–14.
16. Kerr, *Maya Vase Book*, I: 57; Lapiner, *Precolumbian Art*, fig. 469; Peterson, *Precolumbian Flora*, no. 56.
17. Paul, *Paracas Ritual*, pl. 21, figs. 7.10, 7.13.
18. Wilbert and Simoneau, *Bororo*, 35.
19. Tedlock, *Popol Vuh*, 149–50, 289–90 (n. 149), 330; Reents-Budet, *Painting*, 242.
20. Pohl, "Maya Ritual," 75; M. D. Coe, *Maya Scribe*, no. 45; Kerr, *Maya Vase Book*, III: 401, 450, 451; Reents-Budet, *Painting*, 242.
21. Migdalski, Fichter, and Weaver, *Fresh and Salt*, 158–67; Vogt, in Grzimek, *Fishes*, 363–92.
22. Burger, *Chavín*, 28–29; Moseley, chap. 5.
23. Alva and Donnan, *Royal Tombs*, 196–98; Gordon, *Pre-Columbian Pottery*, no. 8; Kutscher, *Nordperuanische*, figs. 241–52.
24. Benson, *Mochica*, figs. 2-7, 2-16, 2-17, 2-22.
25. Alva and Donnan, *Royal Tombs*, figs. 196, 197; Donnan, *Moche Art*, nos. 18–20; Hearne and Sharer, *River of Gold*, pl. 70; Peterson, *Precolumbian Flora*, no. 55.
26. Miller, *Murals of Bonampak*, pls. 1, 7. See Miller, *National Geographic* 187, no. 2 (1995): 60–81, for good color reproduction.
27. Grzimek, *Mollusks*, 50–189; Keen, *Sea Shells*, 96–98, 420–21.
28. M. D. Coe, *Maya Scribe*, nos. 84, 85, 86; Reents-Budet, *Painting*, 42–43, 316–17; Scott, *Ancient Mesoamerica*, nos. 71, 73.
29. Pohl, "Maya Ritual," 102; Thompson, *Maya Hieroglyphic*.
30. M. D. Coe, *Maya Scribe*, no. 16; Jones and Satterthwaite, *Monuments*, figs. 58; Kerr, *Maya Vase Book*, II: 292; Reents-Budet, *Painting*, no. 90; Taube, *Major Gods*, 92–99.

31. Benson, in Townsend, *Ancient Americas*, fig. 2; Donnan, *Moche Art*, no. 102; Kutscher, *Nordperuanische*, figs. 27–33.

32. López Luján, *Offerings*; Matos Moctezuma, *Great Temple*, 73, fig. 82; Nicholson and Quiñones Keber, *Art of Ancient Mexico*, 79, 110–11.

33. Nicholson and Quiñones Keber, *Art of Ancient Mexico*, 79.

34. Alva and Donnan, *Royal Tombs*, fig. 11; Berrin and Pasztory, *Teotihuacan*, no. 53; Burger, *Chavín*, 200, figs. 180, 216, 219; Boone, *Codex Magliabechiano*, 35; Anderson and Dibble, *Florentine Codex*; Guaman Poma, *Corónica*, 350 [352]; Peterson, *Precolumbian Flora*, no. 59; Rostworowksi, *Recursos*, 122–23; Winning, *Pre-Columbian Art*, fig. 195.

35. Berrin, in Berrin and Pasztory, *Teotihuacan*, fig. 22.

36. M. D. Coe, *Maya Scribe*, no. 66; Kerr, *Maya Vase Book*, I: 53, III: 397; Pohl, "Maya Ritual," 62–65, 94–97; Reents-Budet, *Painting*, 263, fig. 5.35, no. 79.

37. Donnan, *Moche Art*, 63, nos. 158, 166, 218; Kutscher, *Nordperuanishe*, fig. 126.

38. Proskouriakoff, in Pollock, *Mayapan*, fig. 47a, b, c, g.

39. Bray, *Gold*, nos. 168, 409, 410; Burger, *Chavín*, 205, fig. 219; Donnan, *Moche Art*, no. 100.

40. Kutscher, *Nordperuanische*, figs. 34–45.

41. Burger, *Chavín*, 177, fig. 183.

42. Burger, *Chavín*, 54; Moseley, *Incas*, 104, 118.

43. Davidson, "Ecology, Art."

44. Burger, in Townsend, *Ancient Americas*, 269, fig. 5.

45. A. P. Rowe, *Costumes*, 165–67.

46. Moseley, *Incas*, 42.

47. Alva and Donnan, *Royal Tombs*, 117, 154, 215, figs. 57, 157; Keen, *Sea Shells*, 667.

48. W. R. Coe, *Excavations*.

49. Fash, *Scribes*, 147–49.

50. Jones and Satterthwaite, *Monuments*, figs. 5, 51, 52.

51. Miller, *Murals of Bonampak*, 60–64, 153–54, pl. 5.

52. Berdan and Anawalt, *Codex Mendoza* (folio 37v), vol. 4, 81.

53. Matos Moctezuma, *Great Temple*, fig. 104. See also López Luján, *Offerings*, 323, 411.

54. Cobo, *Inca Religion*, 127; Rostworowski, *Recursos*, 122.

# Bibliography

Alcorn, Janis B. *Huastec Mayan Ethnobotany.* Austin: University of Texas Press, 1984.

Alderton, David. *Turtles and Tortoises of the World.* New York: Facts on File, 1988.

Alva, Walter, and Christopher B. Donnan. *Royal Tombs of Sipán.* Los Angeles: University of California, Fowler Museum of Cultural History, 1994.

Anderson, Arthur J. O., and Charles E. Dibble, eds. *The Florentine Codex: History of the Things of New Spain, Fray Bernardino de Sahagún.* 12 books in 11 vols. Santa Fe: School of American Research and the University of New Mexico, 1950–82.

*Arte Precolombino de Ecuador* (Pre-Columbian Art of Ecuador). Quito: Salvat Editores Ecuatoriana, S.A., 1985.

Austin, Oliver L., Jr., and Arthur Singer. *Birds of the World.* New York: Golden Books, 1961.

Baus de Czitrom, Carolyn. *Los perros de la antigua provincia de Colima* (The Dogs of the Ancient Province of Colima). Mexico City: Instituto Nacional de Antropología e Historia, 1988.

Benson, Elizabeth P. "Bats in South American Iconography." *Andean Past* 1 (1987): 165–90.

———. "The Chthonic Canine." *Latin American Indian Literatures Journal* 7, no. 1 (1991): 95–107.

———. "The Fox in the Andes: South American Myth and the Use of Fox Skins." *Institute of Maya Studies Journal* 1, no. 1 (1995): 1–15.

———. "A Knife in the Water: The Stingray in Mesoamerican Ritual Life." *Journal of Latin American Lore* 14, no. 2 (1988): 12–24.

———. "The Maya and the Bat." *Latin American Indian Literatures Journal* 4, no. 2 (1988): 99–124.

———. *The Mochica: A Culture of Peru.* New York: Praeger, 1972.

———. "The Multimedia Monkey, or The Failed Man: The Monkey as Artist."

In *Seventh Palenque Round Table,* edited by Merle Greene Robertson and Virginia M. Fields, pp. 137–42. San Francisco: Pre-Columbian Art Research Institute, 1994.

————. "New World Deer-Hunt Rituals." In *Simpatías y diferencias,* pp. 45–59. Mexico City: Universidad Nacional Autónoma de México, Instituto de Investigaciones Estéticas, 1988.

————. "The Owl as a Symbol in the Mortuary Iconography of the Moche." In *Arte Funerario: Coloquio Internacional de Historia del Arte,* edited by Beatriz de la Fuente and Louise Noelle, pp. 75–82. Mexico City: Universidad Nacional Autónoma de México, Instituto de Investigaciones Estéticas, 1987.

Berdan, Frances F., and Patricia Rieff Anawalt. *The Codex Mendoza.* Berkeley: University of California Press, 1992.

Berrin, Kathleen, and Esther Pasztory, eds. *Teotihuacan: Art from the City of the Gods.* New York: Thames and Hudson and Fine Arts Museum of San Francisco, 1993.

*Between Continents/Between Seas: Pre-Columbian Art of Costa Rica.* New York: Henry N. Abrams, 1981.

Blake, Emmet R. *Manual of Neotropical Birds.* Vol. 1. Chicago: University of Chicago Press, 1977.

Boone, Elizabeth Hill. *The Codex Magliabechiano.* Berkeley: University of California Press, 1983.

Bourget, Steve. "El mar y la muerte en la iconografía moche" (The Sea and Death in Moche Iconography). In *Moche: Propuestas y perspectivas,* edited by Santiago Uceda and Elias Mujica, 425–47. Trujillo, Peru: Universidad Nacional de la Libertad, 1994.

Bray, Warwick. *The Gold of El Dorado.* London: Royal Academy, 1978.

Brown, Leslie, and Dean Amadon. *Eagles, Hawks and Falcons of the World.* 2 vols. in one. Secaucus, N.J.: Wellfleet Press, 1989.

Bruce, Robert. *Lacandon Dream Symbolism.* Vol. 2. Mexico City: Ediciones Euroamericanas Klaus Thiele, 1979.

Burger, Richard L. *Chavín and the Origins of Andean Civilization.* London: Thames and Hudson, 1992.

Campbell, Jonathan A., and William W. Lamar. *The Venomous Reptiles of Latin America.* Ithaca: Comstock, 1989.

Caso, Alfonso, and Ignacio Bernal. *Urnas de Oaxaca* (Urns of Oaxaca). Mexico City: Instituto Nacional de Antropología e Historia, 1952.

Cobo, Bernabé. *Inca Religion and Customs.* Translated and edited by Roland Hamilton. Austin: University of Texas Press, 1990.

Coe, Michael D. *The Maya Scribe and his World.* New York: Grolier, 1973.

Coe, Michael D., and Richard A. Diehl. *In the Land of the Olmec.* 2 vols. Austin: University of Texas Press, 1980.

Coe, Michael D., Dean Snow, and Elizabeth P. Benson. *Atlas of Ancient America.* New York: Facts on File, 1986.

Coe, William R. *Excavations in the Great Plaza, North Terrace and North*

*Acropolis of Tikal.* University Museum Monograph 61, Tikal Report 14. 5 vols. Philadelphia: University of Pennsylvania, 1990.

Cooke, Richard G. "Birds and Men in Prehistoric Central Panama." In *Recent Developments in Isthmian Archaeology,* edited by Frederick W. Lange, pp. 243–81. B.A.R. International Series 212. Oxford, 1984.

Cordy-Collins, Alana. "An Unshaggy Dog Story." *Natural History* 103, no. 2 (1994): 34–41.

Culbert, Patrick. *The Ceramics of Tikal: Vessels from the Burials, Caches, and Problematical Deposits.* University Museum Monograph 81, Tikal Report 25, part A. Philadelphia: University of Pennsylvania, 1993.

Davidson, Judith R. "Ecology, Art, and Myth: A Natural Approach to Symbolism." In *Pre-Columbian Art History,* edited by Alana Cordy-Collins, pp. 331–43. Palo Alto: Peek, 1982.

Davis, L. Irby. *A Field Guide to the Birds of Mexico and Central America.* Austin: University of Texas Press, 1972.

DeGraaff, Robert M. *The Book of the Toad.* Rochester, Vt.: Park Street Press, 1991.

Díaz del Castillo, Bernal. *The Discovery and Conquest of Mexico.* New York: Farrar, Straus and Cudahy, 1956.

Dickerson, Mary C. *The Frog Book.* New York: Dover, 1969.

Donnan, Christopher B. *Moche Art of Peru.* Los Angeles: University of California, Museum of Cultural History, 1978.

Durán, Fray Diego. *Book of the Gods and Rites and the Ancient Calendar.* Edited and translated by Fernando Horcasitas and Doris Heyden. Norman: University of Oklahoma Press, 1971.

Easby, Elizabeth Kennedy, and John F. Scott. *Before Cortés: Sculpture of Middle America.* New York: Metropolitan Museum of Art, 1970.

*Ecuador: In the Shadow of the Volcano.* Quito: Ediciones Libri Mundi, 1981.

Eisenberg, John F. *Mammals of the Neotropics.* Vol. 1: *The Northern Neotropics.* Chicago: University of Chicago Press, 1989.

Emmons, Louise H. *Neotropical Rainforest Mammals.* Illustrated by François Feer. Chicago: University of Chicago Press, 1990.

Ernst, Carl H., and Roger W. Barbour. *Turtles of the World.* Washington, D.C.: Smithsonian Institution Press, 1989.

Fabian, Stephen Michael. *Space-Time of the Bororo of Brazil.* Gainesville: University Press of Florida, 1992.

Fash, William L. *Scribes, Warriors and Kings: The City of Copán and the Ancient Maya.* London: Thames and Hudson, 1991.

Fenton, M. Brock, *Bats.* New York: Facts on File, 1992.

Flannery, Kent V., and Joyce Marcus. *The Cloud People: Divergent Evolution of the Zapotec and Mixtec Civilizations.* New York: Academic Press, 1983.

Flannery, Kent V., Joyce Marcus, and Robert G. Reynolds. *The Flocks of the Wamani: A Study of Llama Herders on the Punas of Ayacucho, Peru.* San Diego and New York: Academic Press, 1989.

Fought, John G. *Chorti (Mayan) Texts*. Edited by Sarah S. Fought. Philadelphia: University of Pennsylvania Press, 1972.

Freidel, David, Linda Schele, and Joy Parker. *Maya Cosmos*. New York: William Morrow, 1993.

Furst, Peter T. "The Olmec Were-Jaguar in the Light of Ethnographic Reality." In *Dumbarton Oaks Conference on the Olmec*, edited by Elizabeth P. Benson, pp. 143–74. Washington, D.C.: Dumbarton Oaks Research Library and Collection, 1968.

Garcilaso de la Vega, El Inca. *Royal Commentaries of the Incas and General History of Peru*. 2 vols. Translated by Harold V. Livermore. Austin: University of Texas Press, 1966 [1604].

Gordon, Elsbeth K. *Pre-Columbian Pottery of Peru*. University Gallery Bulletin 1, no. 1. Gainesville: University of Florida, University Gallery, 1975.

Gossen, Gary H. *Chamulas in the World of the Sun: Time and Space in a Maya Oral Tradition*. Cambridge, Mass.: Harvard University Press, 1974.

Greenewalt, Crawford H. *Hummingbirds*. New York: Dover, 1990.

Grossman, Mary Louise, and John Hamlet. *Birds of Prey of the World*. New York: Bonanza Books, 1964.

Grzimek, Bernhard, ed. *Grzimek's Animal Life Encyclopedia*. Vol. 3: *Mollusks and Echinoderms*. Vol. 4: *Fishes I*. New York: Van Nostrand Reinhold, 1984.

Guaman Poma de Ayala, Felipe [Waman Puma]. *El Primer Nueva Corónica y Buen Gobierno* (The First New Chronicle and Good Government). Edited by John V. Murra and Rolena Adorno; translated by Jorge L. Urioste. 3 vols. Mexico City: Siglio Veintiuno, 1980.

Hancock, James, and James Kushlan. *The Herons Handbook*. New York: Harper and Row, 1984.

Harrison, Peter. *Sea Birds*. Rev. ed. Boston: Houghton Mifflin, 1985.

Hartman, C. V. *Archaeological Researches on the Pacific Coast of Costa Rica*. Memoirs of the Carnegie Museum 3 (1907).

Hearne, Pamela, and Robert J. Sharer, eds. *River of Gold: Precolumbian Treasures from Sitio Conte*. Philadelphia: University of Pennsylvania, University Museum, 1992.

Heckenberger, Michael K., and David R. Watters. "Ceramic Remains from Carl V. Hartman's 1903 Excavations at Las Huacas Cemetery, Costa Rica." *Annals of Carnegie Museum* 62, no. 2 (1993): 97–129.

Helms, Mary W. *Ancient Panama: Chiefs in Search of Power*. Austin: University of Texas Press, 1979.

Hill, John E., and James D. Smith. *Bats: A Natural History*. Austin: University of Texas Press, 1984.

Hilty, Steven L., and William L. Brown. *A Guide to the Birds of Colombia*. Princeton: Princeton University Press, 1986.

Hoppe, Dieter. *The World of Macaws*. Translated by Arthur Freud and R. Edward Ugarte. Neptune City, N.J.: T.H.F., 1985.

Houston, Stephen, and David Stuart. *The Way Glyph: Evidence for "Co-Essences*

*among the Classic Maya.* Research Reports on Ancient Maya Writing 30. Washington, D.C.: Center for Maya Research, 1989.

Hugh-Jones, Stephen. *The Palm and the Pleiades: Initiation and Cosmology in Northwest Amazonia.* Cambridge: Cambridge University Press, 1979.

Janzen, Daniel H., ed. *Costa Rican Natural History.* Chicago: University of Chicago Press, 1983.

Jones, Christopher, and Linton Satterthwaite. *The Monuments and Inscriptions of Tikal: The Carved Monuments.* University Museum Monograph 44, Tikal Report 33, part A. Philadelphia: University of Pennsylvania. 1982.

Kampen, Michael Edwin. *The Sculptures of El Tajín, Veracruz, Mexico.* Gainesville: University of Florida Press, 1972.

Keen, A. Myra. *Sea Shells of Tropical West America.* 2d ed. Stanford: Stanford University Press, 1971.

Kerr, Justin. *The Maya Vase Book.* 4 vols. New York: Kerr Associates, 1989–94.

Kutscher, Gerdt. *Nordperuanische Gefässmalerein des Moche-Stils* (Northern Peruvian Vase Painting of the Moche Style). Edited by Ulf Bankmann. Munich: Verlag C. H. Beck, 1983.

Lapiner, Alan. *Pre-Columbian Art of South America.* New York: Harry N. Abrams, 1976.

Lathrap, Donald W. "Gifts of the Cayman: Some Thoughts on the Subsistence Basis of Chavín." In *Variation in Anthropology: Essays in Honor of John C. McGregor,* edited by Donald W. Lathrap and J. Douglas, pp. 91–105. Urbana: Illinois Archaeological Survey, 1973.

Laughlin, Robert M. *The Great Tzotzil Maya Dictionary of San Lorenzo Zinacantán.* Smithsonian Contributions to Anthropology 19. Washington, D.C.: Smithsonian Institution Press, 1975.

———. *Of Cabbages and Kings.* Smithsonian Contributions to Anthropology 23. Washington, D.C.: Smithsonian Institution Press, 1977.

Leopold, A. Starker. *Wildlife of Mexico: The Game Birds and Mammals.* Berkeley: University of California Press, 1972.

Lévi-Strauss, Claude. *From Honey to Ashes.* Translated by John and Doreen Weightman. New York: Harper and Row, 1983 [1973].

———. *The Jealous Potter.* Translated by Benedicte Chorier. Chicago: University of Chicago Press, 1988.

———. *The Raw and the Cooked.* Translated by John and Doreen Weightman. New York: Harper and Row, 1969.

Levy, Charles. *Crocodiles and Alligators.* Secaucus, N.J.: Chartwell Books, 1991.

López Luján, Leonardo. *The Offerings of the Templo Mayor of Tenochtitlan.* Translated by Bernard R. and Thelma Ortiz de Montellano. Niwot: University Press of Colorado, 1994.

Macdonald, David. *The Encyclopedia of Mammals.* New York: Facts on File, 1984.

Matos Moctezuma, Eduardo. *The Great Temple of the Aztecs: Treasures of Tenochtitlan.* London: Thames andd Hudson, 1988.

Migdalski, Edward C., George S. Fichter, and Norman Weaver. *The Fresh and Salt Water Fishes of the World.* New York: Greenwich House, 1976.

Milbrath, Susan. "Astronomical Imagery in the Serpent Sequences of the Madrid Codex." In *Archaeoastronomy in the Americas,* edited by Ray A. Williamson, pp. 263–84. Los Altos, Cal.: Ballena Press, 1981.

Miller, Mary Ellen. *The Murals of Bonampak.* Princeton: Princeton University Press, 1986.

Miller, Mary Ellen, and Karl Taube. *The Gods and Symbols of Ancient Mexico and the Maya.* London: Thames and Hudson, 1993.

Moseley, Michael E. *The Incas and Their Ancestors: The Archaeology of Peru.* London: Thames and Hudson, 1992.

Murra, John V. "Cloth and Its Functions in the Inca State." *American Anthropologist* 64 (1962): 710–28.

Nicholson, H. B., and Eloise Quiñones Keber. *Art of Ancient Mexico: Treasures of Tenochtitlan.* Washington, D.C.: National Gallery of Art, 1983.

Nowak, Ronald M. *Walker's Mammals of the World.* 5th ed. 2 vols. Baltimore: Johns Hopkins University Press, 1991.

Nuttall, Zelia, ed. *The Codex Nuttall.* Introduction by Arthur G. Miller. New York: Dover, 1975.

Obst, Fritz Jurgen. *Turtles, Tortoises and Terrapins.* New York: St. Martin's, 1988.

Paul, Anne. *Paracas Ritual Attire.* Norman: University of Oklahoma Press, 1990.

————, ed. *Paracas Art and Architecture.* Iowa City: University of Iowa Press, 1991.

Peterson, Jeanette F. *Precolumbian Flora and Fauna: Continuity of Plant and Animal Themes in Mesoamerican Art.* San Diego: Mingei International Museum, 1990.

Pohl, Mary. "Maya Ritual Faunas." In *Civilization in the Ancient Americas: Essays in Honor of Gordon R. Willey,* edited by Richard M. Leventhal and Alan L. Kolata, pp. 55–103. Albuquerque: University of New Mexico Press/ Cambridge, Mass.: Harvard University, Peabody Museum of Archaeology and Ethnology, 1983.

Pollock, H. E. D., et al. *Mayapan, Yucatan, Mexico.* Carnegie Institution of Washington Publication 619. Washington, D.C.: Carnegie Institution, 1962.

Preston-Mafham, Rod. *The Book of Spiders and Scorpions.* New York: Crescent Books, 1991.

Preuss, Mary H., ed. *"In Love and War: Hummingbird Lore" and Other Selected Papers from LAILA/ALILA's 1988 Symposium.* Culver City, Cal.: Labyrinthos, 1989.

Proulx, Donald A. "The Nasca Style." In *Art of the Andes: Pre-Columbian Sculptured and Painted Ceramics from the Arthur M. Sackler Collections,* edited by Lois Katz, pp. 86–105. Washington, D.C.: Arthur M. Sackler Foundation and AMS Foundation for the Arts, Sciences and Humanities, 1983.

Rea, Amadeo M. "Black Vultures and Human Victims: Archaeological Evidence

from Pacatnamu." In *The Pacatnamu Papers*, vol. 1, edited by Christopher B. Donnan and Guillermo A. Cock. Los Angeles: University of California, Museum of Cultural History, 1986.

Redford, Kent H., and John F. Eisenberg. *Mammals of the Neotropics*. Vol. 2: *The Southern Cone*. Chicago: University of Chicago Press, 1992.

Reents-Budet, Dorie. *Painting the Maya Universe: Royal Ceramics of the Classic Period*. Durham: Duke University Press, 1994.

Reichel-Dolmatoff, Gerardo. *Amazonian Cosmos: The Sexual and Religious Symbolism of the Tukano Indians*. Chicago: University of Chicago Press, 1971.

———. *Goldwork and Shamanism*. Medellín, Colombia: Companía Litográfica Nacional, 1988.

———. *Los Kógi* (The Kogi). 2 vols. Bogotá, Colombia: Nueva Biblioteca Colombiana de Cultura, 1985 [1949–50].

Reina, Ruben E., and Kenneth M. Kensinger, eds. *The Gift of Birds: Featherwork of Native South American Peoples*. Philadelphia: University of Pennsylvania, University Museum of Archaeology and Anthropology, 1991.

Roe, Peter T. *The Cosmic Zygote*. New Brunswick, N.J.: Rutgers University Press, 1982.

Rostworowski de Diez Canseco, María. *Recursos naturales renovables y pesca: siglos XVI y XVII* (Renewable Natural Resources and Fishing, Sixteenth and Seventeenth Centuries). Lima: Instituto de Estudios Peruanos, 1981.

Rowe, Ann Pollard. *Costumes and Featherwork of the Lords of Chimor*. Washington, D.C.: Textile Museum, 1984.

Rowe, John Howland. "Inca Culture at the Time of the Spanish Conquest." In *Handbook of South American Indians*, vol. 2, 183–330. Bureau of American Ethnology Bulletin 143. Washington, D.C.: Smithsonian Institution, 1946.

Rue, Leonard Lee, III. *Alligators and Crocodiles: A Portrait of the Animal World*. New York: Magna Books, 1994.

Saunders, Nicholas J. *People of the Jaguar: The Living Spirit of Ancient America*. London: Souvenir Press, 1989.

Scott, John F. *Ancient Mesoamerica: Selections from the University Gallery Collection*. Gainesville: University of Florida, 1987.

Seler, Eduard. "Die Tierbilder in den Mexikanischer und den Maya-Handschriften" (Animal Pictures in the Mexican and Maya Manuscripts). In *Gesammelte Abhandlungen zur Amerikanischer Sprach- und Altertumskunde*, vol. 4. Graz: Akademische Druck- und Verlagsanstalt, 1961 [1923].

Shimada, Izumi, and Melody Shimada. "Prehistoric Llama Breeding and Herding on the North Coast of Peru." *American Antiquity* 50 (1985): 3–16.

Smith, Herbert Huntingdon. "Notes." Manuscript. Pittsburgh: Carnegie Museum of Natural History, Section of Anthropology, [1898].

Smith, Larry L., and Robin W. Doughty. *The Amazing Armadillo*. Austin: University of Texas Press, 1984.

Taube, Karl Andreas. *The Major Gods of Ancient Yucatan*. Studies in Pre-Columbian Art and Archaeology 22. Washington, D.C.: Dumbarton Oaks Research Library and Collection, 1992.

Tedlock, Dennis, trans. *Popol Vuh*. New York: Simon and Schuster, 1985.

Thompson, J. Eric S. *Ethnology of the Mayas of Southern and Central British Honduras*. Field Museum of Natural History Publication 274. Chicago: Field Museum, 1930.

———. *Maya Hieroglyphic Writing: An Introduction*. Norman: University of Oklahoma Press, 1971 [1960].

Townsend, Richard F., ed. *The Ancient Americas: Art from Sacred Landscapes*. Chicago: Art Institute of Chicago, 1992.

Tozzer, Alfred M. *Landa's Relación de las cosas de Yucatan* (Landa's Relation of the Things of Yucatan). Peabody Museum of American Archaeology and Ethnology Memoirs 18. Cambridge, Mass.: Harvard University, 1941.

Ubertazzi Tanara, Milli. *The World of Amphibians and Reptiles*. New York: Abbeville Press, 1975.

Uhle, Max. *Pachacamac: A Reprint of the 1903 Edition*. Introduction by Izumi Shimada. University Museum Monograph 62. Philadelphia: University of Pennsylvania, University Museum, 1991.

Urton, Gary, ed. *Animal Myths and Metaphors*. Salt Lake City: University of Utah Press, 1985.

U.S. Department of the Navy (Bureau of Medicine and Surgery). *Poisonous Snakes of the World*. New York: Dover, 1991.

Wassén, S. Henry. "The Frog in Indian Mythology and Imaginative World." *Anthropos* 29, nos. 5 and 6 (1934): 613–58.

Weaver, Muriel Porter. *The Aztecs, Maya, and Their Predecessors: Archaeology of Mesoamerica*. 3d ed. San Diego: Academic Press, 1993.

Wilbert, Johannes, and Karin Simoneau, eds. *Folk Literature of the Bororo Indians*. Los Angeles: University of California, Latin American Center, 1983.

———. *Folk Literature of the Mataco Indians*. Los Angeles: University of California, Latin American Center, 1982.

———. *Folk Literature of the Toba Indians*. Los Angeles: University of California, Latin American Center, 1982.

Wing, Elizabeth. "Human Use of Canids in the Central Andes." In *Advances in Tropical Mammalogy* 254–75. 1989

Winning, Hasso von. *Pre-Columbian Art of Mexico and Central America*. New York: Harry N. Abrams, 1968.

Zeidler, James A. "Feline Imagery, Stone Mortars, and Formative Period Interaction Spheres in the Northern Andean Area." *Journal of Latin American Lore* 14, no. 2 (1988): 243–83.

# Index